SANTOS AND SAINTS

The Religious Folk Art
of Hispanic New Mexico

Thomas J. Steele, S. J.

Ancient City Press

SANTA FE, NEW MEXICO

Revised Edition
Third Printing

Copyright © 1974, 1982 by the Regis
Jesuit Community.

ISBN: 0-941270-12-2 (paper)
L.C. Card No. 74-75452

Printed in the United States of America
by Inter-Collegiate Press
Shawnee Mission, Kansas

CONTENTS

Update: A Preface to the 1982 Edition iv

Author's Note, 1973 viii

I. Santo Space: Pre-Renaissance and Post-Renaissance 1

II. Making A Santo: A Holy Action 29

III. Santos and Saints 45

IV. Saints and Prayer 73

V. New Mexico Reapplication of Saints 97

VI. God, Virgin, Angels, Saints 117

VII. Santos, Saints, and Land 141

Appendices:

A: A List of Saints 169

Addendum: Most Frequently Represented

Subjects 198

B: Santo-Identification Chart 199

C: Calendar of the New Mexican Saints 205

D: Motivational Chart 207

E: A List of Santeros 211

Index .. 215

UPDATE

A Preface to the 1982 Edition

Τ he reviews of this book were very gratifying, and I will
always be grateful for the many nice words written and
spoken about it after its debut eight years ago, in 1974. But per-
haps only the author himself, like a knowing parent, fully real-
izes the blemishes of body and flaws of character in his offspring
and blushes to think of them. So I am very glad to have this op-
portunity of a second edition to correct in silence some of the
more embarrassing typos and to do something of a chapter-by-
chapter and appendix-by-appendix review of this eight-year-old
of mine, noting some painful shortcomings and especially updat-
ing the original "supplementary bibliography," in which I had
tried to note for each chapter the pertinent books and articles
which did not happen to appear in the footnotes.

Chapter One just needs bibliographical updating, especially:

Boyd, E. *Popular Arts of Spanish New Mexico*. Santa Fe: Museum of New Mexico
Press, 1974.
Frank, Larry. *A Kingdom of Saints*. Roswell: Roswell Museum, 1975.
Kessell, John L. *The Missions of New Mexico Since 1776*. Albuquerque: University
of New Mexico Press, 1980.
Wroth, William, ed. *Hispanic Crafts of the Southwest*. Colorado Springs: Taylor
Museum, 1977.

Chapter Two has held up fairly well, but Chapter Three fell
far short of satisfactory in the section regarding the Tomé Passion
Play. Most of this inadequacy I later tried to remedy with a book
wholly on Tomé:

Steele, Thomas J., S. J. *Holy Week in Tomé: A New Mexico Passion Play.* Santa Fe:
Sunstone Press, 1976.

But shortly after that book appeared, I became aware of two very
pertinent articles which (I blush to admit) I failed to know of:

Englekirk, John E., "The Sources and Dating of the New Mexico Spanish Folk Plays," *Western Folklore* 16 (1957), 232-55; and _____, "The Passion Play in New Mexico," *Western Folklore* 25 (1966), 17-33, 105-21.

Fortunately, I was shortly able to make amends in another publication:

Steele, Thomas J., S. J., "The Spanish Passion Play in New Mexico and Colorado," *New Mexico Historical Review* 53 (1978), 239-59;

and I added something of a grace note with:

_____, "The Triple Rostro of Arroyo Seco," Denver *Post* "Empire," 30 # 14 (8 April 1979), 23-25.

Further very important publications about the other matters in that troublesome chapter are:

Ottaway, Harold N., "The Penitente *Moradas* of the Taos, New Mexico, Area," unpublished dissertation, University of Oklahoma, 1975; and most especially:

Weigle, Marta, *Brothers of Light, Brothers of Blood: The Penitentes of the Southwest* (Albuquerque: University of New Mexico Press, 1976);

_____, *A Penitente Bibliography* (Albuquerque: University of New Mexico Press, 1976); and

_____, "Ghostly Flagellants and Doña Sebastiana: Two Legends of the Penitente Brotherhood," *Western Folklore* 36 (1977), 135-47.

Chapter Four, in which I tried to examine the low-technology peasant background, could also use some updating with the help of materials which have appeared since, especially:

Brown, Lorin W. *Hispano Folklife of New Mexico,* ed. Charles L. Briggs and Marta Weigle. Albuquerque: University of New Mexico Press, 1978.

Chávez, Fray Angélico. *My Penitente Land.* Albuquerque: University of New Mexico Press, 1974.

Coles, Robert. *The Old Ones of New Mexico.* Albuquerque: University of New Mexico Press, 1973.

Kutsche, Paul, ed. *The Survival of Spanish American Villages.* Colorado Springs: Colorado College, 1979.

Kutsche, Paul, and Van Ness, John R. *Cañones: Values, Crisis, and Survival in a Northern New Mexico Village.* Albuquerque: University of New Mexico Press, 1981.

Weigle, Marta, ed. *Hispanic Villages of Northern New Mexico.* Santa Fe: The Lightning Tree, 1975.

Chapter Five seems to hold up fairly well, though with a little needed correction from:

Lange, Yvonne. "Santo Niño de Atocha: A Mexican Cult Is Transplanted to Spain." *El Palacio* 84 # 4 (Winter 1978), 2-7.

Chapter Six may benefit from a work on one of the subjects mentioned:

Steele, Thomas J., S. J., "The Death Cart: Its Place Among the Santos of New Mexico," *Colorado Magazine* 55 (1978), 1-14—an article which, I am pleased to note, received the Leroy Hafen Award for 1979 from the Colorado Historical Society.

Chapter Seven, which mainly concerns the land grant problem, remains a piece of America's unfinished business, so the bibliography continues to accumulate. I would like to call attention to the following:

Ebright, Malcolm. *The Tierra Amarilla Grant: A History of Chicanery.* Santa Fe: The Center for Land Grant Studies, 1980.

"Land Grant Issue." *New Mexico Historical Review,* vol. 57, no. 1 (January 1982).

Tijerina, Reies López. *Mi Lucha por la tierra.* México: Fondo de Cultura Económica, 1978.

Van Ness, John M. and Christine M., eds. *Spanish and Mexican Land Grants in New Mexico and Colorado.* Manhattan: Sunflower Press, 1980.

Appendix A, my list of santero subjects, can use a little refinement. First of all, instead of a single entry for the crucifix (#16), I ought to have had at least a subdivision (#16a) for Nuestro Señor de Esquípulas, a version featuring the tree of life which seems to have been carved in New Mexico exclusively by the santero Molleno: for which see Fray Angélico Chávez, *Archives of the Archdiocese of Santa Fe* (Washington: Academy of American Franciscan History, 1957), p. 66; Chávez, *My Penitente Land* (above, 1974), pp. 210, 216-18; E. Boyd, *Popular Arts of Spanish New Mexico* (above, 1974), pp. 352-53. Next: Boyd (pp. 353, 357) and William Wroth, *The Chapel of Our Lady of Talpa* (Colorado Springs: Taylor Museum, 1979, p. 29) have identified San Policarpio, who should become #110a. Next: Marta Weigle, "Ghostly Flagellants and Doña Sebastiana" (above, 1977), p. 146, has identified the Denver Art Museum's A-1621 as a representation of a backsliding Penitente Brother suffering for his omissions after his death; it ought to be #144. And finally, I think the Taylor Museum's #1136 will turn out to be #145 in my list of subjects: it is a retablo depicting a reliquary containing the relic of some Franciscan saint, probably San Antonio de Padua.

Appendix B remains serviceable, but there are still some subjects it will not identify—including one "San Ignoto" which I myself own. Appendix C will get some further commentary in a forthcoming article of mine, "The Naming of Places in Spanish New Mexico," to appear in a University of New Mexico Press/ Spanish Colonial Arts Society volume on Spanish Colonial arts

and ethnohistory edited by Marta Weigle with Claudia Larcombe and Samuel H. Larcombe. And Appendix D may stand as is.

Appendix E, the list of santeros, needs some help, fortunately much of it available in E. Boyd's *Popular Arts of Spanish New Mexico* (above, 1974), the volume that embodies the life's work of a scholar who did more than any other person to sort out the work of different santeros on stylistic grounds and to accumulate the available documentary evidence about them. Boyd makes a few shrewd guesses about possible identities of Franciscan "F," the artist of certain of the hide paintings (p. 121). She opines that the Dot-and-Dash Santero was a disciple of José Aragon (pp. 374-75) and suggests that the Santo Niño Santero might have been José Manuel Benabides of Santa Cruz (pp. 384-85), an opinion shared by Robert Stroessner in *The Cross and the Sword*, ed. Jean Stern (San Diego: Fine Arts Society, 1976), p. 21. William Wroth's *The Chapel of Our Lady of Talpa* (above, 1979) deals extensively with Rafael Aragon's work, while Boyd (pp. 392-95) and Charles L. Briggs, *The Wood Carvers of Córdova, New Mexico* (Knoxville: University of Tennessee Press, 1980, pp. 26-29) note José Miguel Aragon as Rafael's son and a link by marriage to the López family of Córdova, including Nasario Guadalupe López, creator of the first Death Cart and father of José Dolores. And for completeness, on pp. 430-38, Boyd recounts for the record various "names without works," dismissing most of them with regret that so little can safely be said.

William Wroth's *Christian Images in Hispanic New Mexico: The Taylor Museum Collection of 'Santos'* (The Taylor Museum of the Colorado Springs Fine Arts Center, 1982) complements and furthers Boyd's pioneering research into art history. And Larry Frank is presently writing a book which will further extend our knowledge of the older New Mexican santero styles.

And finally, I have long since given up on my listing of present-day santeros, which was never more than fragmentary. They seem to multiply every year, as evidenced by such gatherings as the Albuquerque Museum's Feria Artesana. And if I have had a little to do with the revival, I account my work abundantly rewarded.

Denver
Fiesta de Patriarca San José, 1982.

AUTHOR'S NOTE

The New Mexican culture of upwards of a century ago was unified and "closed," quite the opposite of the "open" and fragmented society we find ourselves in today. A probing of any portion or aspect of such a unified society gives access to every other area, usually with first-remove immediacy. I have attempted in this book to bring to bear upon the New Mexican Spanish religious folk art of the last century — the santos — the kind of analysis by formal criticism, theology, sociology, and psychology which will enable these pictures and statues of saints to illuminate in their special fashion the life of the people for whom and by whom they were made.

The main purpose of this book is to propel the study of the santos from its past and present concern, that of fashioning the necessary historical foundation, into working the different (and I think wider and richer and more interesting) veins of social, cultural, and religious implications. I am conscious of having fetched some of my conclusions from beyond the strict reach of the evidence I am able to offer, but if I have asked the right questions, I have confidence that the right answers will be forthcoming through the work of other students of the santos.

Albuquerque
Fiesta de Santo Domingo, 1973

CHAPTER I

Santo Space: Pre-Renaissance and Post-Renaissance

T he statement that the nineteenth-century New Mexican santos were fashioned by Indians has been disproved time and again, but it has continued to recur in popular magazines as recently as January 1970. Perhaps this error by its very persistence gives a clue to a deep truth about the santos that persons familiar with them and with contemporary art fail to notice: Santos do indeed come from a culture vastly different from the European-American tradition, so different that the careless popularizers compulsively seek an origin for them in a people without European roots. If by "Renaissance" we mean that tradition of visual realism and linear perspective which dominated European-American art from the end of the Middle Ages to the advent of the Post-Impressionists and the Cubists, then I would like to suggest that the nineteenth-century New Mexican Spanish painters had in many ways developed into medieval styles, but in other ways had by mere accident anticipated the vision of post-Renaissance paintings. Much of what Gauguin sought in the South Pacific and Picasso found in African artifacts the untutored New Mexicans discovered merely by meeting the peculiar problems they had, and their vigorous synthesis blended in a unique way the Renaissance and the non-Renaissance into a true if temporary post-Renaissance tradition.

1

New Mexico's recession from the Renaissance was a result of its isolation from the larger world for several centuries. The first Spanish settled in New Mexico in the last years of the sixteenth century; when they were expelled eight decades later for a period of a dozen years, most of those who intended to return retreated only to El Paso, in the southern part of the colony. Visitors to New Mexico were rare, newcomers were few except for the governor and his entourage and the Franciscan pastors and missionaries. McWilliams summarizes the situation:

> Isolation is the key to the New Mexico cultural complex. The deepest penetration of civilized man in North America, New Mexico was a lonely outpost of Spanish settlement for three hundred years, — isolated from Mexico, California, Texas, and Arizona; isolated by deserts, mountain ranges, and hostile Indian tribes. It would be difficult, in fact, to imagine an isolation more nearly complete than that which encompassed New Mexico from 1598 to 1820. For its isolation was multiple and compound: geographic isolation bred social and cultural isolation; isolated in space, New Mexico was also in time. Primitive means of transportation and the lack of navigable streams extend distances a thousand-fold. It took the New Mexicans five months to make the 1,200-mile round trip, along the Turquoise Trail, from Santa Fe to Chihuahua.[1]

And this isolation continued into the first part of the nineteenth century, when even the most important news could not travel from Mexico City to Santa Fe in less than a month. Under these circumstances it is not surprising that painting took an independent backward course in the Spanish New Mexico of the last century, but in doing so it happened to anticipate certain features of post-Renaissance art.

[1]Carey McWilliams, *North from Mexico* (New York: J. B. Lippincott, 1949), p. 63.

Santo Space: Pre-Renaissance and Post-Renaissance

E. Boyd quotes from Ralph Linton a statement very apropos in this connection: "To the people who made what we call primitive art it was not primitive; it was the only form of art that existed for them because they did not know any other."[2] Modern artists often choose to make use of the primitive or folk idioms of Africa and the East, but in contrast to true primitives or folk artists, they are better called primitivists — artists working in conscious imitation of primitive artists but able to do otherwise when they choose. In this light, New Mexican art and culture was as a whole truly folk, peasant, and in a sense primitive, with very little admixture of even the so-called "provincial" — work based on the mainstream styles by craftsmen inferior in talent and training, working with inferior tools and materials.

Besides the obviously Catholic subjects and the basic iconography, New Mexican art retained only the Renaissance trait of painting "easel" pictures — paintings done not on walls and so forth but on stretched canvases and panels fashioned only to be painted on. The change to this new kind of "bearer" of paint as a standard practice is an innovation of the Renaissance and a step typical of the period in that it exemplifies the tendency of the era toward visual abstraction, for during all previous ages painting and all similar decorating was done upon something which was a functional object in its own right. The human body was tattooed or covered with warpaint; a pipe, warclub, shield, or some other tool was decorated with a painted or incised design; a container like a pottery bowl was embellished with a pattern before or after firing; a mural or mosaic adorned a wall or ceiling, a sandpainting the floor of a hogan; stained glass enhanced a window; a design was woven into a rug or blanket or basket. The

[2]E. Boyd, "New Mexico Folk Arts in Art History," *El Palacio* 72 #4 (Winter 1965), 10.

New Mexico Spanish santeros painted on specially prepared wooden panels, thereby retaining the Renaissance innovation of what might be called "picture-space" (on the analogy of Marshall McLuhan's "page-space"), but in most respects their work became almost wholly a folk form.

In New Mexican church architecture, on the other hand, there was a conscious attempt to imitate the European-Mexican Renaissance styles which the pastors and missionaries had seen. Both interior and exterior vistas are deliberately planned; the door is set opposite the main altar, and the floor, walls, and roof frame the altar for the view of the person who enters. In like manner, the facade of the church is properly viewed from the gateway to the cemetery in the walled enclosure in front of the church. The point of view is controlled, and controls what is seen so that it may be properly appreciated. But these are practically the only Renaissance traits common in New Mexico buildings, and they do not occur in domestic architecture.

Other Renaissance characteristics were conspiciously lacking in the New Mexico of the late eighteenth and early nineteenth centuries. The Gutenberg age, which in Europe formed with architectural vista and lineal perspective the bulk of the visualist Renaissance syndrome, did not come to New Mexico until the fourth decade of the nineteenth century, when Padre Antonio José Martinez set up the territory's first printing press. Furthermore, the mercantile aspect of the European Renaissance was also very slow in touching New Mexico, which struggled along with a barter economy and a competitionless system of gift-exchanging within extended-family villages where offering wages for work fell somewhat between the unthinkable and the insulting.

On the other hand, though horses, armor, and steel weapons had played a huge part in the Spanish conquest and domination of the territory, the new gunpowder technology

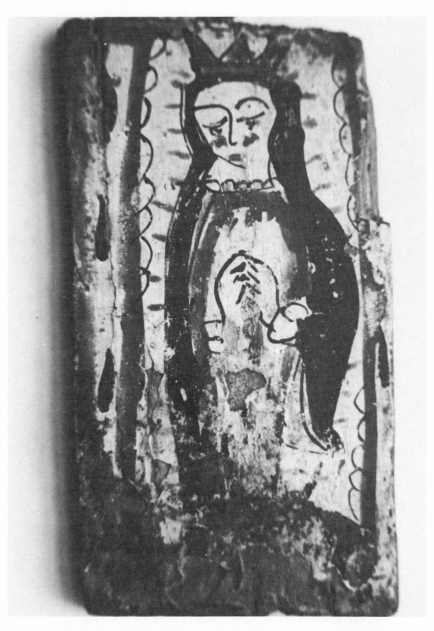

Our Lady of Guadalupe (#33 in Appendix A), by José Benito Ortega. This small retablo, like other of Ortega's paintings, reminds many viewers of the work of the great modern artist Matisse. See page 16. From a private collection, with permission.

had been most effective of all. The Renaissance emphasis on the fixed point of view dominating all that could be seen, which we have noted as the basis of perspective and vista, is the foundation also of marksmanship. But Spanish superiority in musketry did not endure. There were never enough guns for the soldiers, and the ordinary villagers had far fewer; in the Costilla settlement in northern New Mexico in 1854, "there were only two guns, one an old musket; and for years the principal weapons were bows and arrows," and Kenner notes that for most of the century before the American occupation, the Spanish obtained more guns from the Plains Indians than they traded away.[3] The visual domination of space in this respect as in so many others was dissipated by New Mexican isolation; guns could not be made with rawhide and wood, so when they broke they were usually replaced with the cruder, more tactile aboriginal weapons.

Thus in general, the individualistic point of view which is the hallmark of the Renaissance, scarcely imprinted at all on sixteenth-century European Spanish, eroded almost totally in the isolated colony of New Mexico, so that by the nineteenth century the inhabitants at least of the small villages were more like medieval peasants than like the Anglos who arrived with the wagons across the Santa Fe Trail, with Kearny's and Doniphan's armies, or in their wake. The Spanish were immersed in a highly familial religion, in a peasant-type extended family appropriate to their economy of subsistence agriculture, and in a view of time that deemphasized the future as something controllable less by man than by God and the saints and validated the present through its relation with events in the historical past or with eternal entities. And thoroughgoingly, this same regress from standard

[3]McWilliams, p. 94; Charles L. Kenner, *A History of the New Mexican Plains Indians Relations* (Norman: University of Oklahoma Press, 1969), p. 85.

European practice characterized nearly every aspect of the typical art of the region, the painting of retablos. The history of nineteenth-century New Mexican painting is above all contained in the gradual loss of the greatest Renaissance artistic invention, the illusion of a third dimension.

For reasons which subsequent chapters will explore more fully, the New Mexico Spanish of the eighteenth and nineteenth centuries practiced Catholicism in a way that required a large number of images — statues and paintings of the divine persons and the saints. A church or chapel which was not decorated with a score of images of holy persons would have seemed poor indeed; a private household which did not display several saints would have been liable to the suspicion of not being very religiously inclined. But at the same time, the influx of holy images from Mexico and beyond had dwindled to a mere trickle as the support provided by the mother country for her least favored stepchild fell far below any pretense of adequacy. Under these circumstances, the Spanish in New Mexico began to produce sacred art for themselves.

The comparatively few works of art which were being imported into the colony during these years were mainly oil paintings on canvas for churches and the homes of the wealthier laity, and the surviving examples seem almost all to have been Mexican in origin and religious in subject. In the context of European painting of the time — the seventeenth and eighteenth centuries — these are themselves plainly provincial, but many of them are fairly adept at depicting a third dimension through realistic portrayal of garments and background draperies, the chiaroscuro on limbs and other rounded objects, and the exact manipulation of linear perspective. The earliest Spanish painting done in New Mexico was consequently provincial as well, since it was produced by persons so totally under the influence of the wider Euro-

pean-Mexican art world that its criteria served (for better or worse) as the original criteria of New Mexican painting.

An early work done in the colony itself which ought nevertheless to be considered an import is the altarscreen now in the Church of Cristo Rey in Santa Fe. This great stone reredos was donated by the governor and captain-general of the province, Francisco Antonio Marín del Valle, and his wife Maria Ignacia Martinez de Ugarte, to the military chapel of Nuestra Señora de la Luz, also known as the Castrense. These two benefactors commissioned two Mexican artists to travel to Santa Fe and create the great reredos from local stone, carved in bas-relief and painted. It shows at the top God the Father and just below him Nuestra Señora de Valvanera. In the next tier down there are three panels, showing San José with the Santo Niño, Santiago —·patron of the captain-general as of any Christian soldier, and San Juan Nepomuceno, a patron of the Jesuit order. The lower tier contains a panel of San Ignacio Loyola (founder of the Jesuits, whose namesake the governor's wife was), a central niche now occupied by a panel of Nuestra Señora de la Luz which had been a portion of the facade of the original chapel, and a final stone relief of Francisco Solano, for whom the governor himself had been named. The reredos is dated 1761, and comports well with the Mexican provincial work of the era; the garments are realistically draped and the carving of anatomy is handled in such a way as to place the figures effectively in an illusion of deep space. These techniques, of course, were not to be matched by later santeros, but the general structure of the altarscreen, particularly the treatment of the columns dividing the panels from one another, reappears in folk fashion in nearly every later New Mexican reredos. The Castrense stone reredos seems especially to have influenced the makers of gesso reliefs, the "Laguna Santero" (of whom more hereafter), and through him Molleno and

therefore the whole course of New Mexico religious art.[4]

The earliest extant paintings done in New Mexico were done on the hides of large animals, mainly elk and buffalo. Many of these seem to have been painted by Franciscan missionaries and pastors as large decorations for the churches; and even though these men seem to have had little or no academic training, they still strove to embody all the impact of the religious paintings done in other lands, despite the unsuitable materials at hand. Garments are insistently molded, and there is a consistent attempt to give the illusion of space, and even though the techniques used to this end — linear perspective in floor tiling, placing of items before and behind the main figure, and so forth — are usually handled imprecisely, they are still the techniques that were used in the metropolitan areas and taught in the studios.

Some later painters — two of them are known by name — began the New Mexican tradition of painting on wood covered with gesso (gypsum and glue). Fray Andrés Garcia, in the area from 1748 to 1778, and Captain Bernardo Miera y Pacheco, there from 1756 to his death in 1785, had at least occasional access to oil paint, but many of their works were done with tempera, the homemade waterbase coloring that was to be the staple of the nineteenth-century *santeria*. These artists show some improvement over the hide painters mainly because of the more tractable medium (the hide paintings could not be effectively colored with any finesse), but the resemblance of their works to mainstream Renaissance art only makes their inadequacies stand out more sharply. Still, they both had some proficiency in their part-time occupation — for Miera was a military cartographer by trade, Garcia a priest; they both handled lineal perspective tolerably, and both

[4]See Pal Keleman, "The Significance of the Stone Retable of Cristo Rey," *El Palacio* 61 (1954), 243-72.

had some grasp of aerial perspective — giving the illusion of distance by depicting an object more blue than it is, of nearness by making it more red.[5]

During this same early period, some santeros drew and water-colored on pieces of paper — a rare commodity in colonial New Mexico at any period — and others used plaster-stiffened cloth to form realistic clothing. The movement from the dramatic and realistic to the static and iconic had not yet come to New Mexico; the late eighteenth-century statuettes show only the Bernini-like poses of mannerist Baroque, made awkward by the provincial inadequacies of their makers.

And indeed, provincialism is thoroughgoingly the hallmark of the eighteenth-century are done in or imported into New Mexico. None of it is of itself dynamic; all of it stays barely alive by containing the feeblest spark of the great Baroque tradition it imitates. It is the umbilicus connecting the elder tradition to a weak infant destined to become strong — and different, for the history of the independent santero tradition is one of forgetting its provincial origin and nearly all the techniques practiced in the provinces dependent on the European school of fifteenth to eighteenth-century art. Though some lineaments remained throughout the nineteenth century, the New Mexican tradition changed so basically as to have assimilated all these painters' patterns and saints' attributes into a new tradition. For all the traces of Mexican provincialism, New Mexico santos are not provincial art but folk. This art, fashioned almost exclusively from home-crafted local materials, is of three sorts, *retablos, bultos,* and *reredoses.* A *retablo* is a painting made on a pine panel, sawed at top and bottom, the rest hand-adzed and the front smoothed, covered

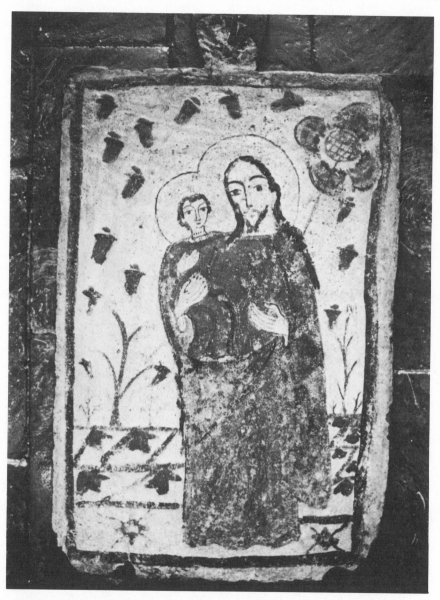

Saint Joseph (#92 in Appendix A), by Pedro Fresquís. The tiling—three rows to the left of the figure and four to the right—defeat any possibility of three-dimensional illusion, and are merely fields for decoration. From a private collection, with permission.

with gesso (a mixture of gypsum and animal glue) and painted with water colors, many of them homemade from carbons, earth oxides, and organic substances, some made from dyes imported into the colony. A *bulto* is a statue assembled from carved cottonwood root, covered with gesso, and painted like a retablo; bultos were frequently clothed; sometimes the nether portions were constructed of small pine laths clad with gesso-soaked cloth and painted when dry. A *reredos* is a large structure of pine columns, niches, and panels to be placed behind an altar, finished like retablos.

The early New-Mexico-born artists, principally the anonymous "Laguna Santero," the "Eighteenth-Century Novice," and the maker or makers of the gesso relief panels, accomplished the transition from provincial to folk art. Some of the early works of the Laguna Santero show realism and a striving after a third dimension only in non-stylized flowers and in the modeling of the patterned garments. The background occasionally includes a tiled floor; since tiles were not used in New Mexico, this clearly shows the influence of Mexican models. The Novice's paintings show vestigial modeling of faces, limbs, and pedestals, but no sure grasp of the strategies needed to make roundness persuasive. One of his paintings manifests an attempt to place a crucifix effectively "on" a table, but lines that ought to be either parallel or convergent on the canvas diverge instead. The gesso reliefs have of course some of their roundness problems taken care of by the introduction of a figure in actual third dimension, but all in all such relief panels as use tiled floors fail totally to convey an illusion of depth because the lines are painted parallel, hence making the tiles seem to stand on edge.

Pedro Fresquís (died 1831) shows especially in his earlier work a couple of distinctively Baroque traits: dark backgrounds and the use of *sgraffito,* scraping away lines in wet paint to expose the surface beneath. But for all this he may be called

the first truly folk santero. In certain of his pictures the tiling is stylized by being given wavy joints which do not attempt to show perspective at all; what had been tiling has become merely a space-filling pattern, much like the stylized flowers which float upon his backgrounds and suggest that Fresquís had a strong abhorrence for a vacuum. In many of his reta-blos, there are trees "standing on top of" the pattern of tiling, carefully refraining from putting their branches behind the main figures, for they are not in a background at all but rather in the same plane — or perhaps better, in the same mode of two-dimensionality. The kind of space they fill is to be mea-sured only in the square inches of the gessoed surface, not in the illusory cubic feet of three dimensions. Appropriately, the trees are not realistically drawn but are highly stylized.

Fresquís occasionally modeled draperies and portions of anatomy to some extent, but in at least one version of the most "pat" picture possible, a Nuestra Señora de Guadalupe, the copying, doubtless done from a Mexican print, is slavish and incorrect, betraying a lack of technical understanding of what the earlier artist was about but still producing a pleasing varia-tion.

That Fresquís retained some perception of picture-space as related to Renaissance page-space is indicated by his use of occasional written inscriptions, recalling both earlier Byzan-tine and later Cubist works. But on the other hand, Fresquís and some other painters seem never to have signed more than their initials to a few of their santos. Here again, though Renaissance individualism may die hard it died completely in New Mexico.

Molleno — if that is how his name is to be spelled — bestrode the small world of colonial New Mexico and is if not the best perhaps the most typical santero, the one who most sums up in his career the leading features of the era. The uncertainty about his name is typical: he knew how to

13

letter, but signed only one known painting. And his career perfectly ran the gamut from the conclusion of provincialism to the sparest of iconographies.

He seems likely to have begun as an apprentice of the Laguna Santero, but as E. Boyd notes, even his earliest work "lacks the latter's organized composition and sense of the third dimension." His earliest work is characterized by variegated backgrounds, draperies, and posed figures, and by a pervasive darkness that was stylish in provincial and even metropolitan painting during the Baroque era. As his career continued, the picture was differentiated less and less into foreground, middleground, and background, and more and more of the single remaining plane was occupied by bare gesso, purely decorative red wedges (the "chili pods" that give him his earlier identification, The Chili Painter), and the highly stylized forms of his principal figures. By the time he arrived at what E. Boyd calls his "abbreviated manner of drawing figures — a shorthand presentation which is more like a code than a human image," he was thoroughly committed to "the deliberate preference among folk artists of New Mexico for the two dimensional treatment of the picture plane when painting on a flat surface."[6] One of the features of Molleno's style is his treatment of part of the beard of male figures, representing the "far" side of a three-quarter presentation with a single nearly straight very heavy line. Mr. Larry Frank has suggested that this is a method of getting a certain three-dimensionality of neither a geometric nor an aerial sort, but one instead more reminiscent of modern cartooning; this insight very perceptively points out the draftsman-like rather than painterly nub of santero art: the black lines carry the picture; the colors are rarely shaded; they fill in previously-structured areas, they do not create them.

[6]Boyd, "The New Mexico Santero," pp. 11-12.

Santo Space: Pre-Renaissance and Post-Renaissance

With the next three santeros, we achieve the most pleasant and probably the best of the "classical" period of New Mexico. José Aragón, José Rafael Aragón, and the anonymous "A. J. Santero" all have a sure if limited capacity to draw simply and well and to compose pictures that are uncrowded and pleasingly colored.

José Aragón is said to have been born in Spain, but it would be impossible to make out a case for his being basically provincial and not a folk artist. He fitted completely into the New Mexican tradition except for a slightly greater tendency than other painters to work from engravings and to letter on the retablos and even sign them — often making use of the cartouche, another definitely Baroque borrowing. His style understandably shows a related tendency to use cross-hatching, which is of course an engraver's rather than a draftsman's or especially a painter's technique; and often when he is not apparently copying an engraving he employs cross-hatching in inappropriate places and sometimes produces rather too busy a design. But in each case the New Mexican tradition is absolutely clear, and the translation from the Mexican-European engraver's idiom to the New Mexican draftsman's is nearly complete: a weaker tradition has met a stronger, and Aragón is not more constrained by the provincial's style than Shakespeare is by Belleforest's or Holinshed's.

Rafael Aragón — his first name, José, is often omitted to distinguish him more clearly from the other Aragón — worked slightly later and has many similar characteristics. He does not so often sign or letter his paintings, and he seems to use parallel lines more than cross-hatching, thus suggesting woodcut rather than engraving. He also often paints a support under the halo on a retablo, thereby hinting that he may have been copying a bulto or at least thinking strongly in terms of the many exquisite ones fashioned. Like José Aragón and the A. J. Santero, Rafael Aragón works almost entirely in two

dimensions, rarely becoming serious about attempting to round his figures or provide the illusion of a background. The decorative devices that fill out the panel are highly stylized, as are most of the attributes of the saints, and all in all he conveys the meaning of the saint to the devout mind rather than the saint's earthly appearance to the physical eye.

The anonymous "Quill Pen Santero" and "Santo Niño Santero" round out the classical period of santero work. The former of these, as his name indicates, used a pen of some sort to make the finer lines of his cartoon, but then filled in the colors and the broader areas of black with brushes. These painters represent no special difference from the earlier classical santeros except that the backgrounds tend to be even more undifferentiated, leaving the figure standing within a painted border in a space of its own, completely incommensurate with real three-dimensional space or any painterly illusion of it.

With the next set of santeros, we come to a different age because of a significant change in the market for santos. The production of retablos falls off sharply, since inexpensive Currier and Ives engravings, lithographs, and oleographs imported across the Santa Fe Trail found a readier market than the handmade and therefore more expensive panels; but the production of bultos continued unchecked — or even increased — until the railroad made plaster statues available. Such santeros as Miguel Herrera are not known to have done any retablos, and the two-dimensional work of most of the others is decidedly inferior to their carvings, which maintain as high a level as ever.

The painting moves in two different directions. Some of the retablos push further in the direction of abstraction, and some of José Benito Ortega's tend particularly to remind the viewer of Matisse, with what seems to be their deliberate denial of a third dimension in favor of maintaining the integrity of the picture-surface: the figures are blocked out into broad

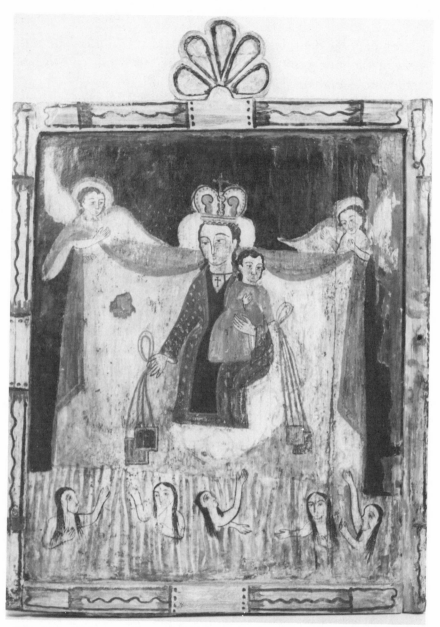

Our Lady of Mount Carmel (#30), by José Aragón. Subordinate figures like these at the bottom are some of the few profiles in New Mexican art. See page 22. Courtesy of the Denver Art Museum, Denver, Colorado; gift of May-D&F.

planes of total depthlessness. Other paintings, under the impact of the new prints flooding into the territory, tend to become provincial or self-consciously primitivist.

But the energy dammed up in painting released itself in a marvelous burst of sculptural activity; some of the most powerful New Mexican bultos date from this period between the flourishing of the Santa Fe Trail and the arrival of the Santa Fe Railroad with its boxcars full of statues too heavy to be brought by wagon from Saint Louis at a profit. The statues of this latter period — the works of Ortega, of Miguel Herrera, of Juan Ramón Velasquez — break free from the archaic "xoanon" — the simple wooden statue whose lines closely follow those of original material, especially the "living" wood of the tree. But whereas the earlier more rigid and frontal statues had tended often to be very lovely, the trump card of the later period was not beauty but the literally raw-flesh power of the suffering Christ as presented in the crucifixes and Jesús Nazareno bultos made particularly for the Pentiente moradas (chapels). Archaic simplicity of line gave way to real hair and teeth, porcelain eyes, and all the possible paraphernalia of public suffering.[7]

Thus the end of a great and vital tradition. Like marble or the gilded monuments of princes, the santos have met with various indignities, accidental, deliberate, ignorant, or misguided, particularly during attempts to clean and restore them. During the nineteenth century, imported priests got rid of the native santos from many of New Mexico's churches, especially those in the larger towns, to replace them with plaster "bath-

[7]In this turn of events, New Mexico sculpture followed the opposite of the pattern which Gerardus van der Leeuw, *Sacred and Profane Beauty* (London: Weidenfeld and Nicolson, 1963), p. 178, finds among the Greeks: "In a work of art, religion fears the presence of an idol, and with good cause, 'the rough and ugly image is of more service to it than the beautiful one; it does not draw the spirit out into the fullness of the world, where it can enjoy itself in freedom, but throws it back upon itself with a violent shove.' For this reason the Greeks preferred the xoanon to the works of art of one of their great masters."

robe art" carted in by the railroad; in the 1890's, the Italian Jesuits at San Felipe Church in Albuquerque collected money from the parishoners for this purpose, and then gave the old bultos away to those donors who wanted them. The best of the heritage of New Mexican art retreated in the face of the worst of the tradition of Europe and America combined. Thirty or forty years later, retablos sold for a few dollars in Santa Fe, and before that there had been no market at all. But today more and more people have come to appreciate this art form that defies many of the most holy canons of nineteenth-century European-American art because it operates with a different space-conception than that of academic art. And it is especially the characteristics of this different space-conception that we will treat schematically in the next section.

One evidence of provincialism that has been mentioned before is the use of a tile pattern at the base of a retablo. Because tile was made or used in New Mexico, this pattern rapidly became a mere stylization — it was evidence not of the everyday world that the santero and his customers inhabited but of the special kind of space where the saints dwelt. Because the tiling had no counterpart in their experience, the santeros betrayed a good deal abut their conception of space in handling it.

In no New Mexican retablo of the classical period that I have seen do the tile-lines converge with true perspective. The closest approach is that of a retablo in the Taylor Collection at Colorado Springs, where the lines on the left of the figure of San Francisco Asís move — in parallels — toward the upper right, and those to the right of the figure move — also in parallels — toward the upper left. Some retablos show a clear lower right to upper left pattern, and some tile — lines move straight up in the picture, but the majority move from lower left to upper right, thus leading the eye of the viewer into the picture from the left foreground; the tendency to

compose from left to right may possibly be taken as evidence of vestigial literacy in the European tradition, where writer and reader alike operate from the lefthand side of the page. (As we will see later, the faces of the main figures almost without exception look toward the viewer's left.) When there are two or more rows of tile from front to back, the rear row occupies almost always as much space on the picture surface as the front row, thereby tending to make the perspective-minded viewer conclude that the rear row is larger than the front.

The santeros denied in various other ways any realistic value to the tiling, though it was clearly used by their Mexican preceptors to strengthen the illusion of depth. In Fresquís' San Miguel in the International Folk Art collection, the rows of tile, stacked up in near rectangles, run right through the "monster" at the Archangel's feet. In his San Antonio in the same collection, there are two rows more of tile to the right of the figure than to the left; and just as the figure of the saint "stands" on the bottom tile-line, so a stylized tree stands on the top line to the left. The tiling is in other words no sort of illusory three-dimensional base on which the figure is enabled to stand in three-dimensional space. As early as Fresquís it is a mere space-filler in the two dimensional retablo.

When objects other than trees start right out of the top tile-line, they are frequently depicted as if seen head-on. In Crucifixion scenes, a slightly modeled vase holding stylized flowers often stands on either side of the cross, but the top opening of the vase is only rarely shown. In a Fresquís retablo of Margaret of Cortona, a table sits on the top tile-line, only the front legs are displayed, the front and top of the tablecloth appear, and the skull and crucifix sit on the top line of the table — they do not occupy any of the tabletop at all. A Flight into Egypt retablo has a very flat tile floor that seems to promise some perspective and depth, but atop this is presented

a nonrealistic sculptural base, seen head-on, on which the frontally-presented angel, donkey, and San José figures stand. In this composition, the tail of the donkey hangs in front of the San José, but otherwise each one of the figures stands in its own space.

In the typical retablo of the classical period, painting other than the border and the main figure or figures is not to be taken as background or foreground so much as space-filling — elements added to balance the composition, which may have more attributes of the saint on one side than the other. Where there is evidence one way or the other, it is almost invariable that the background was painted after the main figure, not before — further evidence of the linear rather than painterly New Mexican approach. The afterthought status of the saint's surroundings, and the seeming practice of working from the bottom area on one side of the figure around it to the other bottom area, results in many inconsistencies apart from those of tiling which have been noted above. A retablo may present a stylized landscape of bumps, trees, and flowers to the left of the figure and a purely decorative pattern of curlicues to the right, or a stylized tile pattern to the left and a piece of what seems to be broken ground to the right, both topped by stylized trees. Santeros occasionally shaped the border at the bottom to avoid elements which happened to conclude lower on the picture surface than they ought. Pedro Fresquís, with his *horror vacui,* sometimes attached a bracket halfway up a side border and grew a tree from it to fill up some empty space. And many retablo borders that are interrupted by swags of drapery or the feet of the saint were not completed consistently on the other side of the break.

Parallels and crosshatching have been mentioned above as a modeling and decorative device, especially in painting derivative from woodcuts and engravings; in some New Mexican retablos, these techniques serve to depict the scales of

serpents and monsters, especially in representations of San Miguel. But though the pattern generally begins from the left of the beast and fills out its form cogently and carefully, it usually becomes perfunctory and casual and ends up supplying the wrong modeling entirely. Other than this, crosshatching and striation are used very often merely for pattening.

Mentioned above were such items as flowerpots, often presented head-on, without the top opening visible. Frequently, the santero has shown not only the top of a similar object but the bottom as well. Gabriel's chalice (or possibly trumpet?) appears with both the bottom and the top concavities open to view, or San Acacio's drum presents both ends at once.

As noted above, the main retablo figures almost invariably turn to the viewer's left, presenting a three-quarters face. Profiles and three-quarters-right faces are almost universally restricted to subordinate figures — the profiles belong especially to souls in Purgatory shown at the bottom of Nuestra Señora de Monte Carmen retablos or occasional Crucifixions.

Another instance of the non-Renaissance quality of New Mexican painting is the almost total lack of stop-action painting — of scenes presented as if a still camera had caught a "slice of life," one crucial moment of an important event in a saint's earthly career. Perhaps only Fresquís' Santa Apolonia in the International Folk Art Collection has such narrative appeal: the wicked soldier is caught in the act of wrenching the saint's teeth out with a great pliers. Even in such presentations as the Flight into Egypt there is a quality of stasis, of total repose; the Holy Family is not hurrying to escape from the dread pursuit of Herod's soldiers. In similar manner, Santiago for all the lifted spear and his mount for all its lifted forefoot are not engaged in mortal combat; the Moors are not his deadly enemies but only his attributes. And since

22

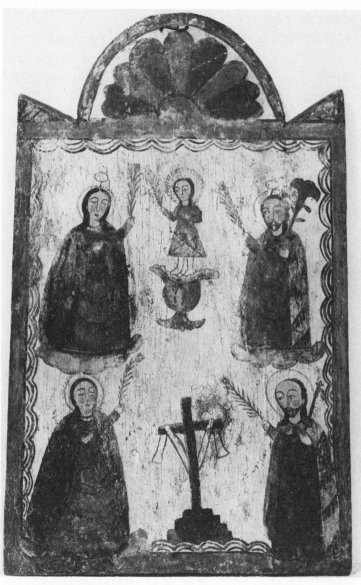

Allegory of the Redemption (#21), by the Quill Pen Santero. Along the bottom row, Mary and Joseph, with a flowerless staff, flank the empty cross; at the top, they wear double haloes and Joseph carries a flowering staff as they flank the Christ Child. The historical element is clearly lacking. See page 51. Courtesy of the Denver Art Museum, Denver Colorado; Anne Evans Collection.

23

stop-action realism is absent, two portrayals of a single saint, two or more "titles" of the Blessed Virgin will often be presented on the same panel or reredos, such as Our Lady of the Immaculate Conception, Our Lady of Sorrows, and Our Lady of Solitude on the Rafael Aragón altarscreen from the Sándoval-Durán chapel at Talpa.

There are, it must be admitted, some indications that the artist realizes that there is a before-and-behind aspect to realistic space, and plenty of retablos portray it. Attributes are held or cloth is draped in such a way as to disappear behind other objects or portions of anatomy, and then realistically appear again. Inaccuracies in drawing happened and remained: modeled inner sleeves, drawn first, appear through the heavier outer sleeves because the artist extended them too far and then could not erase them, any more than a singer of oral narrative poetry can erase a miscue. Similarly, when a saint comes up with two right hands, the artist can only preserve or destroy the entire panel.

The positioning of the main figures caused similar problems in draftsmanship. It cannot always be determined if San Miguel stands on, or over, or beyond his attributed monster; sculptural bases may be nicely modeled, but they are often so drawn at the bottom that they are "supported" only by an open border; a Santa Librada often hangs on her cross with her feet so draped as to deny any realistic modeling.

Generally, then, their feeble attempts at modeling and perspective involve the santeros in troubles that a purely two-dimensional approach would have avoided. Fresquís in painting a Crucifixion models the top and bottom of the cross — but exactly backwards, shaping the top so that it seems to be below the viewer, and the bottom so that it seems to be above. José Aragón shows the top and two of the sides of a cubical stool, but disposes the lines in such a way that they diverge when they should converge toward a vanishing point. The

santero of one large Guadalupe draws properly converging lines for the top edges of Christ's tomb, but the painter of the Denver Art Museum's Guadalupe, having done the same thing, tries to gild the lily by sketching lines within the trapezoidal space which has resulted. He begins drawing lines parallel to the lefthand edge — and of course finishes with a triangle at the righthand end.

We may guess that the earlier bultos were simple in shape, reminiscent of the cottonwood roots from which they were made, austerely and rigidly frontal, because the santeros were able to satisfy the simple needs of the people with the simplest of sculptural techniques; the reasons that many later bultos show increased lifelikeness will be the concern of Chapter III. On the other hand, the historical course of santero painting, of which we have seen some technical specifics, is the primary subject of this present chapter, and needs further inquiry. We have been judging the painting mainly by the criterion of the loss of three-dimensional illusion, which E. Boyd notes as "the deliberate preference among folk artists of New Mexico for the two dimensional treatment of the picture plane when painting on a flat surface."[8] And in an earlier article, Miss Boyd has written,

> In little more than one generation three-dimensional painting was discarded for the single picture plane, linear composition, and static rather than animated poses. Narrative compositions were also discarded. Iconographic elements were retained in nearly abstract form, and the folk artists developed styles comparable to those of medieval or preGothic Europe. While this was an anachronism in the nineteenth-century western world it was not in New Mexico where the austerity and hazards of living were in many ways comparable to those of the middle ages.[9]

The foregoing paragraphs of history and of specific technical

[8] Boyd, "The New Mexico Santero," p. 11.
[9] Boyd, "New Mexico Folk Arts in Art History," p. 12.

difficulties corroborate this quotation and suggest a further synthesis, that the move from perspective into non-Renaissance modes is a function of the failure of the folk tradition to retain what the provincial tradition of Mexican Baroque had tried falteringly to teach it: the primacy of the individual eye which judges reality from a fixed point of view in a single instant of time. Visual realism of the sort that came naturally to the highly literate, print-oriented Renaissance culture gave way to the conception of space and time appropriate to their post-literate culture.

New Mexican art also transcends time by its lack of caught motion and of narrative appeal. The statue or painting is not interested in retelling an event of earthly time or in showing the appearance of an earthly being but in presenting the eternal condition that has resulted. New Mexican retablos share with Byzantine icons and Romanesque and Gothic painting the tendency to represent Heaven — in the backgroundless two-dimensional habitat of the saint of blessed; but it differs from icons and Gothic art by being typically in picture-space, retaining firmly the *abstraction* from wall (or bowl or earth or shield or body) which we have referred to as picture-space. Just as the pre-literate Pueblo Indians had abstracted pottery from storage-cyst and house from pit-dwelling, so the slightly more visual post-literate Spanish had clung to the decidedly more visual Renaissance abstraction which first appeared as easel painting. Thus, due to the geographical isolation and the consequent loss of all need and aptitude for three-dimensional illusion, nineteenth-century New Mexican retablo painting unites in its unique combination of approaches to space the renaissance and the primitive traditions of art, and anticipates accidentally the coming of Cubism and other modern styles of art that have trained even us Anglos to appreciate the work of these Spanish-American masters of deftness and strength.

SUPPLEMENTARY BIBLIOGRAPHY

After the footnotes of each chapter, additional books will be listed which are pertinent to the matter dealt with in the chapter but not cited in the footnotes.

Boyd, E. *Popular Arts of Colonial New Mexico*. Santa Fe: Museum of International Folk Art, 1959.

............... *Saints and Saint Makers of New Mexico*. Santa Fe: Laboratory of Anthropology, 1946.

Dickey, Roland F. *New Mexico Village Arts*. Albuquerque: University of New Mexico Press, 1949.

Frank, Lawrence P. *Santos: New Mexican Folk Art*. Pasadena: Pasadena Art Museum, 1960.

Kubler, George. *The Religious Architecture of New Mexico in the Colonial Period and Since the American Occupation*. Colorado Springs: Taylor Museum, 1940; Chicago: Rio Grande Press, 1962.

Mills, George. *The People of the Saints*. Colorado Springs: Taylor Museum, 1967.

Shalkop, Robert L. *Arroyo Hondo: The Folk Art of a New Mexican Village*. Colorado Springs: Taylor Museum, 1969.

............... *Wooden Saints: The Santos of New Mexico*. Colorado Springs: Taylor Museum, 1967.

Stroessner, Robert. *Santos of the Southwest: The Denver Art Museum Collection*. Denver: Denver Art Museum, 1971.

Vedder, Allan C. "Establishing a *Retablo-Bulto* Connection," *El Palacio* 68 (1961), 82-86.

Wilder, Mitchell A. *New Mexican Santos*. Colorado Springs: Taylor Museum, 1950.

27

CHAPTER II

Making A Santo: A Holy Action

T he flourishing tradition of New Mexico Spanish folk art began toward the end of the eighteenth century when New Mexican artisans imitated to the best of their resources the few statues and paintings imported from Mexico. These artifacts, which served as the roots of New Mexican art, exemplified as we have seen the Baroque phase of the great European Renaissance; but New Mexican paintings and statues could hardly have become more different than they, not in their formal style but also in their very being. A European or Mexican religious painting of the Renaissance, however poor, is fundamentally meant to be an aesthetic object, but a New Mexican one, however artistically successful, is not. It has a different relationship to painter and viewer and it operates at its most important in a different range of experience from the aesthetic, the religious.

The Renaissance placed such a premium on aesthetic quality as to subordinate and even exclude an intrinsic sacredness even from religious art. It stressed the individualistic view through linear perspective, keying reality to the painter's eye in a manner comparable to the way Renaissance architecture demanded that the viewer's eye be situated on a line extending perpendicularly from its balanced facades. The viewpoint the Renaissance painter takes of his subject determines his

painting absolutely; no other person can occupy his place at that moment, and no other artist can, for better or worse, duplicate his personal vision of it. The Renaissance artist as artist is no longer part of nature but has become an objectifying eye operating in contrast to it, an ego freed from it. The Renaissance period thus completes the Greek discovery of the self insofar as this discovery can issue into a formal and technical painterly point of view.

The Renaissance also had its own ideas about some other important factors. Art tradition was replaced by an urge toward innovation by individual genius. Traditional art judges a painting by how well it repeats the previous paintings of the same subject. The Renaissance decided that copying other paintings was an unartistic thing to do, for the only criterion was nature — the earth archetype as mediated by science and the art of the Greeks and Romans, not that of the barbarian Goths by whose name the Renaissance derided the medieval tradition it so deplored. For the new self-conscious men of the Renaissance, novelty was what set a man apart from others and enabled him to express his heroic individuality. He had his own viewpoint to which the world manifested itself in a unique fashion; he had his own artistic style like a handwriting for expressing this unique vision — but the style would not change when it expressed sacred subject matter from what it had been when expressing secular. Hence, the Madonna holding the Infant Christ became in many respects identical with Venus dandling the infant Cupid, and Magdalen took the same postures toward Christ that Venus took to Mars and Adonis. And finally, the Renaissance assumed that an artist had no need to be a good man to do a perfectly good job of depicting a sacred subject; he needed only be a good painter. Whereas in the Greek and Russian culture of the time only a monk was allowed to paint a holy icon, the Renaissance assumed the opposite view, which Oscar Wilde summed

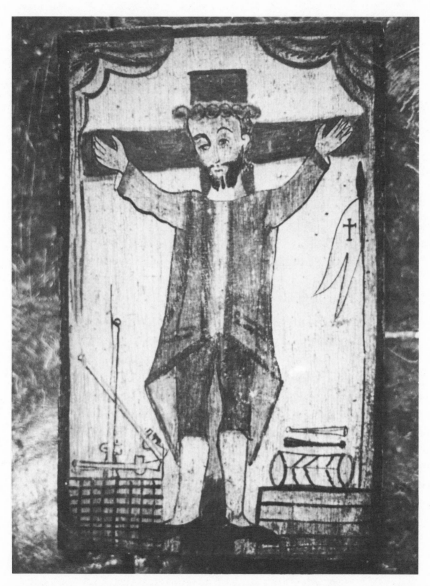

Saint Acatius (#57 in Appendix A), by Rafael Aragón. The soldier-saint appears here surrounded by his attributes: the flag, the guns, the drum with both ends showing, and the two drumsticks which seem to float in air. See page 22. From a private collection, with permission.

up by saying that "The fact of a man being a poisoner is nothing against his prose."

Indeed, there is much in the tradition of Byzantine and Russian icons parallel to that of New Mexico santos. The icons of the Orthodox Churches were painted only by monks who kept while they worked a continuous fast and who used paints mixed with holy water and laced with powdered bits of saints' relics. The icons like the santos show not a "slice-of-life" stop-action scene from the real or imagined earthly history of a saint but the frozen state of that heavenly being which rewards and sums up his life. Similarly, the objects that identify the saints for the viewer are not on icon or on santo tools or implements useful for doing some action or other but are instead attributes which constitute and define the saint's being. Icons like santos inhabit the people's homes, forming shrines in their special corner, in addition to being the principal ornaments of the churches. They differ in that the santero tradition was replaced by mass-produced copies of the decadent phase of the Renaissance from which it had itself arisen, whereas the oriental tradition was superseded by the visual realism of the Renaissance which was alien and posterior to the classic era of icon-painting: "the degeneration is irremediable as soon as images of saints become portraits of saints." Symeon of Thessalonika had feared just such an outcome when he came into contact with the fifteenth-century Italian Renaissance:

> What other innovations have [the Latins] introduced contrary to the tradition of the Church? Whereas the holy icons have been piously established in honor of their divine prototypes and for their relative worship by the faithful, . . . and they instruct us pictorially by means of colors and other materials (which serve as a kind of alphabet) — these men, who subvert everything, as has been said, often confect holy images in a different manner and one that is contrary to cus-

tom. For instead of painted garments and hair, they adorn them with human hair and clothes, which is not the image of hair and of a garment, but the hair and garment of a man, and hence is not an image and a symbol [tupos] of the prototype.

But what Symeon feared came to pass, and "the art of icons as painting was eliminated in favor of autonomous art, which made humans for humans"; and van der Leeuw goes on to say that "The aversion to the 'real' also explains why sculpture was very early banned from the Eastern Church." "Religion fears the presence of an idol," and therefore the Greeks of the classical era "preferred the xoanon [the primitive statue which recalled in its stiff shape the block of stone or wood from which it had been carved] to the works of art of one of their great masters."[1]

Spain had a retarded Renaissance, so that the settlers in the New World were only lightly indoctrinated in the demythologizing of the world which the Renaissance completed. The few external influences that brought themselves to bear in the outlying colonies such as New Mexico were indeed Renaissance-Baroque; but these were submerged in an unbelievably isolated and soon regressive culture. In a hostile and alien situation, the genius of the Spanish took quite another track from the individualized and assertive bent of their contemporary Robinson Crusoe, who imposed his middle-class values on his island and its one inhabitant. Unable to dominate New Mexico as the fictional Englishman had dominated his wilderness, the Spanish instead mythologized it as a way of coping psychologically with forces they could not understand (in our scientific sense of that word) or control. This

[1]Gerardus van der Leeuw, *Sacred and Profane Beauty* (London: Weidenfeld and Nicolson, 1963), p. 176; Symeon, *Contra Haereses* 23 (from Migne, *Patrilogium Graecum*, vol. 155, col. 112), quoted in Cyril Mango, *The Art of the Byzantine Empire* (Englewood Cliffs: Prentice-Hall, 1972), pp. 253-54; van der Leeuw, pp. 176, 178.

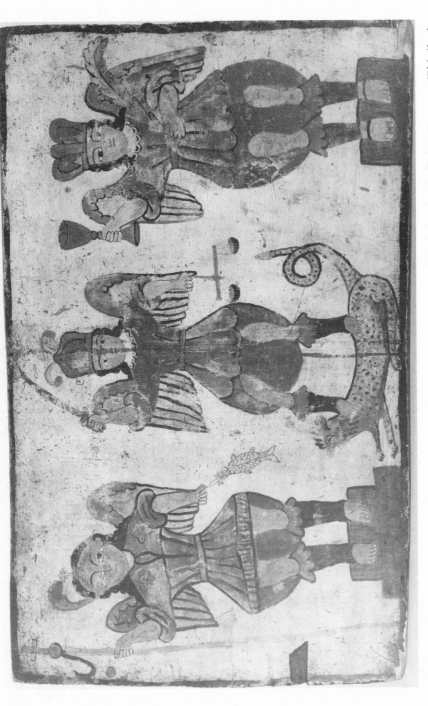

The Archangels Raphael, Michael, and Gabriel (# 54, 53, and 52 respectively), by the Quill Pen Santero. This finely-structured retablo is painted on the back of an earlier retablo, and is unique in that the grain of the wood runs sideways. Note that both top and bottom of Gabriel's chalice (or trumpet?) appear to view. Courtesy of the Denver Art Museum, Denver, Colorado; Anne Evans Collection.

is not to say that they lapsed into animism — animals, for instance, seem always to have remained secularized, and it might indeed be argued that the New Mexico Spanish had a more truly "scientific" view of nature-in-itself than did the nineteenth-century mainstream, a great part of which was indulging in the dubious romantic theory that nature was a source of ethical value and moral strength when approached either as scenery or through farming. In old New Mexico there was no true identification of the natural and supernatural orders, but the line between these two realms which had been so clear in the Reformation and Counterreformation theologies of Europe was certainly blurred, and the everyday and the miraculous were differentiated only as the usual and the unusual and were expected to interpenetrate regularly. God and his saints became familiarized and familiarized in eighteenth and nineteenth century New Mexico.

The New Mexico tradition of religious folk art grew out of and away from the provincial Baroque phase of the Renaissance that prevailed in Mexico during the eighteenth century. In this tradition, the artist's function was to achieve and express an individual vision of his subject matter in such a way as to produce an artifact of maximum aesthetic value. Without scanting the tremendous technical advances of the Renaissance period in painting especially, it must be said that this stress on artistic attainment of a purely aesthetic sort tended to preempt and exclude or at least subordinate many other possible values belonging to the wider context and even to the subject matter. In Renaissance-Baroque painting it is of no value whether the painter is a good man (Fra Angelico) or a bad one (Fra Filippo Lippi); it is of no consequence to purely formal, intrinsic criteria whether the subject matter be Virgin and Child or Venus and Cupid, Magdalen and Christ or Venus and Adonis. In the New Mexico santero tradition, by contrast, it came again to be important that the

painter was a holy man, and it came to be taken for granted that the santo was holy and powerful in the religious sphere in and of itself due to its maker and to its subject matter. The proximate objects of imitation were the previous portrayals of a given subject by the santero himself and by other local santeros whose works he had seen; these determined in almost all respects the form a particular retablo or bulto would take, so that San Geronimo was not shown (as European art generally showed him) seated in his study reading a book or writing at a desk, but always kneeling in a hermit's robe, with a penitential stone to his breast, the trumpet of God's voice speaking in his ear and a lion-monster lying at his feet. Each santero had of course a personal style — a handwriting-like set of artistic idiosyncrasies which stayed with him from painting to painting like an unbreakable habit, however little attention he may have paid to them. But nevertheless, he had remained within the wider New Mexican tradition in his own previous work and had become himself a part of that tradition, and each subsequent instance when he painted or sculpted the same saint he operated again according to the demands of this duplex traditionalism. Within this matrix, the holy santero and the holy pictures he copied effected each new painting and statue as an object holy in itself, intrinsically sacred by reason of how it was constituted. The bulto or retablo was not merely a reminder of some edifying and instructive holy person from legend or the past history of the church; a santo made by a holy santero had a sacredness of its own.

Furthermore, the santo was art which definitely did not exist for art's sake. It was for the people of New Mexico in the last century an instrument within a network or system of such related activities as prayer, penance, pilgrimages, processions, and the like. This network is a power system in that best of all technologies, the magico-religious, through

which the adept can exert a powerful persuasive force on the sacred powers — the God of the New Mexico Spanish, along with his saints — that control the world. Far from being an object created for detached aesthetic contemplation, the santo entered intimately into the life of the family or community to which it belonged. If something was needed, the appropriate saint was besought in the person of his or her santo; if the favor was not forthcoming at once, the santo might be taken in procession to the site of the difficulty. It is said that a Holy Child was so impressed by the sad sight of dry fields that he responded with a great rainstorm which flooded the fields; the next day the figure of Our Lady was carried out to see the havoc her son had caused. If there was considerable delay, the santo might occasionally be "punished" by being turned to the wall, put out of sight, or deprived of some ornament; but such behavior could not have been typical of a people too intelligent and reverent — perhaps fatalistic — to be childishly petulant when disappointed.[2] If on the other hand the favor was given with appropriate speed and restraint, the santo would be rewarded with a new dress or costume jewelry, a vigil light, or some other small token of gratitude; the santo might be carried around the village in accordance with a promise, or honored with an all-night *velorio* of prayers and hymns. In case of illness, a small portion of a retablo or bulto might be burned and the ashes mixed with the patient's food or drink so that the power of the saint and the santo might aid the prayed-for return to health. In this context, it should be clear why the santero, as the producer of an intrinsically sacred and powerful artifact, would

[2]For reputable reports of "punishment" of santos, see Gilberto Espinosa, "New Mexico Saints," *New Mexico Magazine* 13 (1935), 11; José Espinosa, *Saints in the Valleys* (Albuquerque: University of New Mexico Press, 1967), p. 85; George Mills, *The People of the Saints* (Colorado Springs: Taylor Museum, 1967), pp. 58-59; and Roland M. Dickey, *New Mexico Village Arts* (Albuquerque: University of New Mexico Press, 1970), p. 185.

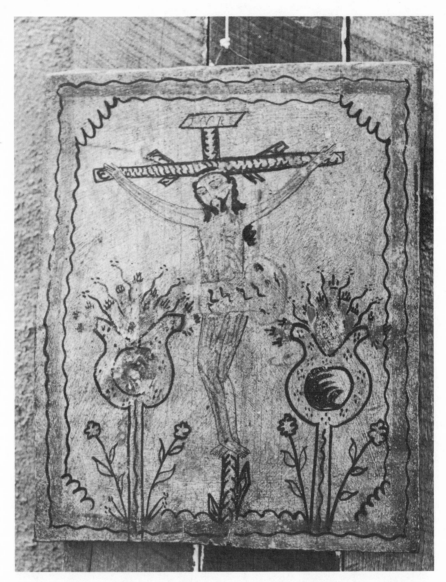

The Crucifixion (#16), by Pedro Fresquís. The modeling at top and bottom of the cross suggests that the viewer is looking up at the bottom of the cross and down at the top. For the vases and flowers, see E. Boyd, "The Sources of Certain Elements in Santero Paintings of the Crucifixion," El Palacio 58 (1951), 225, 234-36. See page 24. From a private collection, with permission.

38

need to possess personal and even a quasi-priestly character.

The painter of a retablo or the shaper of a bulto is occasionally an amateur, trying his hand at one or two works and then abandoning his career. To understand more clearly why the number of santeros is in fact quite limited, it is revealing to recollect the amount of effort a beginner would need to paint one retablo from scratch. First, the would-be santero cuts down a pine tree, saws off a log as long as the retablo is to be tall, and with a hatchet or froe roughly shapes the front, back, and sides of the panel. Next, he trims the front and back with a hand-adze and knife, and then smoothes the front with a stone employed like sandpaper. His next step is to manufacture gesso — "yeso" or "jaspe" the santero would have called it — by obtaining gypsum (not uncommon in New Mexico), scorching it to drive off all excess moisture, and grinding it in a mortar to extreme fineness; then he boils rabbit hides or the hoofs or horns of cattle, mixes the resulting casein glue with the powdered gypsum, and applies it to the surface of the wood panel. He makes his colors in various ways: some from dyes imported into the colony for coloring woven cloth, some from specially gathered earths and plants, some from carbons from charcoal or soot; all the paints are water-soluble. His brushes may be variously yucca fronds or willow shoots chewed to produce the correct texture of "bristle," chicken feathers tied together, or brushes fashioned from animal hair. If the would-be santero has preserved this far, he may now begin to paint.[3]

By far the majority of the extant santos seem to be the work of dedicated men, a dozen of them or so, for whom the making of santos was a lifelong profession — there is the

[3]See Rutherford J. Gettens and Evan H. Turner, "The Materials and Methods of Some Religious Paintings of Early Nineteenth-Century New Mexico," *El Palacio* 58 (1951), 3-16; José Espinosa, pp. 53-58; E. Boyd, "The New Mexico Santero," *El Palacio* 76 #1 (Spring 1969), 5-6.

temptation to use the word "vocation" in speaking of them. At least, the santero was a true specialist, as were very few other men in his culture apart from the priests, and perhaps there were even fewer in the Pueblo Indian culture. His specialization restricted him to a fairly narrow range of subject, for the santeros of the folk and "primitive" phase never bothered to portray secular subjects until the last few of them, in a civilization markedly changed by Anglo values, did carve toys, animals, and other tourist items of the sort. Thus, whatever the earlier santeros might have thought of their artistic ability, they would at any rate seem to have conceived of their application of it to a given work as intrinsically holy. And it was also a requirement, it seems, that they be holy in their personal lives; Miss E. Boyd has found a document which, in granting Pedro Fresquís petition for permission to be buried in the Santuario of Chimayó, records as the motive the fact that he "has labored with devotion in various material works of our churches and in the chapels of Las Truchas and the Santuario of Our Lord of Esquipulas [Chimayó] without having required any recompense at all, and instead merely having been praised for his zeal by the former father-visitor." And of some later artists we learn that "to be successful, at least in the San Luís Valley, a santero had to lead an exemplary life. There was the belief that the better the personal and religious life of the santero the more merit there was to be found in a specimen of his work"; and of a santero of this century, "Celso Gallegos was also in demand as a reader of prayers among his neighbors."[4]

When a contemporary santero moved to a small Spanish mountain village only a half-dozen years ago he received, he told me, marked expressions of respect and even reverence

[4]Archives of the Archdiocese of Santa Fe, Patentes, Book 70, Box 4, Official Acts of Vicar Rascón, 1829-33, p. 25; William J. Wallrich, "The Santero Tradition in the San Luis Valley," *Western Folklore* 10 (1951), 155, 157; Boyd, p. 22.

when the people discovered what he was about. There is no need to suggest that the santero had to be the very holiest man in the region or even the village, and he was certainly not held to be anything like an "inspired magician," but it seems to have been felt that he should be in some way removed from the average; we are at any rate, obviously, a long way from Oscar Wilde and "the fact of a man being a poisoner."

The thrust of the santero's art is, then, toward the good and the powerful rather than toward the beautiful — though in this he was assuredly fortunate, for the conscious effort to create "the beautiful" is just about the worst ill that can afflict art. The santero tried, using but ignoring the talent at his disposal, to make his *retablo* or *bulto* as honestly as possible, and generally achieved a deftness and strength of portrayal that few artists in the era could match. For it was not in the least his own talent, his own vision, his own self-expression, his own reputation, that occupied his attention, but only the rightness of the work at hand. And this was guaranteed for him so long as he worked as well as he could within the tradition that nourished him and which was in practice his whole world of art. The complete adequacy of its iconographic system sustained him in his efforts in such a way as to take precedence over his self-awareness: most of the santeros never signed a work, and those who did signed only a tiny minimum of their productions. It was not the name Pedro Fresquís or José Rafael Aragón that guaranteed the work, but the model existing not in the historical past but in the everlasting eternity of heaven and (even more so) in the constant tradition of iconography which the santero had received. Just as the largest landowner of an area served as the villagers' link to the larger world of Santa Fe, and as the padre connected his flock to the larger Catholic Church, so the santos connected each chapel and every home in the whole colony to the eternally validating domain of heaven. In the images,

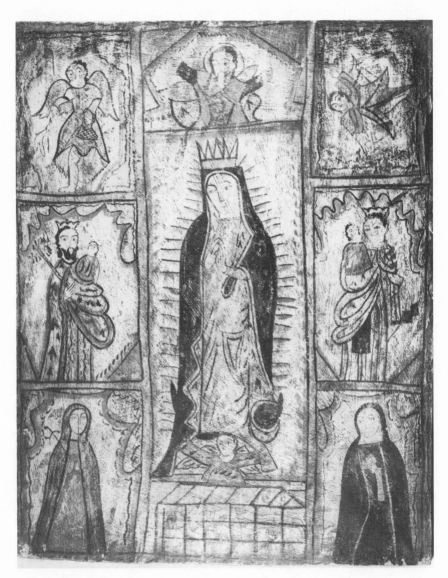

Our Lady of Guadalupe (#33), by the Quill Pen Santero. The two ends of the top of the lattice coffin converge to give some illusion of a third dimension, but the slats painted parallel to the left side destroy this effect completely. See page 25, and compare illustration on page 102. Courtesy of the Denver Art Museum, Denver Colorado; Anne Evans Collection.

42

divine and saintly power becomes most especially present and actual, it approaches the beholder and he can approach it, for with and through the santos man can do business with God and his blessed.

SUPPLEMENTARY BIBLIOGRAPHY

Haydn, Hiram. *The Counter-Renaissance.* New York: Charles Scribner's Sons, 1950.

Martindale, Andrew. *The Rise of the Artist in the Middle Ages and Early Renaissance.* New York: McGraw-Hill, 1972.

Sypher, Wylie. *Four Stages of Renaissance Style.* Garden City: Doubleday, 1956.

CHAPTER III

Santos and Saints

We have seen in Chapter One how the santo formally "inheres" as an artistic unity — an artifact without renaissance sophistication, the painting dominated by its surface, the statuary by its materials. In Chapter II we looked at the relationship of the santo to its maker and its user, and saw that the use the Spanish people made of it presupposed a holiness in the santo due to its having been produced within a matrix of artistic traditionalism and the santero's personal holiness. In the present chapter we will examine the connection of two kinds of santos to the holy persons from whom each kind derives its special quality of power — Christ in the one case, the rest of the holy persons in the other. The chapter will offer various hypotheses which will make up both a theology and a theological aesthetics of santos, as well as a conjectural theology of the New Mexico Penitentes.

As we said at the end of the previous chapter, the proximate objects of imitation in the New Mexico santero tradition were artistic: the previous work of the santero himself, and the representations of the subject at hand by other santeros with which the given santero was familiar. The ultimate imitated object of each santero painting or statue is the saint or other holy person.

In most cases this was some saint, a human person who had attained Heaven after a holy life. Since New Mexico art was religious rather than aesthetic in purpose, so that the goal was to create an instrument of holiness and power rather than an artifact for detached contemplation, the connection between the saint in the picture and the saint of reality was a matter of great importance. Chapter II pointed out that the artifact is intrinsically holy not merely because of what may be done with it (prayer) but because it was made by a holy santero working within this multiple holy tradition. A new dimension of the santo's sanctity may be brought to view by considering the exact mode of existence of the object of imitation and the santo's relation to it. The degree of sacred power of a ritual article or action is gauged by two norms: its nearness as imitation to the original, and the degree of power and holiness of that prototype.

This rule of thumb reflects a mentality which might be termed "folk Platonism." To this way of thinking, an individual cult object — holy picture or statue — is validated by a holy person who lives in heaven, and an individual cultic action — a religious ritual — is validated by an action performed by a "culture hero" in a special mode of time, which gave rise to the ritual action in question and permanently set the pattern for it.[1] This "folk Platonism" runs the risk of

[1] These sacred persons and pattern-setting actions take the place of the Platonic ideas, for this is not a Platonism of knowledge but of being. The important thing is not a flow of knowledge—of explanation—from the more intelligble to the less intelligible, but a validating participation of the power-holiness of the greater (saint or saving event) by the lesser (santo or cultic ritual).

In Platonism, ideas exist independently of human thought and guarantee the things of which they are ideas; thus a man participates in (without exhausting) the idea "man," and is intelligible and indeed real because of his sharing in the validating power of the idea. In Aristotelianism, by contrast, things exist independently of thought and guarantee the ideas derived from them; thus the idea of man is valid and true because it springs in human thinking from some real man or men. In Platonism, consequently, everything is a "symbol" and reification of its idea, and due to its participation in the idea it renders the idea as concretely present as it can be; a thing is hence a natural symbol, its very being is dependent on this fact and cannot be adequately separated from that of the idea. In Aristo-

letting the artifact or the religious ritual deteriorate into an unimaginative and mechanical imitation, for it is much more important in the religious sphere to assure the relationship of the artifact to the sacred reality which it represents than to relate it to an idea in the artist's mind — the exemplar cause of aesthetic psychology — from which it at the same time derives. The santo is like a commissioned portrait, where the subject's likeness is the dominant consideration and the artist's style and artistic ideals are less autonomous than when he is working from his own inclination. Since all aesthetic concern was de-emphasized in the New Mexican art world, where the tradition was far more important than anything the self-effacing artist added to it, the most remarkable thing is that the artistic quality stayed as high as it did for so long. But the dozen or so santeros who produced the bulk of New Mexico *santeria* apparently exercised their craft with the earnestness and honesty that can come from deep devotion both to the santos they made and the saints these represented.

There are two modes in which New Mexico cult objects are validated. The first is the simpler; it has to do with the relationship of pictures and statues of the saints, the angels, the Virgin, the God to those holy persons themselves. The principle stated above, that the power of a cult object or action is gauged by the norms of nearness to the original and power of the original, applies quite readily. The question of near-

telianism, symbols are all artificial and — within limits — arbitrary, and are hence always adequately and really distinct from that which they symbolize.

To quote Karl Rahner on this point: "We call attention only in passing to the theology of the *sacred image* in Christianity. An exact investigation into the history of this theology would no doubt have to call attention to a two-fold concept of image which is presented by tradition. One is more Aristotelian, and treats the image as an outward sign of a reality distinct from the image, a merely pedagogical indication provided for man as a being who knows through the senses. The other is more Platonic, and in this concept the image participates in the reality of the exemplar — brings about the real presence of the exemplar which dwells in the image." *Theological Investigations IV* (Baltimore: Helicon Press, 1966), p. 243.

ness was cared for by the tradition of santero art, for the santero can assume that he is making his santo right if he is making it "the way it's always been done." The question of power insures that the santo will imitate not the saint as he or she was formerly active during an earthly lifetime but the saint presently living at the peak of power and holiness in heaven.

For it is not the saint in this our world, having merely the power of a holy human being, but the saint established in heaven, in the timeless "now" of eternity, who is able to give the maximum power to the bulto or retablo which imitates him. Before death, New Mexican piety believed, holy persons have only a very limited power, but after death God assigns certain of them responsibilities in definite earthly matters and the authority to fulfill them throughout the world for the rest of time. Hence the saints of New Mexican art are shown not in moments from their earthly lives but in the timelessness of eternity, not in the earthly geography of their weak mortality but in the celestial environs of the unearthly paradise. The celestial saint has in a sense "recovered" and summed up timelessly all the moments of his earthly history and (more important) all the power and responsibilities for earthly affairs which God has given him to exercise in all places for all subsequent history. For the New Mexicans, then, the saints are mainly sources not of good example but of aid. The various items they hold — skulls, rocks, crosses, books, pennants, and so forth — are not implements with which they are shown performing some edifying activity or other of their earthly lives; these items are instead attributes which serve to establish the saint's eternal self-identity, and very often they are signs as well of the responsibilities the saint is currently fulfilling on behalf of people on earth.

European religious art of the renaissance era suggests that if Saint So-and-So, pictured in a moment from his earthly history, was once a mere mortal like us, we can attain his

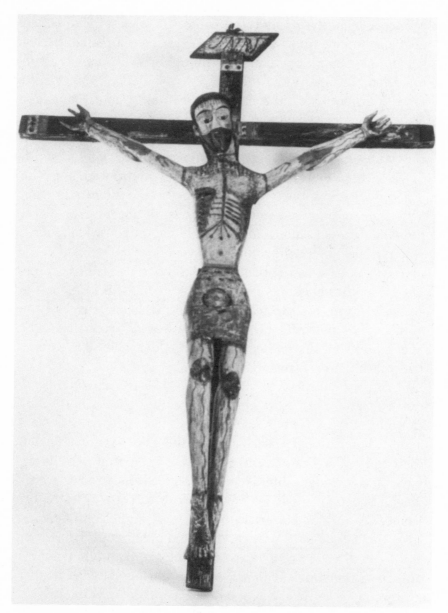

A Penitente-type crucifix (#16 in Appendix A), by José Benito Ortega. Note the blood flowing from under the loincloth; see page 63. Courtesy of the Museum of New Mexico.

eminence by imitating him; this can easily tend in the direction of Pelagianism, that constantly recurring Christian heresy which holds that man saves his own soul by living a good life in imitation of Christ and other holy persons. The New Mexico santero art seems on the other hand to say, Saint Such-and-Such is now in heaven and is assigned by God to aid me; this holy retablo is of itself and by its own sanctity both my powerful claim on him and his potent presence at the spot of need. Since a ritual or ritualistic object is holy and powerful to the degree that it represents (and hence becomes) the ritual-giving action or sacred being from the pattern-setting time or place, the New Mexico santero founds his likeness upon what is most real and most holy: the saint in heaven.

It may be noted at this point that not only ordinary saints but most other holy personages are treated in this fashion: the Blessed Virgin, for the reason that she is, like the rest of the saints, more powerful now than she was on earth; and the angels and God the Father and Spirit, all of whom have never had other than a heavenly existence.

The second mode of validation is that associated with the santero statutes of Christ, the crucifixes and (particularly) the carved bultos of Jesús Nazareno (Jesus the Nazarene or Nazarite, what European art knows as the Ecce Homo). For all their traits of stylization, these figures, and especially the latter, have a tremendous life-likeness rarely encountered in other New Mexico religious art, which tends instead to be highly iconic. The Jesús Nazareno figures derive their life-likeness from the lavishness of very carefully wrought detail; from their size — nearly as large as a man, far bigger than other santos; and from their articulation, for they are hinged with leather at the shoulder like huge puppets so they can be carried through the various stages of scourging, crucifixion, deposition and burial.

The validation of these Christ-figures stems not from

heavenly being (as it does in the case of saints) but from a particular set of earthly actions, the Passion. It is not Christ in his eternal pre-existence or in his present glorification who guarantees these santos, but the earthly Christ in his performance of the only complex of actions that is recognized by Christians as a truly pattern-setting and power-inducing earthly and historical deed: his passion and death. (So far as I know, there are only two representations of the risen Christ, in addition to one or two highly stylized "Allegories of the Redemption" identified by Robert Stroessner.) In the Jesús Nazareno bultos, the hinging of the shoulders suggest that it is not so much the person Christ who is imitated by the bulto as it is the action-sequence of the Passion, Crucifixion, Deposition, and Burial. This complex action (in a fuller theology, with Resurrection added) is the validating basis of Christian salvation and Catholic sacramentalism, and consequently it stands in the Catholic Christian religion as the equivalent of the action-complex of the culture hero of a primitive tribe.

It is important to note that the pattern-setting action of any culture-hero always occurs in a special kind of time — the sort of special period that Mircea Eliade calls "in the beginning" or "*in illo tempore*," what an Australian aborigine would term "dream time" or what a shaman would speak of as "in the dream vision I had," and what a fairy tale names "once upon a time." This last phrasing of the concept really means, as they all do, not simply "once" but "once and for all," for these are special pattern-setting times and hence are the sort of time which, like eternal now of the saints in heaven, can have access to any other time and indeed become identical with it, can absorb this lesser historical time into itself. Just as any and every earth-navel is *the* earth-navel, any and every world-center is *the* world-center, so any and every time which wishes to have access to the sacred time can do so, can *become it again* in its own way. This is the kind of time that baffles

51

Aristotelian logic, for "the beginning," the "once upon a time," the "illud tempus" starts over when the original deed of the culture hero is started over in ritual. It is not at all that the primal event has been captured by the cyclic movement of the day or the year; all cosmic cycles are instead absorbed into the primal event. "Always and everywhere men have had the conviction that in gestures and rites and figurative representations, what is signified and pointed to is in fact present precisely because it is 'represented'; and this conviction should not be rejected off-hand as 'analogy-magic.' "[2]

Within his special kind of time, the culture-hero performs an action which establishes a rite and its mythic accompaniment. The myth validates the rite rather explains it. It generally contains an authorization, in the form of a command, a request, or a grant of permission for the subsequent performances of the ritual (or the primal action in ritual form, if that is what it is): "And this day shall be unto you for a memorial: and ye shall keep it a feast to the Lord throughout your generations: ye shall keep it a feast by an ordinance for ever" (Exodus 12:14); "Do this in remembrance of me" (1 Corinthians 11:24); "The hero is completely engrossed in ritual, and after teaching it to his brother, he repeats it by having his brother sing over his sister so as to rehearse under the hero's directions"; the sacred animals tell the hero, "These things we have given you are what you shall use henceforth."[3]

In general, "the myth is to the savage what, to a fully believing Christian, is the Biblical story of Creation, of the Fall, of the Redemption by Christ's Sacrifice of the Cross. As our sacred story lives in our ritual, in our morality, as it gov-

[2] Karl Rahner, *The Church and the Sacraments* (New York: Herder and Herder, 1963), p. 36.

[3] Gladys A. Reichard, *Navaho Medicine Man* (New York: J. J. Augustin, 1939), p. 76; Alfonso Ortiz, *The Tewa World* (Chicago: University of Chicago Press, 1969), p. 14.

erns our faith and controls our conduct, even so does his myth for the savage. . . . it vouches for the efficiency of ritual."[4] And of course, it operates through a traditionalist unbroken line of performances from the first time on; as Old Man Warner says of the annual village ritual in Shirley Jackson's great short story, "There's *always* been a lottery." In all Christian denominations — Oriental, Protestant, and Roman — there has *always* been a memorial of the Passion of Christ.

Myth guarantees rather than renders rational. As Joseph Fontenrose puts it, "Myth has a justifying or validating rather than explanatory function: a myth narrates the primal event which set the precedent for an institution. It may be a ritual institution or cult; it may be a social, political, or economic institution; it may be a natural 'institution,' a process or phenomenon."[5] In general, the complexus of myth and ritual may be described as follows: the myth, at least partially narrative, derives from an originally oral account of the basic pattern-setting deed of the culture-hero and verbalizes it within a ritual setting; the ritual is the social and interpersonal application of the original deed to an individual or a group by way of action and text which are usually partly narrative, and which usually repeat the sort of authorization quoted above for Jewish, Christian, Navaho, and Pueblo rituals.

The Aristotelian effect-cause analysis which prevailed in both Protestant and Roman Catholic theologies in past centuries cannot satisfactorily connect the mythic pattern-setting deed to the ritual. The principal problem is that in an efficient-cause matrix, the cause must always be *other* than the effect; in the order of rituals, the deed in our time must be *the same* as the paradigmatic deed (the Last-Supper-to-

[4]Bronislaw Malinowski, *Magic, Science, Religion and Other Essays* (Boston: Beacon Press, 1948), pp. 100, 101.

[5]Joseph Fontenrose, *The Ritual Theory of Myth* (Berkeley: University of California Press, 1966), pp. 57-58.

Pentecost event performed by Christ in and at-the-edge-of historical time); if it is something else, then there are as some Protestants have insisted other sacrifices added to Calvary whenever Mass is said. Catholic sacramentalism demands to be understood in parallel with more primitive religions, where differences of time, place, format, "performer," and "patient" are erased so that the rite is identically the same ritual enacted in the "once upon a time" time. The pattern-setting deed, untrammeled by specification of when, where, how, and for whom, is still active. The deed done today is valid because Christ remains the true celebrant; the rite is Christ's eternal act of redemption as it personally affects a particular man or group of men.

This matrix of sacramental theology permits the most productive appraisal of the Penitentes and of the santero art most closely associated with them. The Penitentes — the popular name for La Cofradía (Confraternity) de Nuestro Padre Jesús Nazareno — originated as for as can be known in about 1790-1810.[6] The Penitentes seem to have arisen to fill a vacuum in religious direction caused by the lack of enough priests during the eighteenth century, which was later aggravated by the ousting of the Franciscans by Spain and the Spanish priests by Mexico, and the departure of Mexico-trained secular priests after the American annexation. The Penitentes used the Jesús Nazareno bultos to perform the stages of the passion of Christ during their devotions in the earlier weeks of Lent, but the focal moment of the Penitente year was the re-enactment of Christ's crucifixion on Good

[6]The good accounts of the Penitentes are Fray Angelico Chavez, "The Penitentes of New Mexico," *New Mexico Historical Review* 29 (1954), 97-123; George Mills and Richard Grove, *Lucifer and the Crucifer: The Enigma of the Penitentes* (Colorado Springs: The Taylor Museum, 1966); Bill Tate, *The Penitentes of the Sangre de Cristos* (Truchas: The Tate Gallery, 1966); Marta Weigle, *The Pentitentes of the Southwest* (Santa Fe: Ancient City Press, 1970 — with a good bibliography); and Lorenzo de Córdova, *Echoes of the Flute* (Santa Fe: Ancient City Press, 1972).

Friday, when one of the Brothers was tied to a full-size cross he had carried to the Calvario, raised up on it, and left for some time, frequently until he fainted. This is of course the ritual which has given rise to most of the sensationalizing journalism about the Penitentes.

The Penitentes patterned themselves on many available models. Fray Angelico Chavez suggested the Seville Cofradía of Penitents as a likely source outside the colony, for they also used the extraordinary title Nuestro Padre — Our Father — to refer to Jesus Christ. But within the colony there were many confraternities and pious parish societies including the Franciscan Third Order, although (Fray Angelico insists) it had no special influence on the Penitentes. Their religious rituals were developed for the most part from religious activities and church devotions which preceded them; their Tinieblas is a development for their special needs of the standard Catholic Tenebrae — the name also meaning "darknesses" — a ritualizing as part of communal recitation of the Roman Breviary of the darkening of the sun and moon at the death of Christ. Religious drama also contributed its part: "Passion plays were undoubtedly used by the missionaries in the colonial days, then were taken over by the folk, and later made part of the expiatory practices of the penitent Brothers."[7]

Francis of Assisi's concern with the passion of Christ led to his fostering the devotion to the Way of the Cross — a series of fourteen episodes of the last hours of Jesus, both scriptural and mythical, from the condemnation by Pilate to the placing of the dead body in the tomb. These "stations" concerned the people more during Lent than at any other time of the year, and as that penitential season drew to a close the entire town often cooperated in performing the devotion, as the Yankee

[7]Sister Joseph Marie, *The Role of the Church and the Folk in the Development of the Early Drama in New Mexico* (Philadelphia: University of Pennsylvania Press, 1948), p. 89.

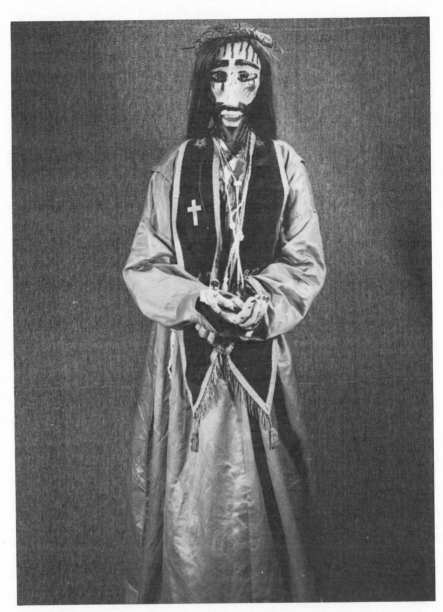

Our Father Jesus of Nazareth (#13), a Penitente-type statue by an anonymous santero. This lifesize bulto, from a morada in the area west of Taos, has a wig of human hair and moveable arms. Courtesy of the Museum of New Mexico.

merchant Josiah Gregg noted:

> An image of Christ large as life, nailed to a huge
> wooden cross, is paraded through the streets, in the
> midst of an immense procession, accompanied by a
> glittering array of carved images, representing the
> Virgin Mary, Mary Magdalene, and several others;
> while the most notorious personages of antiquity,
> who figured at that great era of the World's history,
> — the centurion with a band of guards, armed with
> lances, and apparelled in the costume supposed to
> have been worn in those days, — may be seen be-
> striding splendidly caparisoned horses, in the breath-
> ing reality of flesh and blood.[8]

Gregg immediately continues with a description of the
Holy Week procession at Tomé, an old Spanish settlement
about thirty miles south of Albuquerque on the left bank of
the Rio Grande. As F. Stanley notes, the Penitentes were
strongly entrenched in Tomé well into the twentieth century,
and it was surely one of their processions Gregg described,
though without identifying the events very accurately: "I
once chanced to be in the town of Tomé on Good Friday,
when my attention was arrested by a man almost naked, bear-
ing, in imitation of Simon, a huge cross upon his shoulders,
which, though constructed of the lightest wood, must have
weighed over a hundred pounds. The long end dragged upon
the ground, as we have seen it represented in sacred pictures,
and about the middle swung a stone of immense dimensions,
appended there for the purpose of making the task more labor-
ious."[9] But Stanley notes four pages later that "under the
direction of the padre, the people acted out the Passion during
Holy Week," so evidently in the interval between Gregg's

[8]Josiah Gregg, *Commerce of the Prairies* in Reuben Gold Thwaites, ed.,
Early Western Travels (Cleveland: Arthur H. Clark, 1905), vol. 20, p. 48.
[9]F. Stanley, *The Tomé New Mexico Story* (Pep, Texas: F. Stanley, 1966),
p. 8; Gregg, p. 181.

visit in 1832 and the twentieth century, the Penitente hege-mony gave way to some ecclesiastical control, doubtless that of Father J. B. Rallière, pastor of Tomé from 1858 to 1913.

Florence Hawley Ellis gives an extensive description of the Tomé ceremony, which was performed until about a dozen years ago. The main "character" was the great bulto of Christ, the *Santo Entierro* with its articulated shoulders and neck, which "hung upon the cross, the nails thrust through holes provided in hands and feet. Later, after the scene of the crucifixion, He was taken down from the cross, replaced in the coffin, and returned to the church."[10]

The supporting actors were mainly humans, but perform-ing their roles in as painless a way as possible. The Sanhedrin, the Romans, and Judas enacted the agreement to betray Jesus. Then the priest carried the story forward in a sermon. Next the bulto of Christ was revealed in a prison-cell in the church, guarded by Roman soldiers but ministered to by angels. On Friday morning, Pilate released Barabbas and condemned the bulto of Christ, whom he declared innocent, to the cross.

A centurion on horseback led the entourage to the per-manent and rather elaborate "Cavalry" in the churchyard; the forward movement of the plot ceased while the priest sermonized at the equivalent of the ninth station (the third of the three legendary falls); action returned briefly as the soldiers cast dice for the garments, but the priest and the choir described and interpreted the subsequent events until, at a climactic moment, the curtains were pulled aside to re-veal the bulto nailed to the cross flanked by two youths tied to smaller crosses (and standing comfortably on ample ledges). The three "bodies" were lowered, and the bulto returned to the church in a great procession.

[10]Florence Hawley Ellis, "Passion Play in New Mexico," *New Mexico Quar-terly* 22 (1952), 203.

Another interesting feature of the Tomé enactment was the multiple appearance of the Virgin Mother. She was presented by a young woman dressed in black; by a bulto of Nuestra Señora de los Dolores; by a Pieta; and by Nuestra Señora de la Soledád, the Virgin as crone, the woman bereaved of husband and son.[11]

In addition to the various performances of the Passion which were mentioned above, with bultos, with actors, and with actually suffering men, the Penitentes engaged in a variety of penitential practices — scourging themselves, carrying heavy crosses, applying cactus to their bodies. It should be added that in all of these penances, the wounds "are not deep and the muscle structure is not damaged."[12] There is also an abiding fascination with death among the Penitentes; wakes (*velorios*) conducted by them are practically an art form. But they were, on the other hand, the most significant nineteenth-century patrons and practitioners of the arts: the composition of alabados (hymns) and the fashioning of the santos could not have reached the proportions or the excellence they did without Penitente influence. Because of its separation from ecclesiastical authority, its exaggerated penances, and (later) its alleged involvement in partisan policies, the Penitente brotherhood was under ban from the 1880's (if not earlier, per-

[11]Ellis, pp. 205-11. Sister Joseph Marie lists on p. 89 four principal events as part of the New Mexican enactments of the passion: the three falls; "La Soledad" (by which she must mean the encounter of Christ and Mary, the Fourth Station, known in New Mexico as El Encuentro) ; the crucifixion; and the deposition. San Felipe Neri parish in Albuquerque has long enacted the deposition and entombment; Isaac L. Udell, "In the Dust of the Valley," *South Dakota Review* 7 (1969), 92-93, mentions an episode added in one village where an actor playing Judas stabs the side of the Christ-bulto and punctures a bag of fresh blood concealed there.

[12]Juan Hernandez, "Cactus Whips and Wooden Crosses," *Journal of American Folklore*, 76 (1963), p. 221; he agrees with Margaret Mead, *Cultural Patterns and Technical Change* (New York: New American Library, 1955), p. 167: "Accidents are the source of considerable anxiety, for to be [deeply] cut or broken in some way damages the whole person."

Through the aperture in the back of the corpus on this Penitente-style crucifix, the heart, visible from the front, may be made to palpitate. Courtesy of the Museum of New Mexico.

haps as early as 1833) until 1947; this period doubtless caused an increase in their insistence on secrecy and caused it to take the forms it did; but as will be explored later in more detail, there is some evidence that secrecy was a value to them from the very earliest period of their existence.

All the foregoing analysis suggests that the Penitente crucifixes and Jesús Nazareno bultos and the Penitente ceremonies themselves are best evaluated together, as parallel manifestations of the same religious dynamic. Most New Mexico saints are, as has been said, represented in repose, so that even San Acacio and Santa Librada are not depicted in the moment of their "painful" crucifixions so much as shown possessing their crosses as attributes; but the Penitente crucifixes and especially the Nazarenos are definitely action-oriented, showing a highly dramatic Christ and often made with hinged limbs so as to be put through the various torturous stages of flagellation, crowning with thorns, mocking, crucifixion, deposition, and burial. The events of Christ's passion and death evidently occupy a status as pattern not equaled by the earthly deeds of any other holy person. Hence, when the Penitente brothers move the Jesús Nazareno bulto through the various moments of Christ's earthly passion, death, and entombment, the activity is almost certainly to be understood as a folk equivalent of the Catholic Mass: the action, no less than the articulated statue itself, is validated by the primal Christian event in such a way as to become its ritual symbol, a symbol in which that primal event is truly present. This kind of activity originally took place in New Mexico without authorization by the official Church, and there is no provision in any official Catholic theology of the sacraments for it; but anthropologically the Penitentes were undoubtedly performing a ritual of exactly the same sort as are the sacraments: making present in their own day the identical action upon which the Christian religion is based.

Therefore, especially when the same events are not re-enacted by the nearly-lifesize "puppets" made by the santeros or mimicked by actors, but undergone by actual men, the ritual should be seen not as a Pelagian effort to gain one's own salvation by doing for oneself what Christ did but as a memorializing of him in such a way as to make present again the original crucifixion itself, not *another* event. Just as in Catholic theology the given particular contemporary Mass is not adequately distinguishable from the Sacrifice of Calvary, so the Penitente crucifixion ritualizes and hence *becomes* the original Calvary. Granted that the person tied to the cross may be Hermano Luís Mondragón of our little village, insofar as he matters he is Jesus Christ. There are not two holinesses, one of Calvary, the other of the Penitente ritual; that of the latter is identically if only by participation that of the former, the original ritual-giving and pattern-setting action of the only earthly time which can set patterns. And in like manner, there are not two powers and holinesses, the one of the saint in heaven, the other of the retablo or bulto on earth, but only one — and indeed a kind of singleness of being.

The Spanish people of the latter part of the eighteenth and first part of the nineteenth centuries, brought up in a strongly sacramental religion and then left without sufficient priests, understandably felt a deep need to find a satisfying substitute for confession, the mass, and the eucharist. In re-asserting the inherent priestly character of every Christian people, they fastened especially on the key event, the death of Christ, and used it as a means of securing expiation of their sins. They did not try to ritualize Calvary as does each of the Christian sacraments; instead, they acted it out by imitating the models provided by the various passion plays they were familiar with, by using bultos of Jesús Nazareno like large puppets, and most strikingly of all by appointing one of their number, through the authority of a pious confraternity, to

enact the Christ-event as mechanically and forcefully as possible within the limits imposed by their taboos against violating the human body by intruding more than skin deep.[13]

There is other evidence of the conclusion that the present chapter has been leading toward, that the Penitente practices and the typically Penitente santos of Christ are to be interpreted in a strictly sacramental context. First of all, later Penitente crucifixes do not merely imitate Christ as he might most realistically have been supposed to look when nailed on the cross. They show instead a figure which has turned blue — somewhat as the human Penitente "Cristo" would after having been tied for some time; and very frequently streams of blood are shown issuing from beneath his loincloth — a phenomenon attributable only to the Penitente practice of placing sprigs of cactus in the *calzones,* the white cotton drawers which served as the uniform garb of the Brother practicing active penance. And just as a bulto or an actor or a man in realistic earnest might serve as a quasi-sacramental substitute for Christ in enacted by the nearly-lifesize "puppets" made by the santeros enacting the events of his passion, so the bulto of Jesús Nazareno served in many a priestless village as a substitute for the reserved eucharist: it was carried about the fields to bless them on the feast of Corpus Christi, when with a priest available the consecrated host itself would have been borne in procession.

Finally, the Penitente hymns derive their Spanish name for the opening words of a song in praise of the Eucharist,

[13]Cordova, p. 9, maintains that it was considered a signal honor to be named to enact Cristo — not at all a punishment but instead a reward for having been an outstanding hermano. Richard Gardner, in *Grito! Reies Tijerina and the New Mexico Land Grant War of* 1967 (New York: Bobbs-Merrill, copyright 1970), pp. 73-74, passes along this John Wayne episode: "One little old lady of Rio Arriba recalls standing as a young child in the *placita* of San Pedro on the Sangre de Cristo grant during Good Friday celebrations and receiving the shock of her life when the call to colors sounded and the United States cavalry thundered in to 'save' a highly indignant penitent from the cross."

"Alabado sea, Praised be." These hymns serve as the liturgical texts of many of the Penitente rituals; their ballad-like stanzas narrate the mythic account of the events being commemorated, leading the mind of the devout, and perhaps the actions of a human performer as well, through the sequence of holy history. Juan Rael has translated the text of an alabado chronicling the suffering and death of Christ, the central Penitente (and Christian) event:

> Along the trail of blood
> By Jesus shed, our Christ and Sire,
> Went Mary, Mother of Our Lord,
> Upon a morning dire.

> So early was that morning hour
> When Mary walked forlorn,
> Only the bells of Bethlehem
> Were heralding the dawn.

> St. John the Baptist there she met
> And thus to him did say:
> "Oh! Have you seen my precious Son
> Pass by this grievous way?"

> "Aye, that I have, oh, Mary mild,
> Ere cock had roused the day,
> And on His sacred shoulders
> Five thousand lashes lay.

> "A cross was on His shoulders
> Of heavy, heavy wood;
> The wood was green, at every step
> He stumbled where He stood.

> "A rope about His neck there was
> A hundred knots and more;
> A woman there was with Him,
> Her name, Veronica.

Santos and Saints

"A trumpet went before
Announcing the Passion,
There is a crown of thorns
Of sea rushes.

"Three nails to crucify Our Lord
Within His hands are found,
He carries too a crown of thorns
With which He will be crowned."

When this the Holy Virgin heard
She fell down in dismay;
The good St. John then tenderly
Raised her from where she lay.

"Arise, sweet Mary, do not wait,
Arise now from the ground,
For yonder on Mount Calvary
The mournful trumpets sound."

Oh, Jesus, Father dearly beloved
Suffering thus for me,
Oh, may thy death redeem our sins
For all Eternity.

He who recites this prayer
Each Friday through the year,
From purgatory saves a soul
And his own soul from sin.

He who knows it and does not teach it,
He who hears it and does not learn it,
Will on the great Judgment Day
Know the meaning of this prayer.

To thee, Oh, Mother of Guadalupe,
To thee, Oh, Mother of Consolation,
To thee, Our Lady of Sorrows,
This prayer I offer.[14]

[14]From Juan B. Rael, *The New Mexican "Alabado,"* Stanford: Stanford University Press, 1951), pp. 24-25, reprinted with permission of the publisher;

In a similar manner, the events of Christ's passion and death were enacted by the Penitente Brotherhood and the women of the village — the Last Supper, the Agony, the Encounter of Jesus and Mary as he carries the cross, the Crucifixion, the Deposition — some in one manner, some in another. The Last Supper was a meal of Lenten fare — fish, vegetables, fruit, and the traditional *panocha,* a dish made from sprouted-wheat flour with probably Eucharistic overtones — usually eaten by the Brotherhood just after midnight, though variously on Thursday or on Friday. The Encounter was enacted with bultos, the women carrying the statute of Nuestra Señ-

Rael translates it from Aurelio M. Espinosa, "Traditional Spanish Ballads in New Mexico," *Hispania* 15 (1932), 100-01. The Spanish text:

1. Por el rastro de la sangre
que Jesucristo *rédama,*
camina la Virgen pura
en una fresca mañana.

2. De tan de meñana que era
a la hora que caminaba,
las campanas de Belén
solas tocaban el alba.

3. Encuentra a San Juan Bautista
y des esta manera le habla:
"¿No me has visto por aquí
al Hijo de mis entrañas?"

4. "Por aquí pasó, señora,
antes que el gallo cantara;
cinco mil azotes lleva
en sus sagradas espaldas.

5. "Con una cruz en sus hombros
de madera muy pesada;
como el madero era verde,
cada paso arrodillaba.

6. "Una soga a la garganta
que más que cien *ñudos* daba;
allí estaba una mujer,
Verónica se llamaba.

7. "Lleva un clarín por delante
publicando el padecer,
una corona de espinas
de juncos marinos es.

8. "Tres clavos lleva en sus manos,
con los que ha de ser clavado;
corona de espinas lleva,
con que ha de ser coronado."

9. Cuando la Virgen oyó esto,
cayó en tierra desmayada;
San Juan, como buen sobrino,
procuraba levantarla.

10. "Levántate, tía mía,
ya no es tiempo de tardanza,
que allí en el Monte Calvario,
tristes trompetas sonaban."

11. ¡Ay, Jesús, mi Padre amado,
que por mí estás de esta suerte,
haz que nos valga la nuerte
para redimir el pecado!

12. Quien esta oración cantare,
todos los viernes del año,
saca una ánima de penas
y la suya del pecado.

13. El que sabe y no la enseña,
el que la oiga y no la aprende,
el día del juicio sabrá
lo que esta oración contiene.

14. Madre mía de Guadalupe,
Madre de consolación,
Señora de los Dolores,
yo te ofrezco esta oración.

ora de los Dolores (or perhaps in places de la Soledád) through the streets of the town, the Penitentes the figure of Jesús Nazareno bearing the cross; when the groups join, the statues lean together as if commiserating each other. The crucifixion, again, is re-enacted painfully by the Penitente chosen for that year; he is taken down at a sign from the Hermano Mayor, and taken to the morada to be revived. Then the Brothers conduct the Tinieblas ceremony, the celebration of the time of chaos when the sun and moon were darkened, the earth shook, the dead rose, the veil of the Temple split — or if this is done on Thursday evening, it celebrates the time when the Apostles left Jesus in the garden of Agony and fled.[15]

Even mooting the question whether or not the Penitente practice of penance was excessive, the efficient-cause mentality of Bishop Zubiría in 1833 and Archibishop Lamy and the Jesuits of *Revista Católica* in later years could not cope with the fundamental mentality at the root of Penitente activities; and there is reason to suspect that — however much they may have kept it to themselves — the Mexican and Spanish-educated priests in the colony prior to 1833 were similarly put off by the activities of their charges. To men educated in a world which, unlike New Mexico, had been influenced by the rationalistic Enlightenment, the Penitente rites must have seemed superstitious — survivals or reappearances of a vastly more primitive view of how pious activity was made valid. But this "superstition" about the sacraments and similar activities has indeed a great deal to be said for it, as contemporary theology is discovering again. For the minds of post-Reformation Protestants and counter-Reformation Catholics especially, it had been superseded by a theology

[15] Mary Austin, *The Land of Journey's Ending* (New York: The Century Company, 1924), p. 369; Tate, pp. 39-40; Marta Weigle in Córdova, p. 60; Sister Joseph Marie, p. 89.

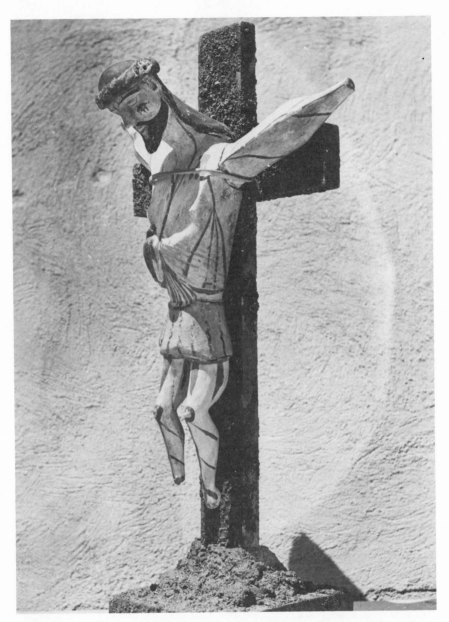

A Penitente-type crucifix (#16), by an anonymous santero. It may be suggested that the statue duplicates certain effects of being tied by the wrists. Courtesy of the Museum of New Mexico.

of "conjoined instruments" in a system confined almost totally to efficient casuality. In this system the ritual is analyzed with an Aristotelian methodology as having its own integrity of itself, and the celebrant, taken to be the true agent of it, is established by his priestly ordination as of himself an adequate (or in Protestant view, inadequate) secondary efficient cause. It is only recently that the more fundamental vision — the "superstition"— has been reformulated in terms that must seem madly Platonic to the older theological mentality, symbolism reified and run wild. It is, granted, a theory founded on exemplar causality which short-circuits the older efficient-cause network into statements like these of Louis Bouyer: "What man does in the ritual is a divine action"; the sacraments are valid because "Christ remains their true celebrant"; for man to perform sacrifice is for him "to do what is sacred" rather than to make something sacred.[16]

"One fact should be emphasized," states Marta Weigle, "that the Brothers never usurped the priestly functions of administering the Sacraments. None of their observations ever violated the Church's principles in this regard."[17] Understood literally, of course, Miss Weigle is perfectly correct. But I hope that what I have said about the santos and the Penitente practices — and other folk practices of the same general sort — shows that the New Mexican Spanish of the last century developed a quasi-sacramental system of their own which ranged from the santos themselves through Corpus Christi processions with a bulto of Christ and velorios for the dead, Christmas and Passion plays, and enactment of the passion of Christ using a statue of Jesús Nazareno, all the way to the Penitente crucifixion by tying one of the members of the brotherhood to a cross. In other words, what the sacraments and

[16]Louis Bouyer, *Rite and Man* (Notre Dame: University of Notre Dame Press, 1963), pp. 57, 66, and 80.
[17]Weigle, p. 27.

the Mass were to a village with a priest, the communal Peni-
tente initiations, penances, wakes and enactments of the death
of Jesus were to a village without one. And none of this should
come as a surprise, for in a social system traditionally sacra-
mental in which "village membership, not kinship affiliation
or extraterritorial membership, is the basis of identifcation,"[18]
the need to relate not the individual but the village as a whole
to the God-Christ-Virgin-angel-saint system of holiness and
power — but without a priest! — would naturally call forth
some significant folk, communal, and sacramental strategy.

In conclusion, I would like to suggest that in our Age of
the Absurd we might take the opportuity of noticing, as we
consider the New Mexico Spanish validation of santos and
ceremonial, that what finally above all is needed is validation
of man himself. This was given in times past throughout Chris-
tendom by the various churches, in New Mexico by the Roman
Catholic Church where it was effectively present in its of-
ficial and ordinary form, and in its absence by the Penitente
Brotherhood. Like the validation of a santo or that of a
ceremony, the validation of a person added little or nothing
to his understanding of himself, but it added enormously to
the assurance that like the statue and the devotion, he himself
made sense beyond his poor ability to comprehend such things.
As the Penitentes put it in one of their alabados,

> There is no one now
> Who is not worth something;
> Christ is already dead.

[18]Edward P. Dozier, "Peasant Culture and Urbanization: Mexican Americans
in the Southwest," in Philip K. Bock, ed., *Peasants in the Modern World* (Albu-
querque: University of New Mexico Press, 1969), pp. 144-45. I would like to
register here—for obvious reasons—my objection to Dozier's reference to the
compadrazgo (godfather) relationship as "fictional" and "ritual or fictitious" (pp.
151, 153). The sponsors or witnesses, who represent the Church as community in
the conferral of various sacraments, are made very much of in the Catholic
system; cf. John L. McKenzie, *The Roman Catholic Church* (Garden City:
Doubleday, 1971), pp. 164-65.

SUPPLEMENTARY BIBLIOGRAPHY

Beshoar, Barron B. "Western Trails to Calvary," pp. 119-48 in *1949 Brand Book.* Denver: The Westerners, Denver Posse, 1950.

Robb, John Donald. *Hispanic Folk Songs of New Mexico.* Albuquerque: University of New Mexico Press, 1954.

CHAPTER IV

Saints and Prayer

P easants are one of the constants of civilized history, dating back as a recognized class of society for millenia before Christ, appearing in practically all the civilized areas of the world both in the eastern and western hemispheres. A peasant society can be described as a small agricultural village which is neither wholly isolated from a more developed society nor wholly complete in itself. The peasant society instead forms a portion — indeed the foundation — of the larger compound society and consequently it must be defined within that larger context. Peasants may therefore be contrasted with primitives, whose society tends to be far more isolated and more complete in itself.

The peasant society, properly, is one that has some significant relationship to a town or city, usually a market town. Peasants produce not only for themselves, but also in hopes of exchange and gain so that they can achieve for themselves a certain success within the village and make possible for their children a greater success within the total and much more extensive system of political-military-taxgathering-ecclesiastical power of which the farming village is only a subordinate part. By means of his agricultural surpluses the peasant indeed supports the non-agricultural specialist workers and rulers, and in the typical total society of this sort in past ages

the peasant was arguably the origin of all economic values. Plainly, industrialization and technology create the main values of the new total system according to processes that are entirely non-agricultural. When this change takes place, as we will see later, the notion of the Physiocrats that the land is the source of value usually retains a sort of half-life as an agrarian ethical ideal with a significantly nostalgic cast. The town and city that the peasant always keeps as a part of his awareness are bearers of what has been well named the "great tradition" of the larger compound society, a tradition of wisdom and religious knowledge, a tradition of wealth and power, a tradition of legal justice and the possibility of its opposite; and consequently the peasant who has frequent dealings with town or city is often in need of the patronage of some powerful person who is more acquainted with the economic and judicial workings of the great tradition and who will be able to protect him from being victimized.

The peasant spends his life in close relationship to the land. He draws his name from the *païs,* the neighborhood in which he spends the overwhelming majority of his life, centered on the village of which he is above all a part, and he spends it in close relationship to the farm which, in the typical peasant tradition, has been controlled by his family for several generations, passing down from father to son; the result is both a deep traditional attachment to the particular parcel of land and a social structure normally patrilineal, patrilocal, and patriarchal. The religion which comes to be associated throughout the world and throughout history with the peasant is (whatever the great tradition might be) utilitarian and moralistic — that is to say, practical and directed to very particular social roles and the duties that one who occupies a social role must perform faithfully if the social order is to retain its stability. It supplements a religious system which does not tend to question the ultimates, since the peasant can as-

sume that they are cared for by the great tradition which he knows *of* but does not himself know. Because the kind of farming that is carried on in a typical peasant system demands a fair degree of cooperation, this religion will tend to curb aggressiveness, diminish any thrust toward individualism, socialize the members of the peasant society by rendering them dependent upon the group, and issue sanctions to them which foster the routine fulfilment of routine tasks. As Robert Redfield has summed up in *Peasant Society and Culture,* his values center around "an intense attachment to native soil; a reverent disposition toward habitat and ancestral ways; a restraint on individual self-seeking in favor of family and community; a certain suspiciousness, mixed with appreciation, of town life; a sober and earthy ethic."[1]

The variation of this sort of society in which the eighteenth and nineteenth-century New Mexican lived labored under a greater than ordinary isolation from the "great tradition" that we have spoken of. We have already noted the isolation of the people from the regular care of the institutional church which seems to have led to the organization of the Penitente brotherhoods, and the general subject of the first chapter of this book was the isolation of the New Mexico santero tradition from the Renaissance tradition of Mexico and Europe. The farming villages in New Mexico were also far more isolated than is usual in peasant cultures from any-

[1]Robert Redfield, *Peasant Society and Culture* (Chicago: University of Chicago Press, 1960), p. 78. Frances Swadesh, "The Social and Philosophical Context of Creativity in New Mexico," *Rocky Mountain Social Science Journal* 9 (1972), p. 15, comments that "In New Mexico, the most admired personality configuration centers on reserve, coupled with sensitive perceptions of the feelings of others, frequently communicated by nonverbal means." On the relationship of peasant to town, an interesting Anglo sidelight is offered by Robert Penn Warren's elegiac "The Patented Gate and the Mean Hamburger," which presents the agrarian tradition in a positive light, the town in a negative; describing mountaineer sharecroppers in the market town: "They will stand on the street corners and reject the world which passes under their level gaze as a rabble passes under the guns of a rocky citadel around whose base a slatternly town has assembled." *The Circus in the Attic and Other Stories* (New York: Harcourt, Brace, 1947), p. 121.

A Death-Cart (Doña Sebastiana, #143 in Appendix A), by an anonymous santero. This muerte, formerly in the baptistry of the church at Las Trampas, is the property of the Penitente chapter there. See page 89. Photo courtesy of the Museum of New Mexico.

thing that might be recognized as market towns as well as from each other. There is a story told of a little mountain village in the northern part of the colony which was neither attacked nor overcome during the Pueblo Rebellion of 1680, but was not even aware that anything at all had happened until the Spanish settlers returned a dozen years later; the village was used to being left alone. The story is almost certainly not true, but it suggests the vastness of isolation in the furthest backwaters of the New Mexican past. In so isolated a world as this, the aid of a powerful and knowledgeable protector against the larger society was rarely necessary; and Frances Swadesh says that "the emergency of *patróns* as a powerful class appears to date from the mercantile development stimulated by the Santa Fe Trail." Further, debt peonage, which often is a sign of the *patrón* relationship and which was the standard social relationship for the bulk of the population of Old Mexico, was very uncommon in New Mexico, occurring only rarely in the Rio Abajo region; peonage becomes a notion applicable to New Mexico only when Anglo agribusiness forced the people off their small farms and into the role of migrant braceros.[2]

Furthermore, in what market towns there were, trade was carried on more by barter than by cash, just as in the villages themselves transactions were carried on by gift-exchange and work-sharing rather than even barter. There were very few things that the people of the farming villages needed from the market towns and the even greater world that the towns mediated; some of the tools the people had to have, particularly those of metal like saws and axes, and metal itself that might be worked up within the village — iron, brass, lead to be used as solder and for bullets. Weapons

[2]Frances Swadesh, p. 12; see also Irving A. Leonard, *Baroque Times in Old Mexico* (Ann Arbor: University of Michigan Press, 1959), p. 222.

would also have to come from the larger society — guns, swords. Some dyes were imported into the colony to be used to tint the woolen cloth made by the Spanish and Indians both; these dyes frequently turned up, as we have said, among the materials of the santeros. And any fine clothing for special occasions or feast days would have to be purchased or traded for.

From the local area the villagers would have to obtain a few more things, especially salt, pottery from the local Pueblo Indians, and santos made by the semi-specialist santeros. In the village itself there were a few specialties — medical attention and medicines from the *curandera* or *curandero*, the local expert in folk cures of the area; blacksmithing, working up the metal that had been gotten in town; and midwifery. But apart from these things, each family — each extended family — would provide the vast majority, practically everything, of what they would need to live. The animals they had — the sheep and the goats, the cattle, burros, and horses — would provide work, meat and grease for candles, hides and wool for clothing. Timber was cut to be used for fuel and for making furniture and portions of the house. And finally, the earth itself provided the adobe and rock for the house, multiple crops for food and other uses, and the remainder of the dyestuff not imported. The skills to exploit these raw materials were provided by the members of the family itself — the minor necessary specialties uncalled-for in a one-crop or wage-work economic system which can purchase in a cash market all that it needs.

The New Mexican peasant life was, by contrast, one of self-subsistent villages made up of self-sufficient families in almost every area of practical daily living; as Karl Marx wrote of nineteenth-century French peasantry, "Each individual peasant family is almost self-sufficient; it itself directly produces the major part of its consumption and thus acquires

its means of life more through exchange with nature than in intercourse with society."[3]

For the village society of New Mexico, the weakness of every peasant society was aggravated by another factor. During the years of isolation, New Mexico experienced a significant decline in effective energy-use due to a recession in the technology of tools (farming impliments especially) and of weapons. A great deal more manpower and manhours were required to perform the same tasks of cultivation and defense than had been needed at the beginning of the colonial period. In the early days, the colony had been relatively well supplied with weapons with which to subdue the Pueblo Indians and coerce work from them which the Spanish later had to do themselves; and further, the farm tools — plows, pitchforks, scythes, sickles, hoes, and so forth — demanded more labor when they were homemade than they had when they were imported from Mexico and Europe.

The New Mexicans were not invention-minded in the way that contemporary English and Americans were — the likes of James Watt, Eli Whitney, Robert Fulton, Cyrus McCormick, and Samuel Morse — mainly because there was not the economic substructure to reward the exploitation of such inventions as these men had made. But the Spanish were indeed resourceful; they had to be even to continue to survive in the face of a practically total abandonment by the "great" Spanish tradition. The population of New Mexico, counting Spanish and Pueblo Indians, appears to have declined in the first two centuries of the colony's history. Disease unassociated with malnutrition doubtless played some part in this decline, but the energy crisis fostered by a tool-and-weapon

[3]Karl Marx, *The Eighteenth Brumaire of Louis Napoleon* in Karl Marx and Frederick Engels, *Selected Works* (New York: International Publishers, 1968). p. 172.

collapse must be held chiefly responsible for this major population decrease.[4]

For the New Mexican villager of a century and a half ago, the "great tradition" existed psychologically as an awareness on the farthest horizon of consciousness, as the fundamental guaranteeing and validating factor among many others within a continuity which began with the royal court of the king in far-off Madrid and the papal court of the pontiff in Rome, passed through the viceroy in Mexico City and the bishop in Chihuahua or Durango, to the governor and vicar-general in Santa Fe and the alcalde and priest of the nearest town, and ended with the people of the village in manual contact with their land.

The peasant attachment to the land has been mentioned already is something that needs to be defined very carefully. The romantic era, beginning in the late eighteenth century and reaching a fever pitch in the nineteenth, set a very high value on the land. Firstly, the above mentioned economic view of the Physiocrats, a French school of economics prior to the Revolution, when rendered obsolete as an economic theory, maintained its existence in the form of the ethic of agrarianism, which pointed to farming — and above all the one-family farm — as a source of tremendous social and personal moral value. And secondly, land in the form of scenery corresponded to the eighteenth and nineteenth-century notion of sensibility, the faculty that Wordsworth presupposed, that Emerson and

[4]D. W. Meinig, *Southwest* (New York: Oxford University Press, 1971), p. 13; Eric R. Wolf, *Sons of the Shaking Earth* (Chicago: University of Chicago Press, 1959), p. 195, states that "Between 1519 and 1650, six-sevenths of the Indian population of Middle America was wiped out"; pp. 198-211 give a cogent argument in terms of energy-use. For other particulars, Wolf, p. 160, notes that "Only one plow, of the many [types of] Spanish plows, was transmitted to the New World," and Irving A. Leonard, *The Books of the Brave* (Cambridge: Harvard University Press, 1949), p. 242, that the Spanish Crown "had forbidden the manufacture of arms in the colonies and had severely limited the importation of them from the homeland." There will be more about this in connection with Santiago in the next chapter.

Thoreau tried to develop into an American lifestyle, and that is an attribute of the vast majority of the heroines of nineteenth century novels and even of such highly masculine heroes as Natty Bumppo, Huck Finn, and the monster in Mary Shelley's *Frankenstein*. Romanticism in this way led to a resacralization of nature after its demythologization at the hands of the rationalistic enlightenment and the technological advances which led to the industrial revolution.

Apropos of the nineteenth century New Mexican peasant, a romantic viewer and writer could consequently make statements like this of Sister Joseph Marie: "The *Padres* and the *Conquistadores* left a cultural deposit in the Southwest which is a blend of religious devotion and adventure, a kind of Romantic Movement in the making."[5] Such a statement gives a seriously distorted notion of peasantry and of New Mexico during the last century.

As Father Walter Ong points out in *Rhetoric, Romance, and Technology*, "Romanticism appears as a result of man's noetic control over nature, a counterpart of technology, which matures in the same regions in the West as romanticism and at about the same time, and which likewise derives from control over nature made possible by writing and even more by print as means of knowledge storage and retrieval."[6] A precondition for Romanticism, in other words, is what sums itself up in the mathematicizing of the universe by Newton (*Principia*, 1687) and the invention of the steam engine by James Watt (1769). The rationalistic Enlightenment and the Industrial

[5]Sister Joseph Marie, *The Role of the Church and the Folk in the Development of the Early Drama in New Mexico* (Philadelphia: University of Pennsylvania Press, 1948), p. 3.

[6]Walter J. Ong, S. J., *Rhetoric, Romance, and Technology* (Ithaca: Cornell University Press, 1971), p. 20. Copyright © 1971 by Cornell University. Used by permission of Cornell University Press.

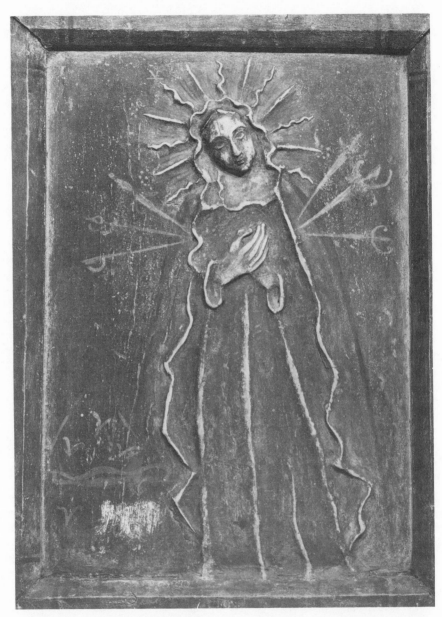

Our Lady of Sorrows (#31), a gesso relief by Molleno. Note the outsize thumbs, a characteristic of this santero throughout his long career. Courtesy of Denver Art Museum, Denver Colorado; Anne Evans Collection.

Revolution serve as psychic preconditions for romanticism. For the first time in his multimillion year career, man is able comfortably to confront nature, which hitherto has been overwhelmingly threatening, knowing that he can always fall back upon the comparatively safe world promised him by Newton, Watt, Diderot, Franklin, and the other liontamers. Now granted that the nineteenth-century New Mexico peasant had a closeness to the land and that he was endowed with a large number of quaint customs surviving from or reverting to or at least reminiscent of the Middle Ages (that period dear to romanticism), it must be remembered that nobody is quaint to himself, nobody is picturesque to himself, nobody is romantic to himself — except perhaps a member of the court of Versailles dressed up as a shepherd or shepherdess and playing with carefully-laundered lambs.

The New Mexico Spanish of the nineteenth century are people *about whom* romantic sentiments were experienced by the sightseers and recorded by the authors of travel books for the sentimental reader. The closeness to the land of the Spanish is not that of the Byronic exile but that of the isolated peasant who is untouched by romanticism because he is unaffected by the Enlightenment and industrialization which are its necessary presuppositions. He cares about *his* land in *his* village, not about nature *in globo*. Nature in general is to the peasant a mysterious and discomforting unknown.

Father Ong goes on the say that "Strong disapproval for the cliche is a regular concomitant of the romantic state of mind, subconsciously convinced that what is already known does not require repetition because what is known is stored in books, whereas art is necessarily a venture into the unknown." Totally devoid of any Renaissance or Romantic hunger for novelties, the New Mexican peasant, like all peasants, had instead a desire for what Eric Wolf, writing in *Peasants*, refers to as "that sense of continuity which renders life predict-

able and hence meaningful."[7] It is precisely this sense of continuity which is served by the ancient Greek rhetorical commonplaces — the aphoristic and proverbial gatherings of inherited wisdom of preliterate and pretypographical societies; as Father Ong points out,

> Oral cultures necessarily place a premium on standardization or fixity, for in the absence of writing the major noetic effort of a society must be not to seek new knowledge but to retain what is known, not to let its scant, hard-won store distintegrate or slip into oblivion. In this economy of thought, commonplaces serve an important function. They are major devices for standardizing knowledge, for keeping it in fixed forms retainable in the memory, so that it can be retrieved orally at will. Indeed, commonplaces are seen to be the most basic or central standardizing devices in the entire noetic economy once we recognize that commonplaces include epithets, which are omnipresent in an oral culture. We here understand epithets in the usual sense of expected or standard qualifiers (the *mournful* cypress, the *clinging* vine, the *sturdy* oak, *wise* Nestor, *wily* Odysseus) or standard surrogates or kennings ("tamer of horses" for an ancient Greek warrior, "The Mantuan" for Virgil, "whale-road" for the sea). Epithets are mini-commonplaces.[8]

I would like to suggest in this context that the santos are a set of visual commonplaces, in which the verbal epithets of the commonplace are replaced by the visual attributes of the santo. It is my contention that the santos as a group make up for New Mexico a nearly complete motivational system

[7]Ong, p. 21; Eric R. Wolf, *Peasants* (Englewood Cliffs: Prentice-Hall, 1966), p. 98.; Swadesh, p. 16, says: "New Mexican perceptions of the relationship between Man and Nature do not apparently lead to the celebration of Nature for its own sake, which is characteristic, for example, of the poetry of Wordsworth."

[8]Ong, pp. 261-62.

having to do with the control of the world exercised on behalf of mankind by God and the various saints. The santos make up a system which is both pictorial and, because of the legends, prayers, and associations passed down by word of mouth about the vast majority of the saints represented by the santeros, also oral.

The majority of these saints are, as has been mentioned already, patrons of various particular needs. Recently I did a small amount of questionnaire work in New Mexico and Colorado, testing the possibility of recovering knowledge on this subject. I asked the question with regard to a list of saints, for what favors was each of them prayed to — for what good was this saint asked, for protection from what evil was that saint petitioned. In this way I hoped to find out as completely as possible the hopes and fears which the New Mexico Spanish of the last century associated with each of the saints. Unfortunately, a great deal of the knowledge, if indeed it ever did exist for each saint, seems to have been lost forever. I was, however, able to recover enough information, both through my questionnaires and by consulting written sources, to become convinced that when compared with a generalized motivational system drawn up for an agrarian, peasant society, the saint-related system of hopes and fears offered a more complete an account of New Mexican motivational psychology than several representative books on the New Mexico Spanish taken together and analyzed so as to supplement each other.

The present chapter will work with the saints as patrons of the various needs of the New Mexican people of the last century so as to draw their motivational profile and thereby contribute to delineating their social character, which Erich Fromm has described as "a character structure common to most members of groups or classes within a given society . . . a 'character matrix,' a syndrome of character traits which has developed as an adaption to the economic, social, and cultural

conditions common to that group."[9] This statement of social character should be understood to apply first of all to the Spanish New Mexicans of the first half of the nineteenth century — before the United States takeover of 1848—though it probably can be validly applied to the people of the smaller, more out-of-the-way villages down to the First World War and perhaps even beyond.

The whole of the generalized motivational chart appears as Appendix D. It is divided into two main sections, the first dealing with individual needs, the second with social. The three subdivisions of "individual" deal with sensation, curiosity, and achievement; the three subdivisions of "social" are affiliation, power, and aggression. Within each of these six subdivisions there is a further cleavage into negative (fears) and positive (hopes). The reminder of this chapter will consist of explicitiations of information that is implicit in the full chart Appendix D.

First of all, the correlations of saints to needs were rarely a simple one to one. Some saints cannot be connected with any special need, and though it is doubtless true that a good deal of information has been lost in the last hundred years, it is still likely that not every saint was patron of something particular and that not every need had a special saint connected with it. Further, some saints were petitioned for a large variety of needs, up to eight or ten. In Appendix A, the complete list of saints has been specified by noting the central needs associated with each of them for whom information is available. Since in statistical theory it is allowable in such circumstances either to assign likely percentages to a saint (so that, for instance, Saint Lawrence would "patronize" 50% against fire, 25% against poverty, and 25% for crops during August), or to assign every need connected with

[9]Erich Fromm and Michael Maccoby, *Social Character in a Mexican Village* (Englewood Cliffs: Prentice-Hall, 1970), p. 16.

him to him ("100%"), I have taken the liberty of splitting
the difference by rejecting certain suggestions made on ques-
tionnaires as irrelevant and idiosyncratic, and then designat-
ing the saint to be wholly patron of each authenticated need.

Secondly, and conversely, certain of the needs cannot be
determined to correspond to any of the saints, and other needs
were submitted to various saints (for this, see Appendix D).
In addition, there were probably some needs that would not
have been submitted to any saint on the grounds that they
were beneath the dignity of his or her sainthood; these might,
however, have been very real needs, such as that for aggres-
sion against a member of the community who was a threat
to its welfare (2.3111) or for sexual satisfaction in marriage
(an aspect of 1.121).

Next, I will make various comments on the particular
motivational economy which appears to emerge from my ana-
lysis of the santos and which points toward emphasis in certain
portions of the generalized motivational chart and deemphasis
in others.

1. With regard to protection against sickness (see item
1.113 in Appendix D), a very significant remark is that made
by Margaret Mead in *Cultural Patterns and Technical
Change*: "There is a sort of persistent hypochondria. . . . not
characterized by general complaints of feeling bad 'all over.'
. . . By projecting the trouble onto a specific body-part, totality
is protected."[10] The list of sicknesses submitted to the care of
individual specialist saints — trouble with teeth, eyes, skin,
plague (smallpox, nearly always), and burns — suggests that
ordinary saints were felt to have less power than they would
need in order to penetrate to the "innards" where more serious
and mysterious ailments reside, and that such troubles would
need to be submitted to the Holy Child of Atocha or the

[10]Margaret Mead, ed., *Cultural Patterns and Technical Change* (New York:
New American Library, 1955), p. 184.

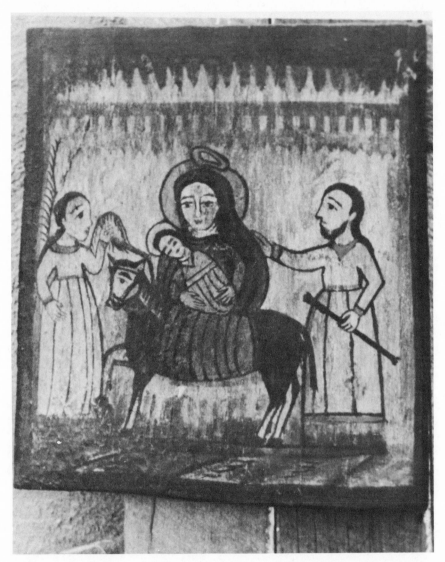

The Flight into Egypt (#4), by Rafael Aragón. The double halo on the Virgin is typical of Rafael Aragón's style. Note how, except for the donkey's tail, all possible features are outlined against the background; see page 20. From a private collection, with permission.

88

Sacred Heart, to Nuestra Señora del Socorro, or to Santa Rita de Casia as the patroness of hopeless cases rather than as a patroness protecting from sickness in general. Furthermore, Penitente wounds, as has been noted above, fall into the superficial class, never involving the amputation of even a finger (a common practice in some Indian tribes), penetration into the body cavity, or (except perhaps in a very few instances) piercing of hands or feet with nails. Lastly, if insanity was suspected to be the result of witchcraft, it would have been submitted to the care of San Ignacio de Loyola, but if that was not so, it would probably have been left to the care of God himself. There was an Iberian tradition that madmen were especially touched by God, and a parallel attitude among certain Indian tribes, but as Ari Kiev has pointed out in his study of Texas folk medicine, it was felt among the Texas Mexicans that madness was often "punishment from God."[11]

2. All the saints prayed to with regard to intemperance (1.114) seem also to have been invoked against unchastity, none against drunkenness or drug-use, which were apparently no significant problem in the period before the American takeover.

3. Several persons who responded to the questionnaire made a point of saying with regard to Doña Sebastiana, the personification of Death, that she was not prayed to as a saint would be, but served merely as a reminder of the possibility of death (1.115); only one respondent mentioned persons invoking her. Thus on balance it must be suggested that the caption in Mills and Grove's study of the Penitentes which says that Doña Sebastiana "is appealed to for long life," and Ely Leyba's remark that persons "would pray to the image of Sebastiana that their lives would be prolonged," must be

[11]Ari Kiev, *Curanderismo: Mexican-American Folk Psychiatry* (New York: Free Press, 1968), p. xi.

Santos and Saints

considered inaccurate.[12] On the contrary, a "good death" (*buena muerte*, one in the state of grace leading to entrance into heaven) was a favor fervently to be prayed for.

4. Granted, as Margaret Mead has noted, that childbirth was not considered pathological (1.121), still its dangers were recognized in connection with San Ramón Nonato (Nonnatus — not born; he was a Caesarean birth), patron of midwives, women in pregnancy and childbirth, and the unborn.[13] — It has already been noted in connection with this topic that the wish for sexual satisfaction in marriage (bracketing the chances of having children) was apparently not submitted to any saint.

5. The remarks of Nancie Gonzalez and of Reeve and Cleaveland which suggest that even prior to the 1930's there was significant overpopulation of some of the older areas of New Mexico and consequent need to expand into new precincts are perfectly compatible with the count of santos of San Isidro, patron of farmers, and Santiago, of soldiers (1.123).[14] San Isidro tends to appear fairly steadily, whereas Santiago falls off from a high in the earliest period to only a few in the later (see Appendix A).

6. San Cayetano is both patron of gamblers (1.1252) and a saint to whom one prays by saying, "I'll bet you a rosary in your honor you don't do this favor for me." There is nothing about gambling in the biography of the saint.

7. Exact symmetry (1.127) was only very rarely — and then probably accidentally — a property of santos; retablos

[12]George Mills and Richard Grove, *Lucifer and the Crucifer: The Enigma of the Penitentes* (Colorado Springs: Taylor Museum, 1966), p. 14; Ely Leyba, "The Church of the Twelve Apostles," *New Mexico Magazine* 11 (1933), 49.

[13]Mead, p. 172.

[14]Nancie L. Gonzalez, *The Spanish-Americans of New Mexico: A Heritage of Pride* (Albuquerque: University of New Mexico Press, 1969), p. 121; Frank D. Reeve and Alice Ann Cleaveland, *New Mexico: Land of Many Cultures* (Boulder: Pruett Publishing Company, 1969), p. 153.

are, much more often than not, visibly non-rectangular, and many of them hung for upwards of a hundred years crooked on the walls of New Mexico homes and chapels. But they have their beauty.

8. I suspect that the received opinion about New Mexican deemphasis on learning (1.211, 1.221) needs to be revised or at least modified. Santo Tomás, a natural patron of scholarly activities, appears once in my sample, but Santa Gertrudis, who appears fifteen times in all, is associated with youth and school twice in six answers, while her official status as the patroness of the Spanish Americas is not mentioned. The New Mexican Spanish were, as has been said, aware that there was a "great tradition"; and even though they may have had no use for it for their own purposes, they would have respected it, felt that it validated their existences *a longe,* and would have hoped that their children might by some lucky stroke come to participate in it.

9. There is good reason to suppose that every one of the saints that have to do with ridding oneself of generalized sin (1.311, 1.312, 2.111, 2.112) are connected with the Penitentes, and that all these saints and all other saints who have to do with getting rid of particular sinfulness (sexual; see 1.114) may also be prayed to on behalf of others. There is, in other words, a communal bent to the New Mexican reaction to sin, whether it be one's own or another's, which points to a shame culture rather than to a guilt culture. A communal reaction to one's wrongdoing — shame — calls for a communal cleansing — penance done in a group; and in this light also, the "death" of the Penitente brother in imitation of Christ's death readily appears as not a personal but a village expiation: the Penitente also "dies" for the sins of the people.

10. The only three saints who appear in the category "Achievement" (1.3), Juan Bautista, Pasquale Baylon, and Antonio de Padua, are associated with strayed animals and

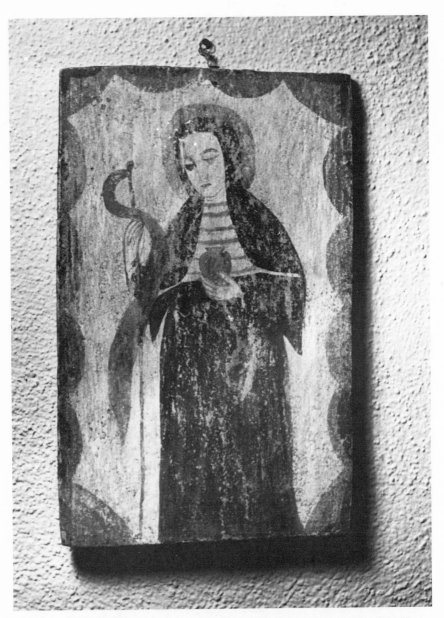

Saint Gertrude (#127), by the A. J. Santero. An exponent of an earlier devotion to the Sacred Heart of Jesus, she is dressed as an abbess and holds a staff with a pennant. From a private collection, with permission.

lost things. That nothing is said about animals or things stolen is probably due to the situation in the old extended-family villages, where apart from wartime incursions by wild Indians, there would have been little likelihood of theft, burglary, or robbery. There would have been instead a tendency toward communal usage of many things privately owned — tools to be borrowed, and so forth — with the whole village to some degree at least co-responsible for everything in the village. This topic will recur in Chapter Seven in connection with the problem of land ownership.

11. As was noted above in connection with 1.115, a happy death was a standard object of prayer, but this is the only benefit belonging to the distant future (1.324), one which does not answer a present need, that the people prayed to the saints for. This may suggest that they did not worry overly much about the remote future, but merely cared for the matters at hand as well as they could and let the year after next take care of itself.

12. Marta Weigle in *Penitentes of the Southwest* notes that "When the Anglos began to move into the region after 1821, they reported rituals of a *nonsecret* religion practiced by much of the population." But she also notes that the performance of penance out of doors but in a hood "was more to insure humility than to hide from authorities," and this accords with what Mary Austin suggests about the origins of Penitente secrecy, that the primary motive was "the moral necessity of protecting [the] penitents from spiritual pride by concealing their identity under the black bag which is still worn by *flagelantes* in all public processions."[15] The statistics relating to the two patrons of Penitente secrecy, San Juan

[15]Marta Weigle, *The Penitentes of the Southwest* (Santa Fe: Ancient City Press, 1970), pp. 35-36; in her notes to Lorenzo Córdova's *Echoes of the Flute* (Santa Fe: Ancient City Press, 1972), p. 51, Miss Weigle says secrecy increased after the Civil War; Weigle, 1970, p. 32; Mary Austin, *Land of Jour ney's Ending* (New York: The Century Company, 1924), p. 353.

Nepomuceno and San Ramón Nonato, suggest that they were adopted from very early on, and that although the entrance of the Anglo Protestants, the Anglo-French Catholic clergy, and the Italian Jesuits forced the ceremonies to be held outside the villages, it was not the signal for starting to keep certain things secret. It may be suspected that the Mexico-trained clergy had imbibed some of the preferences of the rationalistic enlightenment and had their doubts about what the Penitentes under their care were up to. In 1833, Bishop Zubiria while on visitation ordered the Penitentes to cease and desist; and one must suppose that he was advised in this by the local clergy.

13. There is an abundance of articulation of the section on the family (2.1235), with at least two patrons for each of the main subdivisions; there is some concentration of saints with many representations such as San Francisco de Asís (20), Santa Gertrudis (15), San José (59), Santa Rita de Casia (18), and San Antonio de Padua (73). It is worth note that a girl's need for help in finding a husband was the object of a devotion, but not a boy's in finding a wife.

14. The problems of travelers (2.3114) and of captives (2.3115) seem to have been very important in New Mexico during the last century. Though there is as might be expected a good deal of duplication of statistics between saints associated with the two dangers, traveling is connected with 6.8% of my sample of a thousand santos, emprisonment with 3.6%.

15. That there is no saint associated with the responsibilities associated with the very important New Mexican institution of being godfather, godmother, godchild, or compadre suggests that these relationships were subsumed under the basic familial positions of status: father, mother, child, brother. Just incidentally, Frances Swadesh notes that "The most common practice in New Mexico was and is to select as godparents for one's children close relatives, thus intensi-

94

fying existing kin relations rather than selecting a *patrón* figure as fictive kin."[16]

In conclusion, I would like to suggest that this motivational study of the New Mexico Spanish of the nineteenth century portrays a people with a special relationship to the deity and the saints who are portrayed in santero art, and to insist that this relationship needs to be taken seriously into account when the people are spoken or written about. The saints, as they are aligned with the needs — the hopes and fears — associated with them, constitute a particular motivational economy which, while it is not complete in all respects, is a necessary supplement for any and all other accounts of the New Mexico Spanish of the last century: the "People of the Saints," as George Mills accurately names them, cannot be known accurately apart from their saints. The santos — the wooden saints, retablos and bultos — were components of a power-system which reached from earth to heaven and controlled hell, and in so doing protected the culture (including the power-system itself) from that worst of all failures, the loss of the people's confidence in their way of life. The New Mexican Spanish of the last century did not trust in or attempt to put into practice a physical control over their world through technology, however rudimentary, but their culture shows what every living culture shows: that however passive and fatalistic it may seem, especially to an aggressive and nature-dominating culture, every culture enables its people to posit a refusal to yield to basic defeat, a refusal not to endure. Though help may be needed, from the past, from the future, from another world altogether, the vital culture insists that help is available through known strategies. The people of nineteenth-century New Mexico sought help in prayer, and they endured.

[16]Swadesh, p. 12.

SUPPLEMENTARY BIBLIOGRAPHY

Benrimo, Dorothy. *Camposantos.* Fort Worth: Amon Carter Museum of Western Art, 1966.

Dozier, Edward P. "Peasant Culture and Urbanization: Mexican-Americans in the Southwest," pp. 140-58 in Philip K. Bock, ed., *Peasants in the Modern World.* Albuquerque: University of New Mexico Press, 1969.

Kluckhohn, Florence, and Fred L. Strodtbeck. *Variations in Value Orientations.* Evanston: Row, Peterson, 1961.

Mills, George. *The People of the Saints.* Colorado Springs: Taylor Museum, 1967.

Samora, Julian, ed. *La Raza: Forgotten Americans.* Notre Dame: University of Notre Dame Press, 1966.

Sanchez, George I. *Forgotten People: A Study of New Mexicans.* Albuquerque: University of New Mexico Press, 1940; Calvin Horn, 1967.

Sauer, Carl Ortwin. *Land and Life,* ed. John Leighly. Berkeley: University of California Press, 1965.

Vogt, Evon Z., and Ethel M. Albert, eds. *People of Rimrock.* Cambridge: Harvard University Press, 1966.

CHAPTER V

New Mexico Reapplication of Saints

Spain's seven-century domestic crusade against the Islamic Moors came to a successful conclusion in the same year that Columbus discovered America. This event turned the prodigious Spanish energies outward, especially into the western hemisphere, and they flowed ceaselessly in the track of such men as Pizarro and Cortez until, just over a century later, a terminal Spanish settlement began in Northern New Mexico among the Pueblo Indians, an oasis of agriculturalism surrounded by vast deserts dominated by hunting and gathering tribes — the Navajos and Apaches, the Comanches, Utes, and Pawnees, and the dozens of other tribes that intermittently during the following centuries made contact with the Pueblos and Spanish through occasional trade and frequent skirmishing.

Understandably, many of the religious and cultural configurations which the Spanish people had developed during those many centuries of struggle with Islam traveled into the New World with the conquistadores and the settlers who were their heirs. Here, of course, the attitudes had to be reapplied, brought to bear upon situations that no longer had to do with the Muslim "infidels"; but very many of the old Spanish patron saints against Moorish problems became Americanized

on the New Mexico frontier as patrons against Indian problems. This conversion was a development unlike what happened in Mexico where, as Eric Wolf notes in *Sons of the Shaking Earth,* the Aztec diety Hummingbird-on-the-left, a fearsome warrior god for all his dandified name, "became a Spanish Saint James riding down upon the heathens."[1] By far the greater part of the adjustment of Catholicism was made in New Mexico by the Spanish people themselves, and not by the indigenous Indians who accepted Christianity while continuing to live as Indians. The present chapter will offer some tentative hypotheses about the New Mexico reapplication of three important holy persons, Our Lady of Guadalupe, the Holy Child of Atocha, and Santiago, the same Saint James who became syncretized in Mexico with the Aztec deity.

Our Lady of Guadalupe is shown in the famous original picture as a woman of rather Indian features standing in a body halo, supported upon a dark upturned crescent and a winged angel. The story attached to the origin of the picture bears repeating. An Indian peasant, Juan Diego of the village of Tolpetlac, was walking in to hear mass at Tlatelolco, a suburb of Mexico City, in the early hours of December 9, 1531, when he heard beautiful singing and saw a bright cloud atop a hill which formerly had been held sacred to Tonantzin, an Aztec earth and fertility goddess associated with the moon. A voice from the bright cloud summoned Juan Diego to draw nearer, and when he did so he beheld a woman whose brilliance made the rough rocks and the cactus and bramble bushes on the hilltop seem like jewels. She identified herself to him as the Virgin Mary and promised her help to the native peoples if the bishop would build a temple on the hill.

[1]Eric R. Wolf, *Sons of the Shaking Earth* (Chicago: University of Chicago Press, 1959), p. 170.

Juan Diego took her message to the bishop as instructed, but the prelate disbelieved the story. Juan reported to the lady that evening on his way homeward; she responded by asking him to try again the next day, despite Juan Diego's suggestion that she send someone more noble and influential than he.

The next interview with his grace did not go much better than the first, as Juan Diego reported to the lady at a third apparition. She promised to respond to the bishop's demand for a sign, telling the Indian to return the following morning. This Juan Diego was unable to do, for his uncle was very sick and Juan Diego spent all day caring for him; and when his uncle took a turn for the worse during the night and seemed about to die, Juan Diego set out at daybreak to get a priest to administer the last rites of the Church. As he approached the hill, Juan Diego tried to skirt it as widely as possible so as to avoid the woman, but she was waiting for him anyway. She assured him his uncle was cured, instructed him to climb to the top of the hill and pick the roses he would find on a miraculous bush, and arranged them in his tilma when he returned to her. He took them to the bishop, and when he loosened the tilma to drop roses before him, the likeness of Our Lady of Guadalupe was displayed upon it.

It should be noted that the four-part structure of the apparition-sequence, often represented by small vignettes at the corners of New Mexican santero paintings, and the four-day time span of the story, suggest strongly that the basic account of the apparition was composed not by a European, for whom the third time and the third day is the "charm," but by an American Indian, who would have been familiar solely with tales of a strong four-part structure.[2]

[2]On the survival in New Mexico Spanish folk tales of the European three-part pattern, see George Mills and Richard Grove, *Lucifer and the Crucifer: The Enigma of the Penitentes* (Colorado Springs: Taylor Museum, 1966), p. 40.

The two most significant attributes of the picture of Our Lady of Guadalupe are the moon upon which she stands and the angel who supports the moon. The moon is mythologically associated with monsters, with bulls (because of their crescent-shaped horns), and with female deities; there is a presumptive connection, either positive or negative or both, to Tonantzin, the Aztec goddess of earth, fertility, and the moon, and who was mentioned by the Franciscan friar Bustamante in 1556 when he strongly attacked the devotion to Our Lady of Guadalupe as spurious and named the Indian artist he claimed had painted the picture.[3] The moon also has certain associations with snakes: "The serpent, born from itself when sloughing its skin, is symbolic of the lunar principle of eternal return."[4] This relationship suggests Quetzlcoatl, the winged serpent deity of Aztec religion, as does the most plausible explanation of the name Guadalupe: *coatl llope,* "snake" "to tread on," rationalized by the Spanish into the name of a Spanish statue of the Virgin in Extramadura, the Spanish province which supplied many of the New Mexican settlers. The Spanish statue was invoked against the Moors.[5]

The blackness of the crescent may readily be taken to suggest the death of Quetzlcoatl and/or Tonantzin at the coming of the Christian madonna; there is in this connection very likely some transfer from the Spanish situation to the

[3]Eric R. Wolf, "The Virgin of Guadalupe: A Mexican National Symbol," in William A. Lessa and Evon Z. Vogt, eds., *Reader in Comparative Religion* (New York: Harper and Row, 1965), p. 227; Francis Huxley, "The Miraculous Virgin of Guadalupe," *International Journal of Parapsychology* 1 (1959), 22.

[4]Joseph Campbell, *The Masks of God: Oriental Mythology* (London: Secker and Warburg, 1962), p. 276. In representations of Our Lady of the Immaculate Conception, snake and moon are interchangeable. See also Gilbert Durand, *Les Structures anthropologiques de l'imaginaire* (Paris: Presses Universitaires de France, 1960), pp. 340-41.

[5]Donald Demarest and Coley Taylor, *The Dark Virgin* (Freeport, Maine: Coley Taylor, 1956), p. 28. The Spanish Guadalupe (of which I happen to have a French print in a 19th-century New Mexican soldered tin-and-glass frame) shows the Virgin holding the Christ Child, and was supposed to have been carved by Saint Luke.

100

Mexican: as the Spanish Guadalupe aids in conquering the military-religious foe and coercing the Moors — for whom the crescent moon was the preeminent symbol — into Christianity, so the Mexican Guadalupe helps subdue the Indian military and religious systems. In New Mexico this characteristic was applied to any local Indians who were not as Christianized and as obedient as the Spanish thought they ought to be. Thus, although the Pueblo Indians would have been taught by the missionaries to call upon the Señora de Guadalupe as their special patron, insofar as they continued to practice their old rituals and keep their kivas — ceremonial chambers — the Spanish assimilated them to the Moors; thus when the question of taking over a kiva for use as a chapel arose, de Vargas argued "that there were a number of churches and cathedrals in Spain which were formerly Moorish mosques."[6]

The angel initiates another train of associations. Angels seem originally to have been connected, as serpents were, with lightning and rain, and to have served as local manifestations of an elemental sky-god. The angel is also related to the snakelike phallus, particularly in the erotes (winged putti) of Roman funerary art, and in Eros (Amor, Cupid), a personification and deification of masculine erotic drives.[7] The angel's role as messenger (Greek *aggelos*, messenger)

[6]J. Manuel Espinosa, *Crusaders of the Rio Grande* (Chicago: Institute of Jesuit History, 1942), pp. 153-54; there is a hint in the same direction with regard to the Comanches in a volume by this writer's equally eminent brother, Gilberto Espinosa, *Heroes, Hexes, and Haunted Halls* (Albuquerque: Calvin Horn, 1972), p. 27.

[7]Gunnar Berefelt, *A Study on the Winged Angel* (Stockholm: Almquist and Wiksell, 1968), p. 57. An interesting set of transvaluations of gender is suggested by the Old Pecos Bull Dance performed at Jemez Pueblo every year on August 2. The day is the feast of Portiuncula, a title of Our Lady of the Angels, which was the name of the church at Pecos Pueblo (the people from there joined the Jemez Pueblo in 1838). In being associated with angels in a positive fashion, Our Lady assumes a sort of masculine aspect; the bull involved in the dance is a seriocomic monster figure which, through it is masculine, gains a feminine cast through its crescent-shaped horns.

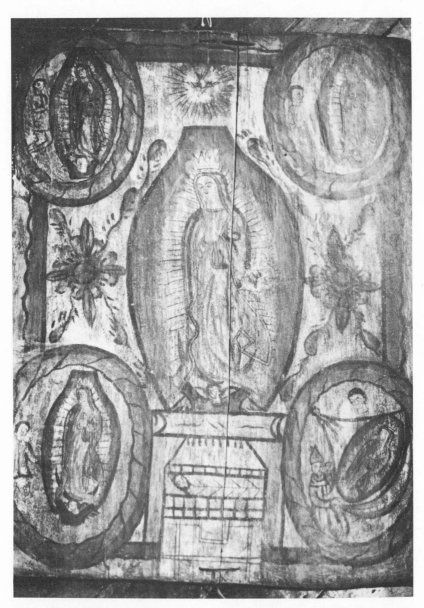

*Our Lady of Guadalupe (#33 in Appendix A), by José Aragón. There
is a bit of accurate perspective in the lines at the head and foot of the
open coffin below the main figure. See page 25, and compare illustra-
tion on page 42. From a private collection, with permission.*

suggests comparison with Hermes, the messenger of the Greek gods and personification of masculinity (cf. "hermaphrodite"; stone herms; his association with Athene, Hera, and Aphrodite; his winged heels and serpent-twined caduceus): he is a winged serpent himself, and admirably suggests that the angel in the Guadalupe picture may, along with the moon, symbolize Quetzlcoatl, not so much supporting the Virgin as being trampled by her, the dangerous and evil masculine being subdued by the powerful feminine.[8]

It has been widely believed that Nuestra Señora de Guadalupe was only a Mexican devotion and was not popular in New Mexico during the last century. When I was nearly

[8]In this speculation, I do not want to suggest that overt sexuality consciously recognized by the people involved was part of the Guadalupe cult; my position here is just that of Erich Neumann's disclaimer in *The Origins and History of Consciousness* (Princeton: Princeton University Press, 1970), pp. 150-151: "Our retrospective psychological interpretation corresponds to no point of view consciously maintained in earlier times; it is the conscious elaboration of contents that were once extrapolated in mythological projections, unconsciously and symbolically." What I have done is to make explicit and thematic what I hypothesize to be contained in the Guadalupe picture, but heretofore to have been only implicit and prethematic.

I would like to bolster the case I have tried to make by referring to the terrible ambiguity of the image of the serpent throughout world cultures. The serpent first appears in the Judaeo-Christian tradition on the tree of life—as Durand notes, "the guardian, the thief, or the keeper of the Herb of Life in Semitic legend" (p. 341, my translation); it next appears as the brazen serpent, also on a tree, saving the people from the bites of the saraphs, the burning serpents who are etymologically and symbolically related to the seraphs, the burning angels. In the same part of the world, the serpent is an attribute of the Magna Mater, as Neumann points out (pp. 48-49); the equivalent figure in Chinese myth, the dragon, is also benevolent (Mircea Eliade, *From Primitives to Zen* [New York: Harper and Row, 1966], p. 243).

But just as the serpent can have a double aspect, so the feminine may, as Ari Kiev explains in his book on Texas-Mexican folk medicine, *Curanderismo: Mexican-American Folk Psychiatry* (New York: Free Press, 1968), p. 164; speaking of overly indulged youngest children feeling abandoned when the next sibling arrives, Kiev says: "It is no doubt partly because of such experiences that mother figures remain in fantasy as both dangerous brujas [witches] and all-loving Virgins, representing both the repressed hostilities toward the rejecting mother and the unsatisfied longings for the pleasant, bygone dependency. If a child cannot turn to an all-accepting mother, he may turn to the Virgin for acceptance and favors." No wonder Durand calls the serpent, both masculine and feminine, both good and evil, both death and life, "the living correlative of the labyrinth" (p. 344).

finished with my census of a thousand santos by subject, I was speaking with a very knowledgeable New Mexican lady who, when I told her of my project, commented that I would not find very many Guadalupes. I had to reply that that was what I myself had thought when I began, but that I was finding Guadalupe to be the second most numerous title of the Blessed Virgin, and trailing Nuestra Señora de los Dolores, with all her Penitente connections, by only three examples, fifty-three to fifty. It would be possible indeed to show from the statistics that if examples not dated were distributed proportionately, Nuestra Señora de Guadalupe was the most popular title prior to 1850, and declined in favor only afterwards.[9] The great popularity of Our Lady of Guadalupe is further substantiated by the research of Professor T. M. Pearce, who notes in his article "Religious Place Names in New Mexico" that "the largest number of place names honoring the Mother of Christ are the eight localities identified as Guadalupe"; my own count, using Professor Pearce's book *New Mexico Place Names: A Geographical Dictionary,* corroborates his findings on the basis of his own fuller and later evidence.[10] So whatever the power of the psychological overtones of the moon and the angel in the pictures of Nuestra Señora de Guadalupe, it must be concluded that despite the profound differences in culture between Old Mexico and New Mexico upwards of a hundred years ago, on this point at least there was a decided affinity of religious devotion and practice.

The Spanish population of New Mexico is very largely mestizo, by reason of the fact that the groups which founded the colony in 1598 and refounded it in 1693 contained some

[9]The statistics are: N.S. Dolores—53 = 10, 34, 7, 2; if the final figure were statistically absorbed by the others, it would give 46 prior to 1850; N. S. Guadalupe — 50=16, 24, 2, 8, which would revise to a total of 48 before 1850.

[10]T. M. Pearce, "Religious Place Names in New Mexico," *Names* 9 (1961), 3; *New Mexico Place Names: A Geographical Dictionary* (Albuquerque: University of New Mexico Press, 1965).

Mexican mestizos and Mexican Indians; by reason of inter-
marriage with the Pueblo Indians; and by reason of inter-
marriage with *genízaros,* Indian freedmen and women sent
out in groups to found towns of their own, often in dangerous
areas. This last group, though they were pure-blooded Ind-
ians, were living Spanish-style and had given up all truly
Indian customs; any Indian who wanted to live as an Indian
would have contrived to do so, either in an Indian tribe on
the fringes of the New Mexico area or in a Pueblo Indian
town. There was no way of "living mestizo." A given family
either spoke Spanish as their first language, lived in a Spanish
town, and worshiped in the Catholic-Penitente fashion, or
they spoke an Indian language, lived with Indians, and par-
ticipated in the Pueblo dances (along with being Catholic) or
in the Navajo or other Indian rituals.

The mixed implications of these facts to the myth of
the Indo-Hispano kingdom of Aztlán are not far to seek, es-
pecially when one understands within their context what has
been said about Nuestra Señora de Guadalupe and her re-
lationship to Moors and the uncooperative Indian tribes.
However much the Spanish in New Mexico may have been
racially an Indian-Hispanic mixture or even in some cases
pureblooded Indian, they thought themselves to be both cul-
turally and racially Spanish, *la gente de razón* as against the
"unreasonable" Indians, and even, perhaps, more Spanish
than the majority of Mexicans, who were (though unknown
to the New Mexicans and even to themselves) involved in
various kinds of "folk Catholicism," Indian religious practices
with a veneer of Catholic nomenclature and additives such as
was suggested above by the uniting of Hummingbird-on-the-
left and Santiago. The New Mexicans were wrong in think-
ing of themselves as non-Mexican; the groups who came to
settle in northern New Mexico in 1598 and 1693 were not
peninsulares and *creoles* exclusively. Secondly, the ties of the

New Mexico Spanish to the local Indians were quite strong, as is suggested by a statement of Don Pedro Bautista Pino in 1812, "Spaniards and pure-blooded Indians (who are hardly different from us) make up the total population of 40,000 inhabitants."[11] Thirdly, the ties to Mexico were strong, as is suggested by the great popularity of Nuestra Señora de Guadalupe, and this popularity did not significantly diminish after her identification with the abortive revolution of 1810-11, begun by Padre Hidalgo's famous *Grito de Dolores* and finally emerging as a movement by some of the *criollos,* mestizos, and Indians against the *peninsulares,* the hated Spain-born *gachupines.* Since the statistics for the chosen patroness of the *gachupines,* Nuestra Señora de los Remedios (de Socorro), are very low in comparison with those for Guadalupe, two as against fifty, it is clear that the New Mexicans did not suddenly identify with the Spanish against the Mexicans.[12]

The break from Mexico, initiated by the American war of expansion, made official by the Treaty of Guadalupe-Hidalgo in 1848, and apparently recognized by the New Mexicans as a fact in their religious lives (if we can draw this conclusion from the decline statistically in the production of Guadalupe santos), took a giant step in the 1910s and 1920s. During these years, immigration from Mexico was very high due to continual political unrest, and simultaneously immigration of Texan Anglos, with their heritage of prejudice against Catholic Mexicans heightened by a revival of Ku Klux Klan activity, brought three groups into close and often difficult contact. Partially to avoid being classed by the Texas types with the Mexican immigrants, the New Mexico Spanish began

[11]H. Bailey Carroll and J. Villasana Haggard, translators and editors, *Three New Mexico Chronicles* (Albuquerque: The Quivira Society, 1942), p. 9.

[12]Hugh M. Hamill, *The Hidalgo Revolt* (Gainesville: University of Florida Press, 1966), pp. 161, 178-79.

to emphasize (and indeed over-emphasize) the very real cultural and even racial differences between the two Spanish-heritage groups. Hence "it was also in the years immediately following World War I that the term 'Spanish-Colonial' first came into general usage" to differentiate the New Mexicans from the immigrants newly arrived from Old Mexico; "Spanish-American" appeared at the same time.[13] To sum up the question of the New Mexican relationship to the myth of Aztlán, it would seem that the truth of the matter lies somewhere in the vast area between my presuppositions about Nuestra Señora de Guadalupe when I started my project, and the assumptions of the proponents of the Aztlán myth, who seem to assume that there is no significant difference among the Spanish-speaking groups in the whole Southwest — that they share a common Indo-Hispanic heritage which includes inheritance of the ancestral territory. It must be said that the proponents of Aztlán are mainly urbanized Spanish, and that there is indeed little important difference in the city experience whether one comes from a New Mexican village, a Mexican village, a Texas farm — or indeed, from Puerto Rico or Cuba; one suffers the same dislocations and indignities, and these may well serve as a common bond among people of greater cultural diversity than the various Spanish groups: the far more diverse Indians have had to realize their need to act together for cultural survival of any sort. If the myth of Aztlán reaches back before the First World War and especially before the Mexican-American War, it will find in the New Mexican devotion to Nuestra Señora de Guadalupe and in the New Mexicans' general view of themselves and

[13]Nancie L. Gonzalez, *The Spanish-Americans of New Mexico* (Albuquerque: University of New Mexico Press, 1969), p. 80; see also pp. 203-04, where Miss Gonzalez cites Erna Fergusson and Mary Austin on the appearance of the term "Spanish-American" in the same decade. See also Matt S. Meier and Feliciano Rivera, *The Chicanos: A History of Mexican Americans* (New York: Hill and Wang, 1972), pp. 113-14.

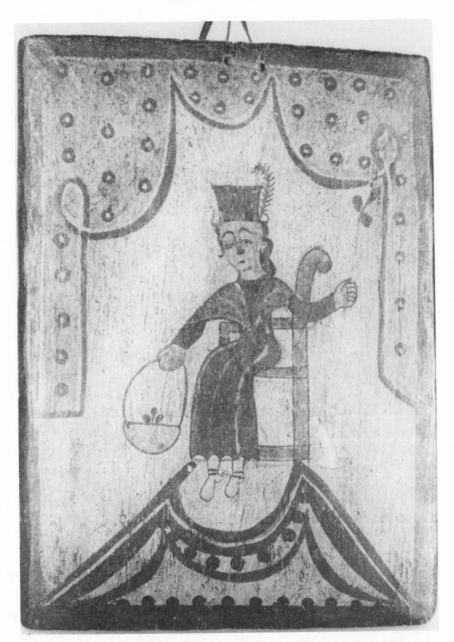

The Holy Child of Atocha (#7), by the Santo Niño Santero. Courtesy of the Museum of New Mexico.

their relationships to the people of Mexico and the local Indian pueblos enough evidence to warrant including New Mexico in Aztlán.

In her book *Saints and Saint Makers of New Mexico*, E. Boyd gives an extensive account of the Santo Niño de Atocha. "In the city of Atocha, in Spain, many Spanish Christians were imprisoned during the later years of the Moorish occupation. The Moorish conquerors forbade all persons to enter the prison on errands of mercy excepting little children. Not even priests were permitted to bring consolation by the dying. The mothers and wives of these prisoners, knowing that they lacked sufficient food and water, as well as spiritual consolation, prayed daily and passionately for Divine aid in permitting some way of bringing comfort to those in captivity.

"One day a child, dressed like the pilgrims of that time, came into the prisons carrying in one hand a basket and, in the other, a staff with a gourd full of water at its tip. To the astonishment of the Moors, the gourd and the basket of bread still were not empty after all of the captives had been served and each one, as he received his portion, received also a blessing. According to the legend, Christ had returned in answer to the prayers of the women of Atocha. As a child, He came to serve those without spiritual and earthly help."[14] As a result of such activity as this, the Santo Niño de Atocha became the patron of travelers and captives. Miss Boyd, in subsequent pages, gives the story of a New Mexican child who was delivered out of captivity by the help of the Santo Niño, and mentions that since many New Mexican soldiers were in Bataan at the beginning of World War II, and were on the infamous Death March, there was great devotion to the Santo

[14]E. Boyd, *Saints and Saint Makers of New Mexico* (Santa Fe: Laboratory of Anthropology, 1946), pp. 126-27. There is a church of Nuestra Señora de Atocha in Madrid, of which city the locale of Atocha is a faubourg.

Niño during their captivity. It may be added that there have been a good many vows fulfilled by pilgrimages to the shrine of Chimayó, where there is a great devotion to the Santo Niño, even in the recent years of the Vietnam War. And an informant told me that his uncle Gerónimo, in about 1870 at the latest, was captured by the Pananas (the Pawnee Indians) in the vicinity of Mora, New Mexico, which lies open to the Great Plains. The Indians confined Gerónimo in a sinkhole of some sort, where he spent the time in fervent prayer for rescue to the Holy Child. Suddenly, the Niño appeared and dropped a string down to him, telling the young man to take hold of it; when he did so, the Niño raised him from the deep hole. The child then led him to water and gave him some bread, and conducted him back to the nearest Spanish settlement.

Plainly then, due both to the story attached to his original appearance and to the miracles he worked in New Mexico during the last century, the Santo Niño de Atocha was patron against harms that had befallen prisoners and that might befall travelers, who were always in danger in the colony of being taken prisoner by the roving bands of unChristianized Indians as the Christian Spanish during the middle ages were by the unChristian Moors. As such, the Holy Child seems to be a sort of younger-brother figure who saves from perilous enclosure; this last motif will be created more at length later in connection with monsters.[15]

Santiago, Saint James the Greater, is the patron saint of horsemen, and as such he is, along with San Rafael the patron of fishermen, the only Christian saint really integrated into the Tewa Pueblo mind, for as Alfonso Ortiz tells us in

[15]If the Niño is a younger-brother figure, then San Miguel and Santiago, both to be treated, would be elder-brother figures. For comparable oral-phase material, see my "Oral Patterning of the Cyclops Episode, *Odyssey* IX," *The Classical Bulletin* 48 (1972), 54-56.

The Tewa World, the other needs of the pueblo people were already covered adequately by their own gods and goddesses.[16] But with the importation of horses into the new world, Santiago began to practice his patronage for peoples previously unfamiliar with such animals.

Santiago's principal role in the colonial era of Spanish New Mexico was to oversee the control of the wild Indians; he was the heavenly embodiment of the successful Spanish military struggle against the Moors which, as Irving Leonard points out in his *Books of the Brave,* "engendered a glorification of the warrior even more pronounced than elsewhere in Europe, particularly since the fighting man was a crusader against a pagan faith. In these struggles individual combats were frequent, and in them the successful contestant won fame and was quickly enriched by the booty. Such rewards were far quicker and more satisfying to personal pride than those of the slower and less spectacular ways of agriculture and the handicrafts, and inevitably there emerged the false concept that soldiering was the highest calling and the deeds of war were the duty and almost the sole honorable occupation of manhood. . . .

"The Spanish reconquest of the Peninsula from the Moorish invaders had associated the more methodical development of agriculture and the manual crafts of the latter with a debased paganism and an infidel religion. To the Christian crusader these practical activities and hard labor were suitable for the enemies of God and a befitting badge of servitude."[17]

It may be suspected that it was the Spaniards' trying to make this ethic a reality in seventeenth-century New Mexico

[16]Alfonso Ortiz, *The Tewa World: Space, Time, Being, and Becoming in a Pueblo Society* (Chicago: University of Chicago Press, 1969), p. 156.

[17]Irving A Leonard, *Books of the Brave* (Cambridge: Harvard University Press, 1949) pp. 5-6; copyright President and Fellows of Harvard University, 1949.

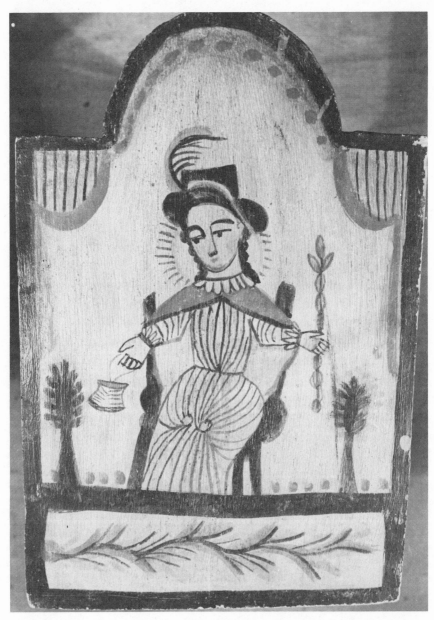

The Holy Child of Atocha (#7), by Rafael Aragón. Courtesy of the Museum of New Mexico.

that brought about the Pueblo Rebellion of 1680. If so, it was doomed to be a try that failed, because among other things the Spanish did not have the firepower or the manpower especially of soldiers to continue to impose a tyranny upon the Pueblos. From the time of the foundation in New Mexico the Crown "had forbidden the manufacture of arms in the colonies and had severely limited the importation of them from the homeland," and up to 1812 gunpowder, which Pedro Bautista Pino claimed could have been made in New Mexico, had to be imported from Mexico under high duty.[18] There were only a hundred and twenty-one soldiers in the colony paid by the crown, so when there was any significant Indian activity at all, the settlers had to volunteer, having to report "with horses, rifles, pistols, bows, arrows, and shields. Likewise, they must pay for their own ammunition and the supplies needed during the time they are under arms, which is usually a period of forty-five days; sometimes, however, there are two or three months of continuous and cruel warfare against wild tribes." And Pino goes on to complain that the Spanish who are born in New Mexico are seldom given positions of command or even suitable promotions.[19] This milieu of citizen-solidiery, armed with bows, arrows, and guns shooting their own powder, is hardly what the conquistadores had in mind.

But Santiago became their patron as surely as he was that of the professional soldier. He had appeared in Spain as early as at the battle of Clavijo in the ninth century, and is described at the battle of Xerez, fought by King Ferdinand III — San Fernando — in the thirteenth century as appearing "on a white horse, with a white banner in one hand and a sword in the other, accompanied by a band of cavaliers in

[18]Leonard, p. 242; Pino in Carroll and Haggard, p. 68.
[19]Pino in Carroll and Haggard, pp. 68-69.

white."[20] And he appeared in the New World fourteen times in aid of Spanish military enterprises, and one of these appearances was at the battle of Ácoma in the very first year of the colony's existence. In January of 1599, the Indians of this pueblo were defending their town, built on its hundred-foot-high rock mesa, against a punitive expedition led by Zaldivar; the Indians testified after they had lost the battle that during it they had seen a very brave soldier fighting among the Spanish whom they could not find after the battle was over. According to Gaspar Perez de Villagrá's recounting of the episode in his versified *History of New Mexico,* they described "a noble Spaniard who was foremost in every encounter. They say he was mounted on a white steed. He had a long white beard, bald head, and carried a flaming sword in his right hand."[21] And a source even closer in the event, a letter of one Alonzo Sanchez of February 28, 1599, describes "someone on a white horse, dressed in white, a red emblem on his breast, and a spear in his hand."[22] And so, domesticated in New Mexico as he had been in Spain, and with the ready transfer from Moors to uncooperative Indians made in the first year of the new colony's experience, Santiago is ready to serve the outlying colony as he had the mother country, as patron of soldiers attacking the unChristian enemy.

[20]Washington Irving, *Spanish Papers* (New York: G. P. Putnam's Sons, n.d.), p. 468.

[21]Gilberto Espinosa, transl., F. W. Hodge, ed., *History of New Mexico* (Los Angeles: Quivira Society, 1933), p. 264. This description led Hodge in his notes (p. 268) to follow George P. Hammond, *Juan de Oñate and the Founding of New Mexico* (Santa Fe: El Palacio Press, 1927), p. 120, in identifying the personage as either Santiago or Saint Paul. I do not believe there should have been any need for doubt that it is Santiago, even though the sword is indeed an attribute of Paul. —Incidentally, Villagrá was bald.

[22]George P. Hammond and Agapito Rey, *Don Juan de Oñate, Colonizer of New Mexico* (Albuquerque: University of New Mexico Press, 1953), p. 427. See also Benjamin W. Read, *Illustrated History of New Mexico* (Santa Fe: New Mexican Printing Company, 1912) p. 229, and Mrs. William T. Sedgwick, *Acoma, the Sky City* (Cambridge: Harvard University Press, 1926), p. 84.

New Mexico Reapplication of Saints

In addition to Our Lady of Guadalupe, the Holy Child
of Atocha, and Saint James, there are some lesser patrons
against the Indians: the Flight into Egypt, the Christ Child
lost in the Temple, Our Lady of Atocha, Saint Longinus,
and Saint Peter. San Longino joins Santiago as a military
man; The Flight into Egypt, Nuestra Señora de Atocha, San
Pedro and the Niño Peridido join the Niño de Atocha in
seeing to the release of those taken prisoner by the Indians
— San Pedro being the keeper of the gate of heaven becomes
a psychopempsoi, a soul-conductor, like Hermes-Mercury of
classical mythology.

These eight saints taken together account for 10.4% of
the total santo sample of a thousand. Subtracting the number
of santos which cannot be chronologically assigned leaves a
total of ninety-two, of which 27 are from the earliest period,
51 from the middle, and 14 from the final period, from 1850
to 1900. This last number is 15.2% of the total of ninety-
two, slightly less than the figure of 17.9% for the sample as
a whole. This reduction may be a result of the greater pro-
tection from wild Indians afforded to the Christianized area
of New Mexico by the United States Army subsequent to
1850, and the consequent relaxation of a very real source of
unease, but it is unlikely. The santos of Nuestra Señora de
Guadalupe and the Niño de Atocha comprise the vast majority
of the sample of ninety-two and as the Guadalupe became
less popular (and we have seen other reasons which can be
conjectured for that decline) the Niño de Atocha became
more popular, probably rather as a defense against illness (for
which he is a powerful protector) than as a savior from cap-
tivity; but their unstable popularity with its various possible
springs renders the sample itself dubious and the remainder
of it — the twenty-eight total of which three are in the latest
period — too small to be trusted. At the end of such a great
deal of conjecture as this chapter has contained, it is not to

115

be expected that statistics will come riding in like the U.S. Cavalry in a cowboy movie, to save the conclusions from the Injuns.

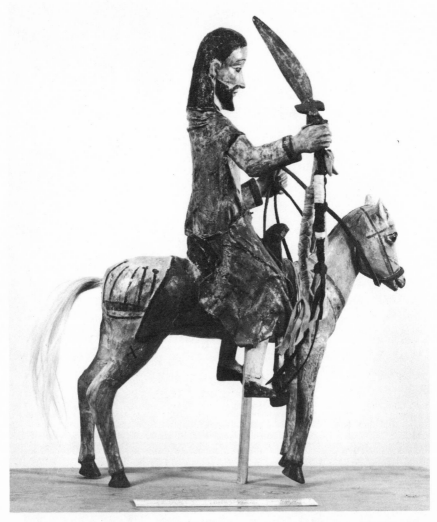

Saint James the Apostle (#115), by an anonymous santero. This bulto of Santiago was listed in the inventory of the Santuario of Chimayó in 1818 and may still be seen there; it is mentioned by Willa Cather in Death Comes for the Archbishop. *Photo courtesy of the Museum of New Mexico.*

CHAPTER VI

God, Virgin, Angels, Saints

T he eighty subjects which were the material for the questionnaire (see the asterisked personages in Appendix A) and the hundred and forty-odd subjects who made up the santero's gallery fall into four main groups: God the Father, Christ, and the Holy Spirit; titles of Mary; the angels; and the male and female saints. The present chapter will detail the information, analysis, and speculation which had led me to conclude that, with exceptions as noted, these several groups of holy persons tend to operate at one of three levels of human need: the divine persons in the supernatural realm, the Virgin and the angels in the preternatural realm, and the saints in the natural.

The Trinity and most of the titles of Christ tend to be strongly associated with general and transcendent needs; the people commonly prayed to the Trinity, for instance, for enlightenment, favors of immediate need, thanksgiving, faith, harmony and peace, and protection against all enemies and temptations — and only in prayers for protection from storms and from "locusts, earthquakes, and famine" is the type of request (as contrasted with the concrete need) very highly particularized, and even then in the direction of acknowledging an elemental thunder-and-lightning sky-god like the one

who lies not very deep beneath the surface of Genesis, Exodus, and some of the older psalms. This last suggestion is corroborated by some intrinsic evidence: the Trinity is frequently represented by three equal men grasping a single bar, which though it is often or always a symbol of unity despite multiplicity, is occasionally portrayed as a lightning bolt.[1] The general and transcendent nature of the power of Christ, as the New Mexican people understood it during the last century, is suggested as well by petitions concerning the salvation of the world; acceptance of suffering; faith; pardon; sanctity; all needs; and a peaceful death.

God the Father, the Holy Family (Joseph, Mary, and the child Jesus; a kind of alternative Trinity in last-century New Mexico), and the Sacred Heart tended to be keyed more specifically to the fostering and protecting of the family. The most popular of the three, the Holy Family, was the most strongly keyed of these subjects to the needs of the family; the Sacred Heart was not very often represented by the santeros. The devotion to the heart of Christ had an older form in association with Santa Gertrudis (c. 1256-c. 1302), and forms part of her iconography; but the present devotion dates from seventeenth-century France. It becomes highly popular only in the latter part of the nineteenth century with the coming of more contemporary European pieties into the territory and especially with the introduction of Italian Jesuits after 1866. God the Father and Saint Joseph — whether by themselves or *en ensemble* — stand as strong father figures.

[1]Corroborated by E. Boyd, conversation of 10 aug. 1972. God the Father holds such a bolt in the Taylor Museum collection, #1232, shown in Robert Shalkop, *Wooden Saints* (Colorado Springs: Taylor Museum, 1967), p. 55; though on p. 54 the author identifies the item as merely a sceptre, it is far more likely a lightning-bolt used as a power symbol. The representation of the Trinity as three equal men, of Gothic origin, was forbidden by Pope Benedict XIV in 1745, but New Mexico seems not to have gotten the word; Shalkop, p. 60; Giovanni Dominico Mansi, *Epitome Doctrinae Moralis et Canonicae ... Benedicti XIV* (Rome: Sumptibus Remondiniansis, 1967), 17; reaffirmed by the Holy See, *Acta Apostolicae Sedis* 20 (1928), 103.

God, Virgin, Angels, Saints

It has been noted that certain representations of Christ are connected with the devotional practices of the Penitentes, the expiatory confraternity which has been mentioned above as practicing severe penances for the expiration of the sins of all the people of their village, climaxed by the reenactment of the crucifixion of Christ with one of the brothers being tied to the full-sized cross he had carried to the "Calvary." Especially apt to have strong or exclusive Penitente interest are the crucifix done in the Penitente mode spoken of already, Jesus the Nazarene (or of Nazareth), and Jesus Burdened with the Cross, particularly if the first two are statues with hinged shoulders so that they can be put like nearly-lifesized puppets through the various actions of the Passion, if they have blood coming from beneath the loin cloth, or if the corpus on the crucifix is a bluish color. At any rate, these artifacts were properly related to the Penitente concerns and in them Christ probably took on much of the father-figure status that is suggested by his Penitente title, Nuestro Padre Jesús Nazareno. It may be possible to read this paternal status into the Sacred Heart images just mentioned.

Christ as a child appears with his mother in various of her titles, with his parents in the Flight into Egypt and Holy Family tableaux, and by himself as the Santo Niño, the Santo Niño de Atocha, and the Niño de Praga. When Christ appears as an infant with Mary, he normally ought to be thought of as an attribute of his mother than as appearing in his own right. In the Holy Family and Flight into Egypt representations, the child is inserted into a family constellation as the son — though of course the "secret-father" and "hidden-life" associations complicate the son-archetype a great deal. As Niño and especially as Niño de Atocha and Niño Perdido, the Christ child operates as a figure in his own right, the patron of travelers, of those who are lost, and of those who are held captive — especially, as was noted in Chapter Five, by the

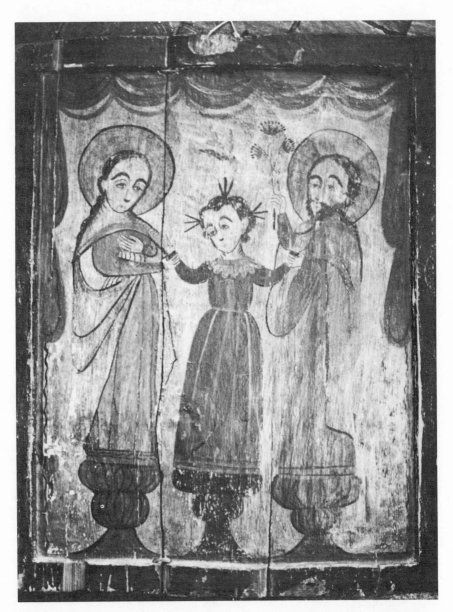

The Holy Family (#5 in Appendix A), by Rafael Aragón. The three bases upon which the figures stand like bultos are carefully if imprecisely modeled, but they simply merge at the bottom into the encircling border. From a private collection, with permission.

Indians. As such he operates as a younger-brother figure. When he is an adult, however, Christ participates fully in the transcendence of the godhead, and becomes as Chapter Three explained, the source of salvation, of Christian life everlasting, and consequently was styled Nuestro Padre.

When I began my questionnaire work, I expected a very great deal of information identifying the various titles of Our Lady (Nuestra Señora) as those of a material figure of a simply benevolent sort. But there was little of the merely sentimental in New Mexico devotion to Mary. The responses I in fact received suggest instead that the people petitioned her rather frequently for generalized and transcendent aid, less often indeed than either God the Father or Christ is asked for assistance in this realm, but more often with few exceptions than are the angels and the saints. Hence it may be suggested that the Madonna occupied in nineteenth-century New Mexican piety a position superior to that of the angels and saints but not equal to that of the Father or Christ: she was not deified, but she was regarded as superior to angels and to ordinary saints. Various specific requests connect with various titles. Our Lady of the Angels did assume a certain maternal aspect by implication, since (bracketing their deeper psychological connotations) angels were traditionally associated with the particular care of children, becoming as it were their powerful elder foster-brothers and indeed generally assisting all Christians of all ages. Our Lady of the Candlesticks (Nuestra Señora de los Candelarios) was associated with blessed candles and with Lent, and hence perhaps with Penitente activity.[2] Nuestra Señora de la Purísima Concepción

[2]Nuestra Señora de las Candelarias is the name mistakenly given to pictures of Nuestra Señora de San Juan de los Lagos (of Saint John of the Lakes, a shrine in Mexico) by nineteenth-century New Mexicans; cf E. Boyd and Frances Breese, *New Mexico Santos and How to Name Them* (Santa Fe: Museum of New Mexico, 1966); letter of E. Boyd, 27 July 1972. See items 29 and 45 in Appendix A for further information.

(of the Immaculate Conception) tended to be associated with purity, Nuestra Señora del Socorro (of Help) with curing illnesses, and Nuestra Señora del Rosario with consolation in bereavement. On the other hand, certain titles of Our Lady seem to have had Penitente connections: Nuestra Señora de los Dolores (of Sorrows) took a leading role in Penitente reenactments of the Passion; Nuestra Señora Refugio de Pecadores (Refuge of Sinners), for general reasons; and Nuestra Señora de la Soledád (of Solitude) represented Mary in grief for Christ after the Passion and Death — and Resurrection and Ascension. In this last title, Our Lady fits the archetype of the crone, the mother become widowed and childless, and in this title Our Lady assumes the role of patroness of elderly women living alone.

In certain of her forms, Our Lady took on the function of monster-controller. In this role, she appeared under the titles of Our Lady of Angels, of Mount Carmel, of Light, of the Immaculate Conception, and (by implication, as has been said) of Guadalupe. The first four Madonnas are all shown overcoming dangers of various sorts on behalf of mankind: Our Lady of Angels and of the Immaculate Conception with serpents at their feet, symbolizing her power over the devil; Our Lady of Light drawing a soul (an unclothed or scantily clothed child) from the mouth of a monster; and Our Lady of Mount Carmel appearing as an advocate of souls shown immersed in the flames of Purgatory. In general, this kind of symbolism needs to be associated with Freud's oral phase of development, but in the Catholic setting of last-century New Mexican piety it readily takes its place with notions of devils, Hell, and death. The whale-like monster of Our Lady of Light retablos is in effect the same whale that swallowed Jonah in the Old Testament and which as a sign of death formed the "sign of Jonah" in the New (Matthew 12:39; Luke 11:29); along with the snakes and flames, it holds

kinship with the lion which Carl Jung says is "an emblem of the devil and stands for the danger of being swallowed by the unconscious," and which Erich Neumann suggests "bears all the marks of the uroboros. It is masculine and feminine at once. The fight with the dragon is thus the fight with the First Parents, a fight in which the murders of both father and mother, but not of one alone, have their ritually prescribed place."[3] It must first of all be insisted that what is being spoken of here does not at all involve sex in the narrow sense of the word, but only gender, sex in the widest Freudian sense — if so much as that; see Neumann's Jungian introduction of the bisexual uroboros, the serpent swallowing its own tail, which symbolizes the undifferentiated consciousness which every human being conquers in his process of individuation, of establishing his self-identity. At any rate, there does appear again here a series of transvaluations of role, with Our Lady adopting the usually masculine task of conquering the monster, and the monsters, especially in the form of serpents, adopting feminine guises. Some of the most obvious complications of this material appeared in connection with Our Lady of Guadalupe.

Whether in her own person or through her close association with the suffering Christ, Our Lady in certain of her titles appears as monster-savior also in the Penitente songs, the alabados. Our Lady of Solitude is addressed as follows:

> your power is so great
> Against the wicked Satan
> That you save the souls
> From eternal fire. . . .

> If to Purgatory our colleagues go,
> We pray you, Oh Mary,
> That you immediately save them.

[3]Carl G. Jung, *Psychology and Alchemy* (New York: Pantheon, 1953), p. 172; Erich Neumann, *The Origins and History of Consciousness* (New York: Pantheon, 1954), p. 153.

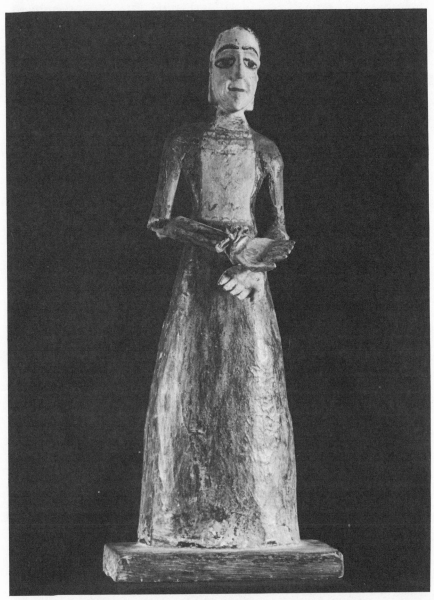

Our Lady of Solitude (#48), by José Benito Ortega. This bulto, hinged at the elbows, was probably meant to be clothed in the nun-like garments it was imagined Mary wore after the deaths of Joseph and Jesus. Charles D. Carroll Collection, courtesy of the Museum of New Mexico.

The Virgin of Mount Carmel is shown in santero art holding her scapular, a religious item made of cloth and string and worn around the neck to symbolize dedication to the Señora de Monte Carmen. A Penitente alabado addresses her thus:

> Your scapulary is the
> Sacred chain
> With which the big dragon
> Can be bound.

To Our Lady of the Immaculate Conception, shown in the santos either standing on a serpent or a crescent moon, the Penitentes sang these stanzas:

> May your will save us
> From that cruel serpent
> That aims to destroy us. . . .
>
> Being the beloved daughter
> Of the Holy Heavenly Father
> Save us from the hands of Satan. . . .
>
> Satan finds himself
> In greater pain,
> Since Mary binds him
> With stronger chains.[4]

Thus the Lady stands very conspiciously to the forefront in the scheme of salvation according to New Mexican folk theology, but she does not so much provide positive benefits as remove the dangers, Satan and Hell and their various serpent and monster symbols.

As has been suggested in connection with the angel in the Guadalupe representation, this species of being serves as

[4]Laurence F. Lee, "Los Hermanos Penitentes," *El Palacio* 8 (1920), 13, 14, 15-16.

God's messenger or his theophany, and relates to lightning, serpents, and a quite ambiguous masculinity. Of the four angels represented in New Mexican folk art, the Guardian Angel and San Gabriel are infrequently represented: of the nine Gabriels, five were originally attached to crucifixes, holding a cup under the wound in the side of the dead Christ.[5] Rafael is a fine soul-guide type (psychopempsos), as in the Book of Tobit where he operated as traveling companion, monster-guardian, and healer for the human placed in his care.

San Miguel Arcangel is a more specified guardian, connected consistently with battle against evil and especially against the devil. This function of his derives from the Apocalypse of the New Testament: "Michael and his angels fought against the dragon" (Rev. 12:7), and manifests itself in the usual portrayal of Michael standing on a serpent — in New Mexico, often a giant rattlesnake — treading it down as Guadalupe does. It is interesting to speculate that in this characteristic Michael joins the Blessed Mother under the titles of Angels, Light, Mount Carmel, Immaculate Conception, and Guadalupe in being a specific protector against cosmic dangers — devils, Hell, the irruption of the unconscious, the fearsome unknown agencies that a pretechnological people cannot hope to defend itself against and prefers not even to think about. That Michael and Mary work together against these forces is strongly suggested by the lettering on a Fresquís retablo of the archangel: "Lord Saint Michael,

[5]This is my identification; it is suggested by Gabriel's association with the start of Christ's earthly life in being the messenger of the sky-god's fertility and by his attribute of a chalice when he is not attached to a crucifix (though, incidentally, he usually appears only as one of the three major archangels in a painting or reredos; see Denver Art Museum collection, A.US.18.XIX.110; José Aragón reredos in the Santuario at Chimayó, identified as item h of reredos A in Stephen F. Borhegyi, "The Miraculous Shrines of Our Lord of Esquípulas in Guatamala and Chimayó, New Mexico" [Santa Fe: Spanish Colonial Arts Society, 1956], p. 26).

First Colonel of the Squadron of Most Holy Mary, Defend Us."[6]

The majority of the santo subjects are male and female saints, holy men and women from the earliest days of the Christian era — and some few from the Old Testament period — down to the sixteenth and seventeenth centuries. By and large, these saints prove to be far less generalized and transcendent in their function than are most of the titles of God and Christ, and far less concerned with protection from cosmic evil than the archangels and the titles of Our Lady studied above.

There is almost no monster material among these saints; the exceptions to this rule are four: Jerome, Ignatius Loyola, John Nepomucene, and Procopius. San Gerónimo is almost always shown with a lion at his feet, deriving from a European convention of iconography where the lion is a benevolent animal from whose paw the saint had removed a thorn, and who in gratitude acted as wrangler for the monastery's donkey. The application of the traditional Androcles-and-the-lion tale to Jerome suggests of course a reversal of the division between man and animal that began with the original sin; this kind of story is to be expected in connection with monastic situations, which aspire to be restorations of Eden, reconciliations of man with God, with other men, and with subhuman nature. But since in New Mexico the santeros were so unfamiliar with lions that in the development of their tradition

[6]Erich Neumann, p. 162, refers to the destructive maternal-unconscious as "the archenemy of the hero who, as horseman or knight, tames the horse of unconscious instinct, or, as Michael, destroys the dragon. He is the bringer of light, form, and order out of the monstrous, pullulating chaos." Walter J. Ong, S. J., conjectures that the Romantic movement became possible only when Western learning and technology had advanced enough that men could "face into the unknown with courage or at least equanimity as never before." *Rhetoric, Romance and Technology* (Ithaca: Cornell University Press, 1971), p. 278; see also Chapter Four of this book. The Fresquís retablo is #2865 of the Museum of New Mexico collection.

the lion turned into something of a monster, Jerome may be taken to have a monster-control function along with his job as patron of penance. Further, what is usually taken to be the trumpet of God's voice sounding in his ear has sometimes been identified as the trumpet of Gabriel announcing the end of the world; one respondent identified Jerome as patron of orphaned children, a task compatible with angelic qualities; if there is anything to either of these hypotheses, then the angelic associations could reinforce the saint's status as protector against diabolical forces.

San Ignacio became for New Mexican Spanish of past centuries a protector against witchcraft — so far as I know, this is a duty which does not fall upon him elsewhere in the Christian world — but in the New Mexican system, this would make Ignatius a kind of defender against monster-power. Juan Nepomuceno is shown once with a dragon in santero art, but usually there is no such attribute involved. San Procopio, shown in the few santos of him that are extant with a doe which took refuge with him when it was pursued by hunters, sometimes appears to be in the company of a monster of some sort, since the "doe" has often been metamorphosed into a misshapen and deformed creature.

Certain of the representations of Christ and Mary have already been mentioned as being connected with Penitente concerns — Jesus the Nazarite (or of Nazareth), Jesus Carrying the Cross, certain of the crucifixes; Our Lady of Sorrows, Our Lady Refuge of Sinners, Our Lady of Solitude. A goodly number of the saints possess similar associations with the Penitente herman dad. The mythical Saint Acatius and St. Liberata were both supposed to have been crucified, and so naturally serve as patrons of those Penitentes who reenact the crucifixion of the Lord.[7] Saint Philip of Jesus was actually

[7]For the sources of the legends, see Roland F. Dickey, *New Mexico Village Arts* (Albuquerque: University of New Mexico Press, 1949), p. 157; José E. Espinosa, *Saints in the Valleys* (Albuquerque: University of New Mexico Press,

crucified in Japan. Saint Longinus (the name is traditional, deriving probably from the Greek word for spear) was the centurion at the Crucifixion who "with a spear pierced his side, and straightway there came out blood and water" (John 19:34); Saint Veronica (name and story both traditional) was the woman who wiped the face of Christ on the Way of the Cross and found that he had left an imprint of his face on the cloth. Saint John Nepomucene and Raymond Nonnatus were patrons of Penitente secrecy, San Juan because he was drowned for refusing to reveal to the wicked king of Bohemia the contents of the queen's confession, San Ramón because when he refused to stop preaching while in slavery to the Moors, his captors padlocked his lips shut.[8] Saints Rita of Cascia and Rosalia of Palermo — and Saint Jerome, little thought of in New Mexico as a scholar and doctor of the church — were practitioners of penance; Saint Francis of Assisi is regularly shown with the stigmata connecting him with the Passion, and he was the major patron of the Penitentes; furthermore, like Santa Rita and Santa Rosalia, San Francisco de Asís was most often shown with a skull. Saint Peter seems to have been a special Penitente patron of a happy death;[9] and the Penitentes seem to have had a special and exclusive interest in an allegorical image of death as a skeletal

1967, first edition 1961), pp. 92-93 and 93-94; Hippolyte Delahaye, S.J. *The Legends of the Saints* (Notre Dame: University of Notre Dame Press, 1961), pp. 109-10, 206, 209.

[8]For San Juan Nepomuceno: E. Boyd, *Saints and Saint Makers of New Mexico* (Santa Fe: Laboratory of Anthropology, 1946), p. 133; Richard E. Ahlborn, *The Penitente Moradas of Abiquiu* (Washington: Smithsonian Institution Press, 1968), pp. 139-40. For San Ramón Nonato: intrinsic evidence backed by questionnaire information.

[9]See the comments of Robert L. Shalkop, *Arroyo Hondo: The Folk Art of a New Mexican Village* (Colorado Springs: Taylor Museum, 1969), p. 42, on the retablo of San Pedro (Taylor Museum collection #1676) with notations on the back of the deaths of members of the lower morada, 1916-43. The keys also suggest Peter as a psychopempsos figure, and see Acts of the Apostles 12:6-11 and the widespread notion that Peter keeps the door of heaven.

woman seated in a cart, known as Doña Sebastiana, to be found in every morada late in the last century, though nowhere else.[10]

Other of the saints served to aid the New Mexican peasant in his unending struggle with a recalcitrant earth. "Can we even begin to realize," asks J. H. Plumb in his book *In the Light of History,*

> the anxiety of an agrarian society which lived on the margin of existence, dependent entirely upon the whims of weather? One year may be abundance, a glut of food, for all; and the next maybe with crops shrivelled or blackened on the stalk; starvation certain for all and death for the old, the weak and the young. And yet this is how our ancestors lived in Western Europe and Africa. The vast majority never knew security in their basic needs. The average span of life in Elizabethan England was twenty-six, less than the hungriest and most famine-ridden Indian peasant of today. The pot bellies and protruding eyes of staving children were more a part of the Elizabethan scene than madrigals.
>
> Such fears about the harvest bred anxiety, heightened fear and made the peasant hysterical, hag-ridden with fearsome spectres. The terrors of hell, of Armageddon, of sorcery, of witchcraft, of devilment everywhere abounded.[11]

Even bracketing all the preternatural terrors, the natural obstacles to subsistence and survival were ample in the New

[10]On the Death-Cart as always and only found in moradas (or in churches or chapels dominated by Penitentes), I have the word of many informants and no evidence to the contrary. Also, Ahlborn, p. 138, states that the presence of the image "clearly marks a building as a *penitente* sanctuary." E. Boyd told me in a conversation (10 August 1972) that a tradition in the family of santero José Dolores Lopez maintains that Lopez' father made the first New Mexican Doña Sebastiana around 1860; at any rate, none older are found. Margaret Miller, "Religious Folk Art of the Southwest," *Bulletin of the Museum of Modern Art* 10, #5-6 (May-June 1943), 5, wrote that it was a grandfather.

[11]J. H. Plumb, *In the Light of History* (Boston: Houghton Mifflin, 1973), pp. 197-98.

Mexico of the late eighteenth and early nineteenth centuries to keep the saints busy. Fostering the crops was particularly the job of Saint Isidore of Madrid, the standard patron of farmers, with some help during the month of August from Saint Lawrence.

In connection with the food-raising efforts of the New Mexican peasant communities of the last centuries were the communal irrigation system, a feature of every Spanish and Pueblo village. Saint John Nepomucene had been martyred by drowning, and therefore he was taken as the patron of the communal work of ditching and irrigating which was so important in sustaining the village. In like manner, Saint John the Baptist, due to the connection with water suggested by his name, was the patron of water in all its forms, and it was thought that on his feast day in June all the water in the world became purified of all disease.

The New Mexicans were herders as well as farmers, and their flocks of sheep needed a special patron — and even a number of them. Santa Inés del Campo — Saint Agnes of Benigamin, who took the name Sister Josepha as an Augustinian nun — is a sort of Diana figure, a patroness of purity and the outdoors, and especially of sheep and shepherds (because of the likeness of "Agnes" to the Latin word for lamb, *agnus*). Santa Inés is shown in santero art with some lambs in the background, and thus resembles Our Lady as a Shepherdess, Nuestra Señora como una Pastora. Saint Anthony of Padua and Saint John the Baptist also seem to have served as patrons of the welfare of domesticated animals. For horses and mares, for men and women riding horses, Saint James and Saint Anne were the patrons, Santiago because he always appears on horseback in santero art, Santa Ana because her feast day falls the day after Santiago's, on the twenty-fifth and twenty-sixth of July. Saint Pascual Baylon, due to his name and to his having worked as a shepherd before he joined

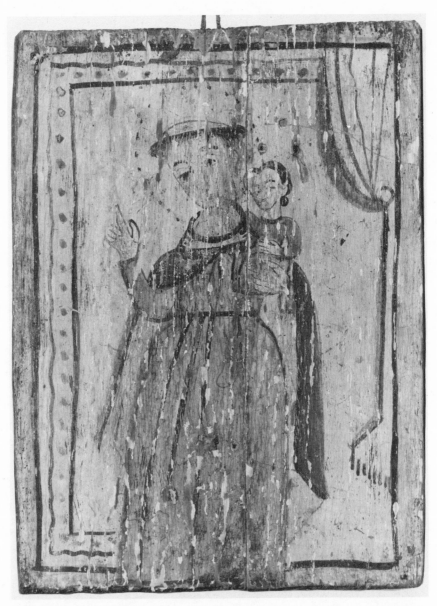

Saint Anthony of Padua (#59), by an anonymous santero. The inner border which runs from the top right to the lower left is not completed consistently at the lower right; see page 21. Taylor Museum, Colorado Springs Fine Arts Center.

a religious order, served as patron of shepherds and sheep.

Fred Cottrell, in his fascinating book *Energy and Society,* notes the findings of sociologists studying a peasant system in China:

> The size of farm that can be worked by a man and his wife alone is too small to support a family. As a result children must work; in the absence of children the older adults will starve. . . . Economic reciprocity between parents and children tends to become a necessary in societies that are dependent on organic converters. Children supply in these areas what is secured in industrial societies through unemployment, health, and disability insurance, and old-age allowances. Parents develop in the child values that will ensure their own survival.[12]

A great many New Mexican villagers were probably in roughly the same condition in the unmechanized agrarian world upwards of fifty years ago, and consequently the emphasis placed on strong family ties — on obedience of the young to parents in the prime of their lives and on generosity of grown children to their aged parents — can be expected to have been strong enough to have involved the saints quite extensively as patrons and supporters of famly values. And this is certainly the case.

God the Father and Saint Joseph — frequently in New Mexico accorded the epithet "Patriarca," patriarch — have been mentioned already as father-figures, as have the Sacred Heart and the Holy Family as patrons of the family at large. In addition to these four subjects, Santa Ana is the patroness of mothers and grandmothers — an important function in an extended family. Saint Rita of Cascia, though she was the victim of an unhappy marriage unwillingly entered into (she had wanted to become a nun), is patroness of young women

[12]Fred Cottrell, *Energy and Society* (New York: McGraw-Hill, 1955), p. 37. Copyright 1955 McGraw-Hill Book Company. Used with permission of McGraw-Hill Book Company.

in need of a husband, and Anthony and Rosalie of Palermo aid in the selection of a man; the latter is also the patroness of engaged couples. Inés, as has been said, guards the purity especially of young girls; Mary Magdalen aids those who have been unchaste to repent and reform. Saint Raymond Nonnatus, as his name suggests a Caesarian birth himself, is patron of women during pregnancy and childbirth, of the unborn, and of midwives. Saints Stanislaus and Aloysius Gonzaga, boy saints of the Jesuit order, along with Philip of Jesus and Gertrude, are patrons of growing children, who are protected from outside evils by the angels.

In a society which had to rely on the most primitive sorts of folk medicine, the people often called on the saints for help in combating illness. In this broad field a number of the saints became very definitely specific to certain precise disorders or areas of the body. Thus Saint Roch protects against troubles of the skin, plague and especially smallpox; Saint Rosalie of Palermo against the plague. Saint Blaise guards against throat trouble, Saint Apollonia against toothache, Saint Lucy against disease of the eye. Saint Lawrence, who was burned to death, protects from burns, and Saint Barbara guards persons against lightning. Thus are the most important threats to the health of the body fended off by the New Mexican saints.

In summary, the santero subjects which have been termed "monster-saviors" occupy a kind of middle position within the complex structure of the New Mexico Spanish patronage system. Above these subjects are the Trinity, God the Father and the Spirit, and representations of the suffering Christ; beneath them are the ordinary saints who deal with less heroic matters. The monster-saviors that have been isolated for study are Our Lady under the titles Ángeles, Carmen, Guadalupe, Luz, and Purísima Concepción; the archangels

Miguel and Rafael; and the saints Gerónimo and Ignacio. The count of these nine fairly popular subjects from my count of a thousand santos reveals a total of 186, with 43 from the earliest period, 108 from the 1815-1850 era, and 22 from the concluding period of santero folk art; another thirteen cannot be assigned to a period. Omitting this last group, we find that 12.7% of the santos representing monster-saviors derive from the latest period, though 17.9% of the total sample does. The lessening demand for these santos seems to suggest both the better protection from such real danger as roving Indians that resulted from the presence of the United States Army and the effects of the newly introduced Anglo world-view, which took a very optimistic attitude toward man's situation in the cosmos. This attitude tended to deride anything like a peasant's cosmic fearfulness, to laugh at anyone who interpreted the course of daily events as being governed significantly by the power of devils and witches. One must wonder, though, if the bulk of the New Mexican Spanish concern with the powers of darkness was really so significantly lessened as the statistics suggest, or simply went underground; Robert Bellah, writing in *People of Rimrock*, suggests that the latter was the main truth: "Belief in the devil, witches, and ghosts is strong in Atrisco. . . . These beliefs are strongest in women and are in some degree a projection of the fear of possible sexual attack by males." And Ari Kiev, studying the psychological aspects of Texas-Mexican curanderismo, corroborates what Bellah states when he says, "There are a number of standarized and culturally acceptable objects of fear such as ghosts, witches and snakes. They provide individuals with ready-made, culturally acceptable fears, thus reducing the need to develop idiosyncratic fears and phobias."[13] The sur-

[13]Evon Z. Vogt and Ethel M. Albert, eds., *People of Rimrock* (Cambridge: Harvard University Press, 1966), p. 252; Ari Kiev, *Curanderismo: Mexican-American Folk Psychiatry* (New York: Free Press, 1968), p. 99.

vival of the fears together with the decline of santo-making points to the breakdown of the coherent system of santos attuned to the principal hopes and fears of the society. In addition, the traders from Saint Louis introduced over the Santa Fe Trail increasing numbers of pictures of saints to whom no veneration had been paid before; in a small collection which includes four such prints in tin-and-glass frames, three are subjects never represented by the older santeros: the Spanish Guadalupe, Saint Paul, and Saint Vincent de Paul. Not only did the introduction of the prints undercut the painters (as the importation of plaster statues across the railroad would undercut the carvers of bultos), but the immigration of a great variety of new saints destroyed the coherence of the old system.

Finally, what is to be made of the relative status of the various personages who made up this old system, as they appeared to the people of the time? George Mills and Richard Grove, writing about the Penitentes, offer a starting point for answering this question for the wider culture:

> The saints and holy figures link human needs, God's transcendence, and the recalcitrancy of human nature. In the Spanish-American view, the saints function in a special way, leaving God an aloof, inscrutable, and unpredictable authority. Numerous stories suggest that the saints have three characteristics: 1) being humanized, they are made aware of local conditions as if by means of human senses, 2) they exercise direct power, 3) their exercise of power may have wrong consequences.[14]

A respondent to my questionnaire volunteered that in the view of the older generations, the saints had independent power in certain areas given them by God to use as they saw

[14]George Mills and Richard Grove, *Lucifer and the Crucifer: The Enigma of the Penitentes* (Colorado Springs: Taylor Museum, 1966), pp. 34-35.

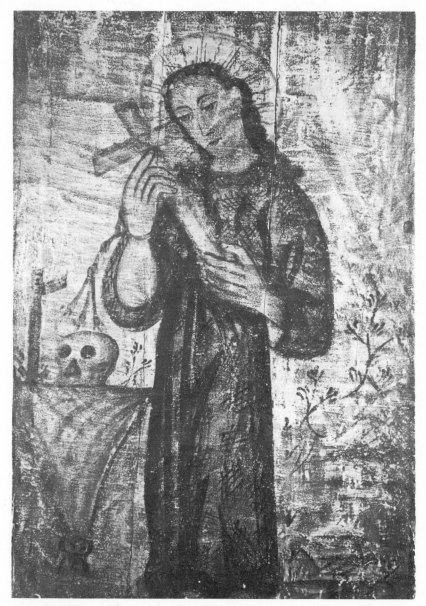

Saint Rosalie of Palermo (#137), by Molleno. This retablo dates from the santero's earliest of three stylistic periods. Courtesy of the Museum of New Mexico.

137

fit. But I would like to suggest that the people fairly clearly differentiated the four groups — the divine persons, the Blessed Mother, the angels, the saints — into clustered gatherings on the basis of the needs, and hopes and fears, associated principally with each group. As has been said already, these clusterings are perhaps best described in terms of the three realms of being in traditional theological terms, the supernatural, the preternatural, and the natural. The versions of the three persons of God — the Trinity, God the Father and the Spirit, Christ in his Passion — are most at home in granting favors in the realm of the strictly supernatural, which has to do with faith, charity, holiness, and salvation. The Holy Family, the Flight into Egypt, the Niño de Atocha and the Niño Perdido form exceptions to this rule; where Christ is shown as a child, the concern changes to family coherence or to the safety of travelers, the release of prisoners, the return of those who have gotten lost. Thus, whereas the "mature" divine persons serve as father-figures — including Nuestro Padre Jesús — the divine Niño serves as a younger-brother figure.

The second level, the preternatural, includes first of all Nuestra Señora under the various titles where she acts as a monster-savior, the one who saves us from the serpent-devil, with whom she was sharply contrasted in the Roman Catholic translation of Genesis 3:15: "I will put enmities between thee and the woman, and thy seed and her seed: she shall crush thy head, and thou shalt lie in wait for her heel." But Our Lady also serves as a figure of security in a peasant world in which everywhere one looked was frontier in the American sense of that world: the opening to that which is unbounded, undefined, beset by unknown and unknowable dangers of every sort, from imagined monsters, witchcraft, and ghosts down to snakes and centipedes. And the Señora also has duties closer to the supernatural realm, having to do with

salvation as such. All in all, she is the protective mother pre-ceived as the helper, the defender; as has been said, there was little of the sentimental in the New Mexican view of her.

The angels also deal in the world of the preternatural as monster-saviors, and moreover serve as guides of the soul, psychopempsoi. As the Virgin is the maternal figure, they are the elder-brother figures, the protective *hermanos mayores* of each man's pilgrimage through the world.

The saints are elder brothers and elder sisters to man-kind; even the youngest of them, Stanislaus and Aloysius, Flora and Inés, were older than the children whose patrons they were. Their realm of activity was for the most part restricted to the natural — the world of crops and animals and family serenity and health; all in all, the less ultimate, less cosmic, less salvation-oriented matters of the people's lives.

Thus the saints provide a coherent and fairly complete summary and defense of New Mexican Spanish values of the late eighteenth and early nineteenth centuries. These are the hard-won values of a peasant world surrounded by hostile Indians, farming the arid lands in the environs of the small villages, living in family homes adorned with the saints who validated, protected, and enhanced every important aspect of this life which the people could bring to consciousness, and putting roots down deep into the universal human psychic substratum so as to integrate the total human experience, to make it comprehensive and coherent.

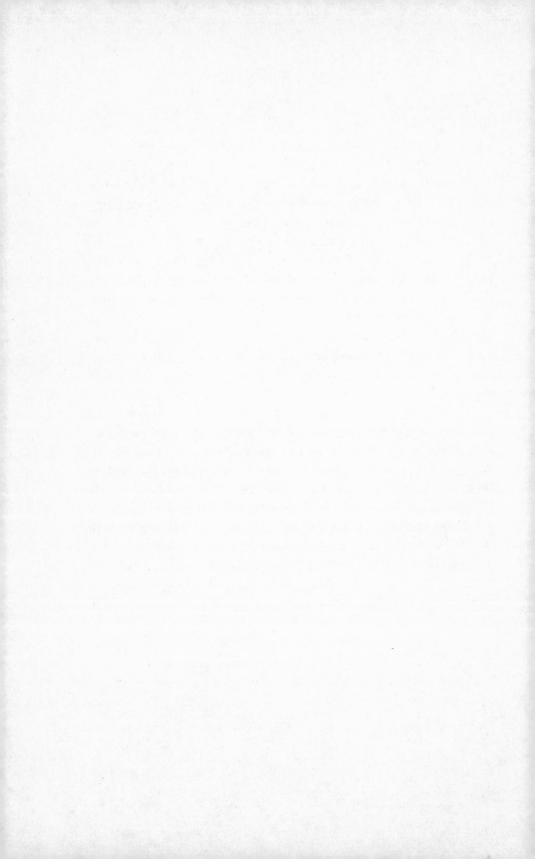

CHAPTER VII

Santos, Saints, and Land

C onspicuous by absence from the motivational chart (Appendix D) is a consiously felt need dating from the earlier part of the last century that private property stood in need of protection. A glance at the ordinary living conditions of the people will suggest the reason this is so: ordinary New Mexicans lived in villages characterized by the extended-family social system which is typical, as Charles Wagley's *Latin American Tradition* points out, of stagnant and declining economic situations among both the elite and the lower classes — the middle class tends to prefer the individualistic and self-subsistent nuclear family instead.[1] Since in time the whole village was interrelated in some degree of kinship by blood, marriage, or baptismal sponsorship, there was understandably a feeling of security about the availability of one's own possessions in relation to fellow villagers; and since the villages were typically quite isolated from each other, there would have been little likelihood of vagrants absconding with anything of value. With regard to the land, this is even more true, so far as can be known. Those who might tend to covet a neighboring farm — according to the farmer's principle, "I don't want all the land in the world, only what adjoins mine" —

[1]Charles Wagley, *The Latin American Tradition: Essays On the Unity and Diversity of Latin American Culture* (New York: Columbia University Press, 1968), p. 176.

would have known that he would have to face the adverse opinion of all the villagers, and possible ostracism from the only society available to him, if he cheated one of his fellows.

In a situation like this, right of possession would have been a plain public fact stemming, in the case of most tools, from the owner having made them with his own hands, and in the case of land, from his having lived all his life on lands inherited directly from ancestors who had been born and died there before him. Receipts of sale, wills, and deeds were superfluous in such a situation. The state of mind would seem to have been, we have always lived here. Of course, the people knew of the original land grants made by the king of Spain or the Republic of Mexico, but these would have assumed the status of pattern-setting deeds, much as did the passion of Christ as it was discussed in Chapter Three. Just as Christ's passion, an event in historical time, did not need to be repeated in order to retain its ability to reach out into all times and all places with its saving effects, so the original granting of the land by the sovereign power and the original ritual of taking possession of it by the grantees were actions that perpetually validated the ownership of the successive generations of villagers. And the very sequence of fathers and sons bequeathing and inheriting was like the unbroken succession of ritual reenactments of the passion in the Mass, or like the succession of Penitente ritual reenactments in their ceremonies: a continuing validation of the original pattern-setting deed.

In such a setting, it should come as no surprise that there was no saint held to be responsible for protecting moveable possessions, privately owned land, or the vast areas of commonly owned land, from theft. This is not to say that the Spanish of the period did not recognize that there were some problems to be dealt with; but Santiago was there to protect them against unconquered or rebellious Indians, and even

if his protection broke down so badly that the people had to leave — as happened frequently in small areas and once, in 1680, for the entire colony — there was still the expectation that the Spanish would soon return and take up again the ownership they had held before. In addition to Santiago, the patrons of property were Saint John the Baptist and Saint Pascal Baylon, patrons of lost animals, and Saint Anthony of Padua, patron of lost things (and probably animals were included here); but the emphasis is on "lost," and nothing is said about things being stolen, particularly land. This sense of the inherent invulnerability of the land, both of private tracts and the extensive *ejidos,* probably contributed to the almost totally ineffectual efforts of the Spanish to retain their lands when the Anglo laws and lawyers arrived.

Spanish notions of land ownership in New Mexico were developed along wholly other lines from the Anglo. For the Spanish, the granting of land was not perfected until there was a ceremony of taking possession. A reader who skims through Ralph Emerson Twitchell's two-volume *Spanish Archives of New Mexico* will encounter numerous instances where a petty official reports that he accompanied the recipient of a grant to the piece of land, and looked on while the grantee tore up grass, picked up stones and threw them about, and cried out, "Long live the King of Spain!" Will Keleher, in his article "Law of the New Mexico Land Grant," comments on this practice that "the thought behind the so-called English livery of seisin and the delivery of possession of land customary to Spanish and Mexican rulers was that there could be no valid vesting of title unless there was personal, manual delivery and investiture."[2] Correlative to this emphasis on personal posses-

[2]William A. Keleher, "Law of the New Mexican Land Grant," *New Mexico Historical Review* 4 (1929), 354. The author adds that ancient Roman jurisprudence allowed the delivery of land "by an instrument in writing at a distance from the land, without manual delivery," but he makes it clear that this was not allowed in medieval Europe.

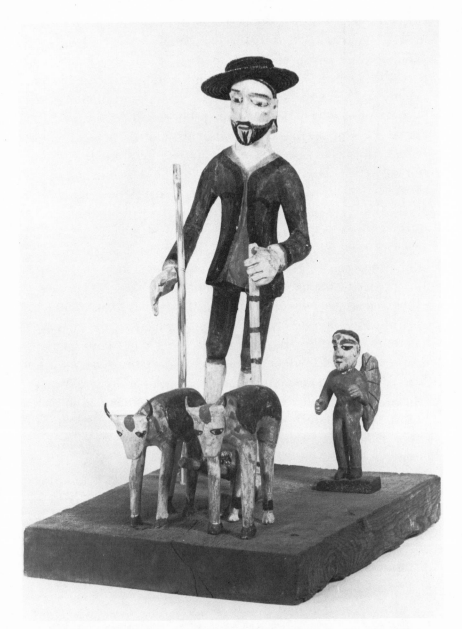

Saint Isidore the Plowman (#89 in Appendix A), by José Benito Ortega. The relative importance of the saint is shown by the way his figure dwarfs that of angel and oxen. Courtesy of the Museum of New Mexico.

sion and occupancy, there was a deemphasis of written documents, maps, wills, and bills of sale, for once the original document of the grant had been completed, nothing could be added to render the perfect possession of the land more perfect.

This system of land-holding, as might be expected when so much stress lies on physical possession and occupancy, placed emphasis on centers rather than margins, which tended to be remarkably vague. The fertile valley in the case of a land grant, the house in the case of a piece of privately owned property, is central and determinative, and the boundaries are often derived from it. This does represent a great advance over the Pueblo system of land-control of the adjacent territory, in which the pueblo is frequently made up of a central plaza containing a kiva and bounded by four blocks of houses; this core is in turn surrounded by four sacred mesas, one in each cardinal direction, and then by four sacred mountains — and by no continuous line of any sort. The Spanish revision of the Indian system is instructive in demonstrating the differences: the king allotted to each Pueblo a tract "four leagues square, or 17,712 acres, measured from the church. . . . The principle of this method of granting land did not originate in the New World. In fact it was quite common throughout Europe to measure grants by laying off a definite distance in each of four directions from a church or other public building."[3] This is a perfect instance of a center "generating" its edges; but here the edges consist not of four sacred mountains but of a completed Euclidean figure. In the case of many of the land grants, however, where there is no church yet built to measure from, the boundaries around the valley are often described as running from such and such a tree to

[3]Herbert O. Brayer, *Pueblo Indian Lands of the "Rio Abajo," New Mexico* (Albuquerque: University of New Mexico Press, 1939), pp. 13-14. See, for instance, Ralph Emerson Twitchell, *The Spanish Archives of New Mexico* (Cedar Rapids: Torch Press, 1914), I, 476.

such and such a hill to such and such an arroyo, and eventually back to the starting point. A description of this sort was perfectly adequate for the time and place, though as later became clear it would leave too much to the imagination of persons who did not live there, or who had a vested interest in making the grant larger or smaller than was intended.

This method of constructing parcels of land so that they had approximate and somewhat vague but enclosed and complete borders is analogous to the Spanish retention of "picture-space," with which Chapter One dealt at length; and the Pueblo practice of boundaryless land-control is similarly analogous to their practice of making designs — sandpaintings, bodypaintings, pottery-design, murals — on items that were meant for uses in addition to decoration. The Spanish abstracted the "capacity to be painted on" from wall, body, and so forth, and hypostatized it in a wooden plaque that did not have any other than an artistic purpose. And further, in contrast to Anglo practices, the New Mexican retablos have an imprecision of rectangularity, a lack of ruler-sharp straightness of edges, that betrays a different approach to the whole notion of space than that of the four-square Anglo with his compulsion to straighten lampshades and crooked-hanging pictures. These three cultures, each of which has played so important a part in the history of New Mexico, thus show both by their diverse control of space in art and by their diverse control of space through techniques of land ownership the truth of S. Giedion's assertion in *The Eternal Present: The Beginnings of Art* that space conception is "the portrayal of man's inner relation to his environment: man's psychic record of the realities which confront him, which lie about him and become transformed. Man thus realizes, so to speak, his urge to come to terms with the world, to express his position graphically." Space-conception is thus, for Giedion, a projection of the human mind; but unlike Kant's category, it

varies vastly from age to age and from culture to culture —
it is indeed an adequate criterion for differentiating cultures.
"It develops instinctively," Giedion goes on, "usually remain-
ing unknown to its authors. It is just because of its uncon-
scious and compulsive manifestations that the space concep-
tion of a period provides such an insight into its attitudes
toward the cosmos, mankind, and eternal values."[4] The Pueblo
Indians place their art upon the real things of the world in
such a way as not to separate the one from the other (the
"ceremonial break" in pottery design comes to mind), and
the pueblo itself is not bounded off from the remainder of
the world. The New Mexican Spanish art provides its own
context of "picture-space," but the panels are only approxi-
mately rectangular; and their land boundaries, though they
form a complete enclosure in a way that the Pueblos' own
did not, have an analogous way of being approximate, un-
mathematical, and at times very vague. The Anglo preference
in art is for precise rectangularity in framing and for the
creation of a self-sufficient "little world" with consistent lineal
perspective in control throughout; and their land ownership
displays the sort of lineal and mathematical exactness and the
kind of literate "page-space" domination through maps and
title deeds that comports precisely with their art. Thus each
of the three New Mexican peoples gives evidence of a space-
conception which dominates art and land-ownership and ef-
fectively distinguishes the people from both of the others.

The Spanish land-control was designed for owners who
would live and work on the property they owned. Numerical
descriptions in terms of acres and feet, in terms of angles and
arcs, would add nothing significant to the understanding of
a piece of farmland the man had plowed and harrowed and
seeded and hoed and harvested, a piece of pasture the man

[4]Giedion, *The Eternal Present: The Beginnings of Art* (New York: Pan-
theon, 1962), pp. 515-16.

had ridden over dozens of times to watch his sheep and cattle. Land was for living and working, and taxes were not levied on the land itself but on its produce; it is only in a system of landholding where land can be viewed as a speculative investment that land-taxes make good sense. Such a system is the Anglo.

The entire Anglo culture of the nineteenth century displayed very much more visual bias than the Spanish. It was a print-oriented culture, especially because of the strong Protestant heritage of reading the Bible. Its visual arts stressed perfect matching of picture to subject, whether in painting or in the new and popular techniques of daguerreotype and photography; and within the picture, balance of one side by the other was a greater value than in santero painting. In domestic architecture, especially, Anglo preferences were for a facade which was divided by a hypothetical line running vertically down the center of the building and dividing two sides which exactly mirrored each other: "Americans introduced another note almost unknown to casual New Mexican architecture — the symmetrical placing of openings. Customarily, a formal front door was flanked on either side by pairs of windows, all in the same design,"[5] In this small difference lies the change from the Spanish Colonial to the Territorial style of domestic architecture: the visual value is emphasized over the practical, and if one room on the front of the house is forever too small for its purpose and the other too large, the house still looks right from the outside and its socially secure inhabitants will put up with continual inconvenience knowing that they have satisfied the neighbors.

Visual emphasis, applied to land ownership, led to the practice of treating a written document as sufficient and necessary. In a culture with such great respect for the written

<hr>

[5]Roland F. Dickey, *New Mexico Village Arts* (Albuquerque: University of New Mexico Press, 1949), p. 45.

word, the assumption tends to be that a written document achieves whatever it sets out to do; and consequently, mere possession is no basis for title, and possession is no strengthening of a title. So long as the written document—the title deed, the plat, the bill of sale, the will — is in proper form, precisely designating the last fraction of an inch and the last degree and minute of the angle, land can be transferred by mere manipulation of paper. The new owner does not need to go and see if there is anything there, does not need to pull up grass and throw stones and cry "Long live Richard Nixon!" so long as the map and the deed assures him there is a rectangle somewhere on the face of the earth that he has bought. Fenimore Cooper satirized this attitude in the 1830s in his novel *Home as Found,* where he has a Wall Street land speculator explain to the hero, "As soon as it was properly mapped, [the piece of land in question] rose to its just value. We have a good deal of the bottom of the sea that brings fair prices in consequence of being well mapped."[6]

In such a system, land can be divided and sold at a distance with the help of page-space; Colorado and Wyoming can be created as territories and states with only a ruler and a pencil. So long as the description is precise, it does not matter that the division does not follow the terrain, that natural and national unities — like Korea and Vietnam — are split up into divisions. As the Anglo artist dominated picture-space by perspective, so the Anglo real estate agent and surveyor dominate the land by page-space. Though the Spanish New Mexican did not own what he did not somehow use, the Anglo could own with equal validity the spot where he was, another he had visited, a third he had never visited but could if he wished, and a fourth totally inaccessible except to birds — or, as Cooper suggested, to fish. A piece of paper, in a legal

[6]James Fenimore Cooper, *Home As Found* (New York: W. A. Townsend, 1860), p. 120.

system designed to serve the interests of the literate, is everything. To quote lawyer and historian Will Keleher again, "Under our law, that is the law of the United States, and the law of Mexico, the record is the grant, and the grant is the title. Briefly, if there is no record, there is no grant; and if there is no grant, there is no title."[7] Such a system could be loved and manipulated only by lawyers, surveyors, and real estate agents — and in New Mexico in the last century, it certainly was.

One of the most biting ironies of New Mexico history is contained in a series of letters to and from Ramón Ortíz, who had been empowered by the government of Mexico to see to the repatriation of those New Mexican Spanish who wished to emigrate from the territory newly conquered by the United States, as provided for in the eighth article of the Treaty of Guadalupe-Hidalgo. Here is part of his report to his superior in Mexico City:

> On the following day I set out for El Vado county [San Miguel del Vado; hence, San Miguel County], where it was generally believed that there would be the least number of persons wishing to emigrate to the republic of Mexico. I had barely arrived in the settlements of that county when all its inhabitants appealed to me with enthusiasm, asking me to enlist them and their families among the immigrants to the territory of Mexico. Although they knew that, according to the guarantees of the peace treaty, they would lose all their property, they were willing to lose everything rather than to live in a country whose government gave them fewer guarantees than our own and in which they were treated with more disdain than members of the African race. In this county, the total number of families is less than one thousand; and more than nine hundred of them en-

[7]Keleher, pp. 361-62.

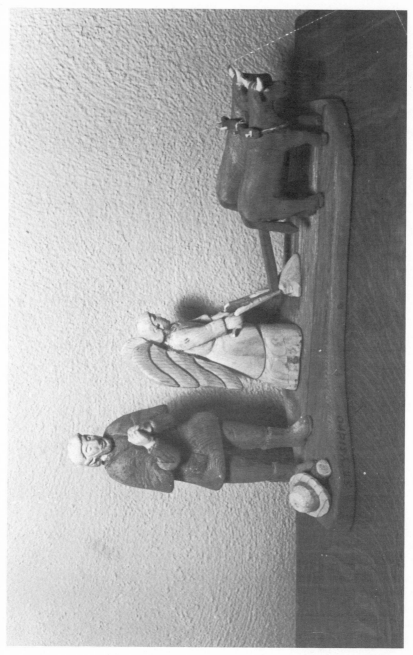

Saint Isidore the Plowman (#89), by Luis Aragón. This contemporary santero works in natural woods, using the different colors of pine and cedar to achieve his effects. From a private collection, with permission.

listed; the majority of the others failed to do so because the heads of families were absent.[8]

And Ortíz goes on to estimate that the Mexican government had better be prepared to resettle fully 80,000 New Mexican Spanish who will wish to emigrate — a prediction which is altogether astonishing since reliable estimates of the total Spanish population give the figure 70,000. But the United States officials, acting through government secretary Donaciano Vigil, were not about to let the vast majority of their subjects walk out on them, so they ordered Ortíz to suspend his operations and order his agents to do the same, and then instituted a deliberately unworkable system, providing

> that all persons wishing to retain their Mexican citizenship must go in person to enroll in the register which was to be open in the offices of the prefectures. It is well known that many of these persons are separated from the prefectures by more than one hundred leagues. Furthermore, despite the fact that only thirty days remained, all the prefects, with the exception of the one at Santa Fe, were out of their counties. In the capital itself, I can testify that after making those who wish to register go around in circles by sending them from the prefect to the secretary and from the secretary back to the prefect, the Americans refused to write the names of those who did not know how to write unless they were accompanied by a person of authority.[9]

[8]H. Bailey Carroll and J. Villasana Haggard, editors and translators, *Three New Mexico Chronicles* (Albuquerque: The Quivira Society, 1942), pp. 144-45. The letters are an appendix to José Augustín de Escudero's additions to Pino's and Barreiro's earlier chronicles. The charge that those who left would lose all their property "according to the guarantees of the peace treaty" is flatly contradictory to Article 8, which guarantees their "retaining the property which they possess in the said territories, or disposing thereof, and removing the proceeds wherever they please; without their being subjected, on this account to any contribution, tax, or charge whatever."

[9]Carroll and Haggard, p. 147.

152

Thus began the implementation of the Treaty of Guadalupe-Hidalgo — strangely — by restraining people from abandoning lands which would soon be taken from them.

The land was the main asset of New Mexico in the latter half of the nineteenth century, and with the coming of the Anglo lawyers and surveyors, two mutually incomprehensible manners of possessing land collided; and even when raw force did not prevail over human rights or deliberate injustice over justice, then merely legal justice often prevailed, through the insensitive application of literate and mathematical norms, over the deeper justice of familial and peasant possession of the land through peaceful generations.

But deliberate injustice was rampant. The Spanish and Mexican eras in New Mexico had seen very little formal legal activity — law courts, lawyers, and so forth. There was no lawyer at all in the colony until the 1830's, no Spanish barrister with academic training until the 1890's; and this situation was a cause of complaint by citizens who were acquainted with Mexico and knew that things ought to be done better. The Spanish population was hardly prepared for the influx of lawyers into the territory — Clark Knowlton estimates that ten percent of Anglo immigrants came to practice law, and it was probably during this period that the New Mexican proverb "Buen abogado, mal vecino — A good lawyer makes a bad neighbor," obtained popularity.[10] There was little ordinary legal work to do, and it appears from the results of their work that they came to get the land, the only valuable asset the territory had to offer, and one which became of very great value in the 1880's, when the railroad opened up im-

[10]George Mills, *The People of the Saints* (Colorado Springs: Taylor Museum, 1967), p. 31; Carey McWilliams, *North from Mexico* (New York: J. B. Lippincott, 1949), p. 77; Antonio Barreiro in Carroll and Haggard, pp. 60-61; Clark S. Knowlton, "Causes of Land Loss Among the Spanish Americans in Northern New Mexico," *Rocky Mountain Social Science Journal* 1 (1964), 203; Rubén Cobos, "New Mexican Spanish Proverbs," *New Mexican Folklore Record* 12 (1969-70), 7.

mense possibilities for large-scale sheep and cattle ranches. As Carey McWilliams notes in his classic work *North from Mexico,*

> Up to 1880, there was little Anglo-Hispano competition for land or resources; but, with new markets, land values began to rise, and the Spanish-speaking elements began to feel, at a dozen different points, the pressure of Anglo-American competition. For a time commercial cattle-raising assumed something like bonanza proportions in New Mexico. The number of cattle increased from 100,000 in 1880 to one million head in 1900. Competition for grazing lands became keen, with control of "waterholes" being used by wily Anglo-Americans as a means of acquiring ownership of the available range lands. A similar expansion took place in commercial sheep-raising. The Hispanos also began to feel the competition of dry-land farming which the Anglo-Americans introduced to the eastern portions of the state. Later, with the passage of the Reclamation Act in 1902, competition for agricultural lands became intense.[11]

The Anglos in the eastern part of the state, bordering on Texas, relied mainly on violence and barbed wire to accomplish their purposes, as students of the Lincoln County War and Billy the Kid are aware. In the remainder of the state, it was the lawyers who engineered the takeover of the majority of the land; they relied principally on their bag of tricks, which ranged from gross to subtle.

Carey McWilliams, in *North from Mexico,* notes the Spanish custom of dividing the property equally among the heirs, thus creating in time a series of small strips within the village, ownership of any one of which entitled the owner to use the common lands — the ejidos — of the community; "some far-seeing Anglo-American stockman would purchase one of the individually-owned parcels and claim an unlimited

[11]McWilliams, p. 76.

154

right to use the commonly-owned grazing lands."[12] A villager who tried to do something like that would, of course, have been ostracized from the only family he knew and made to feel great shame for it, since the ejidos were for the benefit of all and were the property of all. In other cases, a speculator might buy up the private titles of a family prominently named in the original grant, and then claim the entire grant, ejidos and all, as his private property; this is how Thomas Benton Catron, one of New Mexico's first senators (the other was Albert Bacon Fall of Teapot Dome notoriety), came into "possession" of the immense Tierra Amarilla Grant. It is to be doubted that the villagers themselves could ever have gotten the grant approved for 595,515 acres, but Catron, a member of the famed "Santa Fe Ring" of lawyers and Republican politicians, found no difficulty.[13] It is to be admitted that the problem of the ejidos is controverted, with some persons claiming that they were always public domain and passed from the Spanish crown to Mexico to the United States; others that they were not but should have been made so; still others that they are inalienable from the village community and immune from prescription.[14] I incline to the third view.

[12]McWilliams, p. 77; he refers to Erna Fergusson as a source, but names no book or article.

[13]Victor Westphall, *The Public Domain in New Mexico* 1854-1891 (Albuquerque: University of New Mexico Press, 1965), p. 54; Frankie McCarty, *Land Grant Problems in New Mexico* (Albuquerque: Albuquerque *Journal*, 1969), pp. 11-13; Richard Gardner, *Grito! Reies Tijerina and the New Mexico Land Grant War of* 1967 (New York: Bobbs-Merrill, 1970), pp. 60-61; Stan Steiner, *La Raza: The Mexican Americans* (New York: Harper and Row, 1970), p. 67.

[14]McCarty, p. 2, quotes Dr. Myra Ellen Jenkins and lawyer Gilberto Espinosa for the first view; p. 3, quotes lawyer Will Keleher for the second view; Reies Lopez Tijerina, "Spanish Land Grant Question Examined" (Albuquerque: Alianza Federal, 1966), pp. 9, 13-14, quotes in support of the third view the Third Partida of the Spanish Laws of the Indies and the first surveyor-general of New Mexico, William H. Pelham (1859): "The instructions of this office provide that the existence of a town when the United States took possession of the country being proven, is to be taken as prima facie evidence of a grant to said town; . . . and was recognized as a town by the Mexican Government, it is believed to be a good and valid grant, and the land claimed severed from the public domain."

Saint James the Greater (#115), by an anonymous santero. Santiago is protector against military enemies and patron of soldiers, horsemen, and horses. Spanish Colonial Arts Society; photo by Laura Gilpin, courtesy of the Museum of New Mexico.

Another lawyer's trick .is described by Sister Blandina Segale in her account of early days in the territory, *At the End of the Santa Fe Trail:*

> When the men from the States came out West to dispossess the poor natives of their lands, they used many subterfuges. One was to offer the owner of the land a handful of silver coins for the small service of making a mark on a paper. The mark was a cross, which was accepted as a signature, and by which the unsuspecting natives deeded away their lands. By this means, many a poor family was robbed of all its possessions.[15]

Clark Knowlton, in his article "Causes of Land Loss Among the Spanish Americans in Northern New Mexico," notes the practice of lawyers, some of whom would challenge a land grant, others of whom would defend the Spanish owners and demand their fee in land; win or lose, the lawyers came away with a sizeable portion of the property if not all of it, and then divided the proceeds among themselves; Will Keleher's book *The Fabulous Frontier* comments that "Lawyers were quick to learn that they could extract important interests in land for professional work."[16]

Another cause of land-loss was the American system of taxation. As has been mentioned, the Spanish and Mexican governments taxed only the produce of the land, and that only in bountiful years, and the tax could be paid in kind. The American system levied taxes with notices doubly unintelligible to an illiterate people who did not speak English, who would have been nonplused at the concept even had it been explained to them, and who were still operating in a barter economy. The demand for taxes, as well as those for registration of

[15]Blandina Segale, *At the End of the Santa Fe Trail* (Milwaukee: Bruce, 1948), p. 194.

[16]Knowlton, p. 205; Gardner, p. 57, echoes this; William A. Keleher, *The Fabulous Frontier* (Santa Fe: Rydal Press, 1945), p. 86.

land titles according to mathematically precise boundary determinations, of course spelled disaster sooner or later to the Spanish landholders. A ploy which the lawyers were able to use against even the most informed native property owner was to juggle the tax assessment: a piece of land which some politician wanted might be assessed at many times its value, so that the owner could not afford the taxes; if he was not forced to sell it immediately, it passed through a sheriff's auction into the hands of men who immediately had the taxes reduced to their proper level or below.[17] Further, certain mercantile organizations took mortgages for credit on merchandise or for cash loans, and came into a good deal of property that way.[18]

Next, it was a frequent practice to arrange for overly generous surveys, thereby adding land to a captive grant which by rights belonged to the true public domain — the Tierra Amarilla Grant mentioned above and the immense Miranda-Beaubien-Maxwell Grant were both given under the Mexican government, which restricted grants to 96,000 acres; the Tierra Amarilla survey gave Catron 595,515 acres, and the Miranda survey gave Maxwell a stupendous 1,714,764. The practice of paying surveyors by the mile, joined to Spanish imprecision in describing landmarks, allowed this to happen.[19]

And finally, if there was documentary evidence that stood in the way of Anglo progress, the documents were destroyed.

[17]McWilliams, pp. 76-77; Bernard Valdez "The History of Spanish Americans" (Denver: Colorado Department of Institutions, 1963), p. 4; Knowlton, p. 206; Armando Valdez, "Insurrection in New Mexico—Land of Enchantment," *El Grito* 1 (1967), 21; Gardner, pp. 57-58.

[18]William J. Parish, *The Charles Ilfeld Company* (Cambridge: Harvard University Press, 1961), p. 84, mentions the practice, absolves Charles Ilfeld of it, and argues that it generally stemmed from carelessness in granting credit and callousness and shortsightedness in settling lagging accounts.

[19]George W. Julian, "Land Stealing in New Mexico," *North American Review* 145 (1887), 19-25. Even Ring member Stephen W. Dorsey, " 'Land Stealing in New Mexico': A Rejoinder," *North American Review* 145 (1887), 396-409, does not try to deny the practice was going on, only that he was not personally doing it.

Governor William A. Pile in 1870 disposed of a great deal of the official archives; in 1878, Thomas Benton Catron conveniently lost a valise full of other people's documents while traveling between towns. A saying arose among the Spanish, "Mejor una hijuela en el colchón que cien en Santa Fe— Better one title-deed in the mattress than a hundred in Santa Fe." But the plain fact is that there are no title-deeds for much of the lands the Spanish people were living on, farming, and using for pasture and woodlot. The course of their history bespeaks instead a people who relied on the known fact of long-term occupation, based on an irreversibly validating royal land-grant in the distant past; the quiet confidence of the people in the security of their property bespeaks a cultural background in which, however great the danger from Indians, illness, drought and witches, the land was secure, was in no need of a protective patron, would always be there for them. Then the fences would start being strung, the eviction notices would start arriving, cattle and sheep would be turned off the old lands by the new owners, the Forest Service and the Anglo ranchers and lumbermen, and the people sank deeper into poverty until the men drifted away in search of employment. As Margaret Mead notes, "The first type of change evident in the gradual shift from an agrarian economy to wage-work was the development of migrant labor. The families remained in the villages; the men went off to work." As Chapter Four pointed out, in the older peasant village societies, wage labor was felt to be incompatible with the extended-family solidarity; Miss Mead does not feel that this shift in employment has as yet broken down characteristics so deeply ingrained, but it remains that even before the Great Depression ninety percent of village families had to send men outside the area in search of work.[20] And since that time, there has been a

[20]Margaret Mead, *Cultural Patterns and Technical Change* (New York: New American Library, 1955), pp. 168-69, 172.

steady outflow of population from the valleys of northern New Mexico into the urban ghettoes — the barrios — of Albuquerque, Pueblo, Denver, Phoenix, and Los Angeles.

To a great extent, of course, the New Mexico Spanish have felt the same impact that every other farming community throughout the United States has felt. The change from unmechanized "forty-acres-and-a-mule" farms to expensively mechanized contemporary agribusinesses has left farm homes and houses in farming villages standing empty throughout the nation. But there is a difference in this, that no other segment of the American farm population has had so large a *cultural* investment in the farming community as the New Mexico Spanish. The whole society of the last-century New Mexico villager was tied to his land, and when his unprotected land was wrested from him, his whole world came to an end.

The Spanish did not submit to losing their land without protest. In San Miguel County in the 1890's, an organization known as Las Gorras Blancas — The White Hats — used force at times to try to prevent Anglo homesteaders from settling on land which the natives felt they still owned but which had been declared public domain, and organizations known as La Mano Negra — The Black Hand — took revenge during the twenties and thirties upon those landowners whom they identified as squatters. But even before these latter groups appeared, the hope of recovering the land through legal means had led heirs of the Tierra Amarilla Grant to found the Abiquiu Corporation, and there were many similar land-grant groups in the state, working independently of each other — and with total futility.[21]

[21]Gardner, pp. 76, 29. Tijerina, p. 18, warns "The Anglos should not forget the 'Mano Negra' movement in New Mexico earlier in the century. Vigilance Committees and vendetta movements are always terrible for both sides . . . If the Alianza loses the confidence of the Spanish people, and can no longer guide them upon a proper course of action within the law to recover their rights, then the Anglos should realize that the failure of the Alianza is their failure also."

Enter Reies Lopez Tijerina, of course. The unfortunate things about popular movements which strive to correct injustices affecting a people is that a good leader who is not permitted to succeed will not be followed by a better. The reader who thinks that Tijerina has been a bad leader of his people can look back to the leaders of the land-grant organizations he supplanted and regret that they were not at least given their day in court. Those readers who think Tijerina has been a good leader have thoughts of their own to think about the future.

Reies Tijerina has been, is, and will doubtless remain in history a controversial figure. Born in the Falls City, Texas, area of a poor sharecropper family of Texas Indian and Mexican ancestry, he endured the family's financial decline into the condition of migrant farm workers who worked for five years as far north as Michigan. Significant features of his background include the example of a strong grandfather who stood up to Anglo harrassment, the death of his mother when he was seven, a father who had often been run off his land, and had been so severely cut in one such incident that he often had to be carried to and from the fields by his wife. When he was four, Reies had a dream of Jesus and heaven, a dream which shared his memory with his grandfather's accounts of a family land-grant near Laredo.

The boy had very little formal schooling, but did attend the Assembly of God Bible school at Ysleta, Texas for almost a year, was expelled for being somewhat less than orthodox, married, and became a circuit preacher, following the roads for a while, then settling down as pastor of the Assembly of God church in Victoria, Texas. In 1950 his preaching license was revoked, and he took to the road again. Next he founded a commune in Arizona, the Valle de la Paz, which was soon at odds with the local law. Reies walked out of his trial and went to California. There he had a dream of frozen horses,

an old kingdom with old walls, and tall pine trees. The horses came to life, three angels came to help him. He awoke, interpreted the horses in the dream to portend the Spanish land grants in New Mexico, and went there.[22]

For Reies Tijerina to come to power as a leader of New Mexican Spanish required a certain tolerance on their part of his significant differences from them. His background is peon and bracero, which is not the same as New Mexican peasant; and Texas shares nothing with New Mexico culturally apart from the common Spanish and Mexican roots. The mountain villages, the Penitente moradas, the locally made santos on every wall — these are to be found only in northern New Mexico. The people are Roman Catholic, their new leader a pentecostalist minister; the objects of the new organization are rural territories in the north of the state, for the most part, but the leader places the headquarters in the center of the state's only large city. The Spanish tradition is that an elder brother assumes leadership, but Reies is the second-youngest of five brothers, all of whom have been associated with the Alianza in some capacity. The New Mexican people stem from a background of illiteracy, of possession of the land grown away from documents and maps, but Reies Tijerina is a fiercely literate man, oriented to lawbooks and legal documents, a prowler of archives, a searcher of records. What he did have going for him was a knack for leadership of Spanish folk, a charismatic presence unequaled by any figure in American political history, and a happy freedom from commitment to any one region of the state which would lay him open to the suspicions or jealousies of someone from another region.

The Alianza Federal de Mercedes, the Federated Alliance of Land Grant Heirs, held its first convention in Sep-

[22]Michael Jenkinson, *Tijerina* (Albuquerque: Paisano Press, 1968), pp. 17-25; Peter Nabokov, *Tijerina and the Courthouse Raid* (Albuquerque: University of New Mexico Press, 1969), pp. 193-205; Gardner, pp. 31-47.

tember 1963, with representatives of fifty land-grant organizations present. In July 1966, Tijerina led a march from Albuquerque to Santa Fe, ending at the governor's office. October of that year saw two temporary takeovers of a National Forest campground at Echo Amphitheater, which the Alianza claimed as part of the San Joaquin del Rio de Chama Grant; the second effort was marred by pushing and shoving and memorialized by numerous federal indictments. In May of the next year, District Attorney Alfonso Sanchez arrested various members of the Alianza (though without ever bringing them to trial for charges alleged), and on June 5, 1967, a couple of dozen Alianza partisans took over the Rio Arriba County courthouse in Tierra Amarilla for about two hours, wounded two men seriously, and escaped without being able to enact a citizen's arrest of District Attorney Sanchez, who was not there. Two men taken as hostages escaped shortly; the raiders got away into the hills; the National Guard brought two tanks into the hills (but no ammunition for them), rounded up about forty women and children and held them without charges for a day, and retired undefeated. On January 2, 1968, Eulogio Salazar, a jailer who was expected to be a key witness against Tijerina, was savagely murdered outside his rural home. The story has been told well by Peter Nabokov's *Tijerina and the Courthouse Raid,* Richard Gardner's *Grito!,* and Stan Steiner's *La Raza;* it has been told as one would expect by the Communist Party's Patricia Bell Blawis in *Tijerina and the Land Grants* and by the John Birch Society's Alan Stang in *Reies Tijerina: The Communist Plan to Grab the Southwest,* and these last two books are recommended to anyone with a taste for the skewed and doctrinaire. But the real story ought to be read, both for its intrinsic interest and as a practical introduction to New Mexican injustice, humor, politics, absurdity, and violence.

Reies Lopez Tijerina is out of jail, out of official office

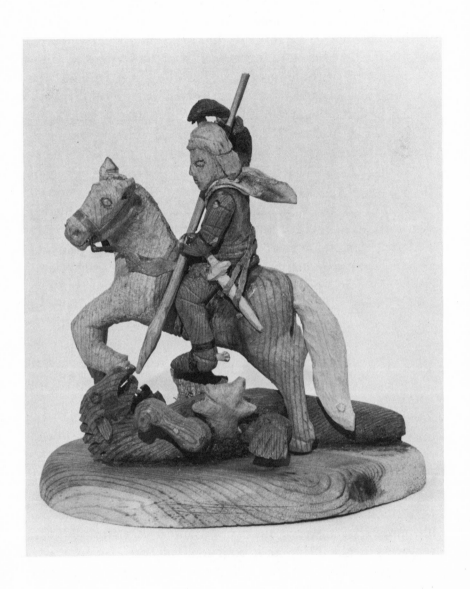

Saint George (#91), by Luís Aragón. This subject was very rarely represented by earlier santeros. From a private collection, with permission.

164

in the Alianza as a condition of his release, but very much in evidence in the wider Chicano movement. What can be said of him now is probably premature, but it may be hazarded that with respect to the land-grants, things did not get better and do not show much likelihood of improvement in the near future; the powers that be seem to find it impossible to give the grant heirs their day in court, despite the likelihood that until they do tens of thousands of Spanish will continue to feel — with good cause — that a "nation under God with liberty and justice for all" is impossible. It may also be hazarded in a state where the governor can tell some northern New Mexico Anglo ranchers, "You paid taxes on it. You hold it by adverse possession. You hold it, but the land was stolen originally," that Tijerina did not make things worse, but only different.[23]

Part of the difference is an emergence of Spanish self-awareness in New Mexico paralleling that in the rest of the Southwest. There is a new awareness of the Indian heritage of blood, though it seems to me to take a futile form in the Aztlán myth, however politically functional that may be especially in the larger cities. There is a new awareness of their past closeness to the land, some attempts to come to grips with the peasant heritage which lies not too many generations behind most of the peoples who migrated to this nation's cities; scratch a suburbanite and you find a peasant. But here again, the concern with one's origins on the land are often taking the form of a nostalgic romantic pastoralism, a kind of adobe Bonanzaland, which is not truly useful for self-awareness. Thirdly, there is a growing appreciation and understanding of the New Mexican Spanish cultural past, the principal "documents" of which are the monuments of ecclesiastical and domestic architecture, the folklore, proverbs, and songs, their

[23]David Cargo in 1967, quoted in Nabokov, p. 163.

165

religious practices — the Penitentes, and the santos. Instead of selling the santos to museums and dealers, the New Mexicans are now to their great credit increasingly keeping these holy saints in the families they were made for. I hope I shall have been of some small help to them in retaining and retrieving some understanding of what these santos meant to their ancestors who made them in the last century and to the ancestors who prayed to them in the years since, so that the descendants may have cause to glory in the beauty, sanctity and honesty of a set of artifacts that would do honor to any people on the face of the earth.

SUPPLEMENTARY BIBLIOGRAPHY

Leonard, Olen E. *The Role of the Land Grant in the Social Organization and Social Processes of a Spanish-American Village in New Mexico*. Albuquerque: Calvin Horn, 1970.

Pearson, Jim Berry. *The Maxwell Land Grants*. Norman: University of Oklahoma Press, 1961.

Swadesh, Frances L. "How the Hispanos Lost Their Land," *New Mexico Review* 2 #1 (January 1970), 1, 5-6.

———————— "Property and Kinship in Northern New Mexico," *Rocky Mountain Social Science Journal* 2 (1965), 209-14.

Tobias, Henry J., and Charles E. Woodhouse, eds. *Minorities and Politics*. Albuquerque: University of New Mexico Press, 1969.

APPENDIX A

A LIST OF SAINTS

This is meant to be a list of all the saints who were represented by New Mexico native santeros between the late eighteenth century and the end of the nineteenth. Pertinent biographical and devotional information about the saint or holy person, his or her inconographic properties, any information about patronages, and the ratio of occurrence in a sample of a thousand will be given.

A note about this last item: the sample of a thousand renders each particular santo precisely a tenth of a percent of the whole. The figures will be given as five numbers, for instance 13 = 8, 5, 0, 0. This means that there are 13 occurrences of the subject in a thousand (hence 1.3% of all santos are this subject), of which 8 date from 1785 to 1815, 5 from 1815 to 1850, none from 1850 to 1900, and none unable to be assigned chronologically. The grand totals are 1000 = 203, 567, 168, 62; omitting the last figure gives 21.6% of santos in the first period, 60.4% in the 1815-50 era, and 17.9% in the last.

1. *La Santísima Trinidád (The Holy Trinity)
 Biblical Sunday after Pentecost
 These three divine persons in numerically one nature constitute the deepest mystery of the Christian faith. The Father is the first person, the Word the second became man as Jesus of Nazareth, the Holy Spirit dwells in the Christian.
 Three chests and heads growing from a single lower torso; three equal or even identical men. The emblem of the sun marks the Father, the lamb the Son, a dove or a tongue of fire the Spirit. They often hold a bar, chain, or lightning-bolt. Confer the first footnote to Chapter 6.
 Enlightenment, favors of immediate need, thanksgiving, faith harmony and peace, protection against all enemies and temptations, deliverance from locusts, earthquakes, and famine.
 13 = 8, 5, 0, 0.

2. *Nuestro Padre Diós (God the Father)
 Biblical-celestial No special feast day
 See the previous entry.
 A single man, bearded, often with a pointed crown, often with a triangular halo, holding his hand in blessing, often with a book or power symbol in his left hand — lightning or arrow. Occasionally holding a heart.
 Enlightenment, aid and fortitude, paternity.
 3 = 0, 3, 0, 0.

169

3. Espíritu Santo (The Holy Spirit)
 Biblical-celestial Pentecost Sunday
 See first entries.
 Shown as a dove, especially within a lunette which is supposed to be
attached to a reredos.
 Enlightenment (?)
 2 = 0, 2, 0, 0.

4. *La Huida a Egipto (The Flight into Egypt)
 Biblical (Mt. 2:13-23, modeled on Genesis 47) 17 February
 An episode in Matthew's infancy narrative where Joseph is told to take
Mary and Jesus and escape into Egypt to prevent Herod from killing the child.
 Joseph leads the donkey, Mary rides sidesaddle on it and carries the child;
an angel sometimes accompanies them.
 For travelers.
 2 = 1, 1, 0, 0.

5. La Sagrada Familia (The Holy Family)
 Biblical First Sunday after 6 January.
 Jesus, Mary, and Joseph; Jesus is shown as a child.
 The Child Jesus in the center, very often holding hands with each of his
parents. Sometimes, the dove appears above the group in a retablo.
 Of the family.
 13 = 1, 9, 3, 0.

6. El Santo Niño (The Christ Child)
 Biblical No Feast Day
 The Christ Child as a boy.
 A young boy kneeling in a long robe, with hands together in prayer.
 Protection for children, probably.
 0 = 0, 0, 0, 0.

7. *El Santo Niño de Atocha (The Holy Child of Atocha)
 Legendary No Feast Day
 In Chapter Five I quoted at length from E. Boyd's account of the Atocha
story in *Saints and Saint Makers of New Mexico* (Santa Fe: Laboratory of
Anthropology, 1946), pp. 126-27.
 A child, almost always seated, in pilgrim's garb (broad-brimmed hat, staff
with gourd, shoes), with basket which generally contains roses. Staff often decor-
ated with ribbons. Ankles very often shackled together.
 Of travelers, for delivery of prisoners; more recently, against illness.
 26 = 1, 14, 9, 2.

8. *El Niño Perdido (The Lost Child)
 Biblical (Lk. 2:41-50) No Feast Day, but it is the fifth joyful
 mystery of the rosary
 Christ remained behind in the Temple at age twelve when his parents left
and had to be sought.
 A child, usually standing, in short trousers and no shirt or in a long robe,
holding nothing.
 Of lost and kidnaped children; of travelers especially pilgrims in danger.
 4 = 0, 4, 0, 0.

170

9. El Niño de Praga (The Infant Jesus of Prague)
A devotion associated with a 17th-century No Feast Day
statue in the Carmelite church of Our
Lady of Victory.
A celebration of the childhood and kingship of Jesus.
A child dressed in a full robe, usually red, holding a globe with a cross on top, and often a staff with a banner lettered IHS.
(?)
13 = 1, 10, 1, 1.

10. Cristo, el Divino Pastor. (Christ the Good Shepherd)
Scriptural (John 10:11) No Feast Day
Christ referred to himself as "the good shepherd" in relation to his "flock," willing to die for them.
Standing, wearing a hat, carrying a lamb on his shoulders, with another by his feet, marked with the stigmata.
Of shepherds (?)
1 = 0, 1, 0, 0.

11. La Entrada en Jerusalem (The Entry into Jerusalem)
Biblical (all gospels) Palm Sunday
The temporary triumph of Christ shortly before his death, entering Jerusalem surrounded by an admiring crowd.
An apparently unique subject, Christ on a donkey, with persons bearing palm branches.
(?)
1 = 1, 0, 0, 0.

12. La Coronación de Espinas (The Crowning with Thorns)
Scriptural (Mt. 27, Mk. 15, Jn. 19) Good Friday
This is part of the passion of Christ, when the Roman soldiers mock his claim to kingship.
Christ clad in a purple robe, with a crown of thorns placed around his head. Can be a pose of a #13 bulto.
Penitente associations, since they practiced it themselves.
0 = 0, 0, 0, 0.

13. *Nuestro Padre Jesús Nazareno (or, de Nazareno)
(Our Father Jesus the Nazarene or Nazarite; or of Nazareth; or The Man of Sorrows; or Ecce Homo)
Scriptural (Mt. 27, Mk. 15; especially John 19:5) Good Friday
The presentation of the scourged, thorn-crowned, purple-robed Jesus to the crowd; also, the bulto which can be put through most of the phases of the passion (see Chapter Three), especially the Scourging at the Pillar.
Usually a bulto, nearly life-size, hinged at the shoulders (and sometimes neck and knees), bearing the marks of the passion.
Penitente associations. Forgiveness of mortal sins, against evil and enemies: penitence; the daily cross; faith, hope, and charity; for a good death.
21 = 1, 12, 8, 0.

14. *Jesús es Cargado con la Cruz (Jesus Carries his Cross)
Biblical (John 19:17) Good Friday
It was the custom of Roman prisoners condemned to the cross to carry their own instruments of death. Matthew and Mark are not explicit about this; Luke is a bit vague; only John makes an explicit point of it. This is of course

171

a key Penitente practice, and very often other of the Brothers than the Cristo carried crosses to the Calvario.

The examples in the sample are all retablos, though this subject could be a phase of the Jesús Nazareno bultos. The retablos show Christ in a long robe bearing the cross.

For repentance and bearing suffering; this last would especially be suggested by Mt. 10:38, 16:24; Mk. 8:34; and Lk. 9:23, 14:27.

5 = 1, 2, 2, 0.

15. El Divino Rostro (Veronica's Veil)
 Legendary (the Sixth Station of the Way of the Cross) Good Friday
 According to a pious legend, a woman wiped the face of Christ as he carried the cross, and he left an imprint of his face indelibly on the cloth. A Latin-Greek phrase, *vera icon,* was metathesized into "veronica," which soon came to be understood as the name of the kind lady in question.

The veil is occasionally shown by itself, but usually Santa Verónica is shown holding it. I counted both types as one unit.

Imprint of Jesus on our hearts, miracles, converts, sexual purity. Also, through association of Santa Verónica with the woman in Mt. 9:20-22 and Mk. 5:25-34, for healing hemorrhages.

8 = 4, 3, 1, 0.

16. *Cristo Crucificado, Crucifijo (Crucifix)
 Biblical (all gospels) Good Friday
 The death of Christ, dealt with especially in Chapter Three above.

Christ nailed to the cross, clad in a loin cloth, with a crown of thorns about his head. Penitente crucifixes, discussed above in Chapter Three, tend to bluish color, often have blood coming from beneath the loin cloth, are often nearly life-size. Horgan, *Great River* (New York: Holt, and Winston, 1960), p. 368, mentions a crucifix where the body is tied to the cross with strips of cotton cross, thus imitating the Penitente practice. — There is often a great pouf standing out from the loin cloth to the viewer's left.

Salvation of the world, pardon from sins, bearing of sufferings, faith, piety, peaceful death, all needs.

81 = 21, 26, 26, 8.

17. La Santa Cruz (The Holy Cross)
 Biblical (Good Friday)
 The cross, shown without the body of Christ. It is often decorated with designs made of straw.

Sometimes the cross is shown with a cloth draped over both arms, presumably having been used as an aid in deposing the body; it is then called La Santa Cruz Cubrita or Vestita, the Draped Cross.

Presumably, the cross would have the same patronage as the crucifix.

15 = 1, 5, 9, 0.

18. El Santo Entierro (Christ in the Tomb)
 Biblical (all gospels) Holy Saturday
 The dead body of Christ in a casket which is usually made of an open latticework.

(?)
2 = 0, 1, 1, 0.

19. *El Sagrado Corazón (The Sacred Heart)

Perhaps suggested by Mt. 11:29 ("Learn of me for I am meek and humble of heart") and by John 19:34 ("One of the soldiers stuck a spear into his side, and immediately blood and water came forth"), there was a medieval devotion to the heart of Christ associated with Santa Gertrudis (*q.v.*), but the major devotion originated in 17th-century France and was particularly promoted by the Jesuits.

Friday after the third Sunday after Pentecost.

The heart is a symbol for the love of Christ for men and the object of reparation for sin.

The heart is often shown by itself, seldom encircled by a wreath of thorns, usually with a cross above it; it is sometimes shown at the center of the chest of Christ, who may have a triangular halo.

Forgiveness of sins; all petitions; protection of family and home; health; against avarice, jealousy, and hatred.

9 = 0, 5, 1, 3.

20. El Gran Poder de Diós (The Great Power of God)
Allegorical No Feast Day

A representation of the divine power operating in the world.

This is a unique piece in the Museum of New Mexico's Charles D. Carroll Collection (N.M./4 CDC) showing Christ enthroned among angels, with the Blessed Virgin above him, and a priest, flanked by a deacon and subdeacon, elevating the host. It appears as an illustration in E. Boyd, *Popular Arts of Colonial New Mexico* (Santa Fe: Museum of International Folk, Art, 1959), p. 49.

(?)

1 = 0, 0, 1, 0.

21. Alegoría de la Redención (Allegory of the Redemption)
Allegorical No Feast Day

This is a presentation in a single panel of two different times, the first of bereavement, the second of glory.

Across the bottom of the picture are the Blessed Virgin, a draped cross, and Saint Joseph. The two parents are represented as bereaved (San José's staff is bereft of its usual flowers). Above are the same two figures as at the sides below, but now rejoicing, and between them Christ as a child. In another example, figures that seem to be Saint Joachim and Saint Ann, the parents of Mary, replace two appearances of Mary and Joseph, and the cross is lacking. This latter could indeed be meant as a version of the Holy Family.

(?)

1 = 1, 0, 0, 0.

22. La Resurrección (The Resurrection)
Biblical (all gospels) Easter Sunday

The rising of Christ to a new life after his death and burial.

Christ in white robes or a white loincloth, rising in air, sometimes with stigmata, sometimes flanked by angels, sometimes shown above a tomb which is reminiscent of the lattice-work coffins of the Santo Entierro. — The only New Mexican representations of the risen Christ known to me are the two by Rafael Aragón in the Museum of New Mexico.

Promise of reward for fidelity to God's will, acceptance of suffering, perhaps.

2 = 0, 2, 0, 0.

Santos and Saints

TITLES of the BLESSED VIRGIN

23. *Nuestra Señora de los Ángeles (Our Lady of the Angels) also Portiúncula.
A title of Mary August 2
As mother of Christ, Mary possesses a rank higher than the angels.
Mary is dressed in a blue mantle, holding the Niño or a sword and cross or a dove she stands on a serpent and is surrounded by angels.
Directress of the angels who are guardians of men; monster control.
3 = 0, 3, 0, 0.

24. Nuestra Señora de la Anunciación (Our Lady of the Anunciation)
A title of Mary March 25
This is our lady when she is approached by the Angel Gabriel and asked to become the mother of Jesus. It is possible that there is insignificant difference between this title and that of the Immaculate Conception.
Shown standing; a tree with buds and a monsterance are in the background.
(?)
0 = 0, 0, 0, 0.

25. Nuestra Señora de la Asunción (Our Lady of the Assumption)
A title of Mary August 15
A teaching of the Roman Catholic Church holds that Mary was taken body and soul into heaven, and is like Christ already in the resurrected state.
A painting of Mary with no special attributes was so identified for me by the mayordomo of a small chapel.
(?)
1 = 0, 1, 0, 0.

26. *Nuestra Señora de Atocha (Our Lady of Atocha)
A title of Mary No Feast Day
This is a development of the Santo Niño de Atocha (#7); there is a church in Madrid named from this title of Mary.
Mary holds the Niño de Atocha; she wears a brocaded hoop skirt and a crown. She is sometimes shown seated.
As with the Niño de Atocha, prisoners and health.
0 = 0, 0, 0, 0.

27. Nuestra Señora de Begona (Our Lady of Begona)
A title of Mary No feast day
I can discover nothing about this title.
Holding the Christ Child and a globe, seated in a chair.
(?)
0 = 0, 0, 0, .

28. Nuestra Señora del Camino (Our Lady of the Way)
A title of Mary No feast day
Probably a Spanish version of the Italian Madonna della Strada.
Mary holding the Niño and a palm or palmer's staff — the symbol of a pilgrim — wearing a crown and with angels on either side.
Protection of pilgrims and travelers.
0 = 0, 0, 0, .

29. *Nuestra Señora de las Candelarias (Our Lady of the Candlesticks)
A title of Mary February 2
This is a very confused title in New Mexico. The real Candelarias became confused with Nuestra Señora de San Juan de Los Lagos so that the former

Appendix A

name became universally applied to the iconography of the latter, who is listed below as #45.

The real Candelarias holds the Niño, a small bouquet, and no candle. (?)

1 = 0, 0, 1, 0.

30. *Nuestra Señora del Carmen (Our Lady of Mount Carmel)
A title of Mary July 18
The orders of Carmelites, both monks and nuns, spread devotion to the brown scapular; a contemporary author speaks of "Our Lady's triple promise to assist us in life and death and to bring us as soon as possible to the gate of Heaven" (E. K. Lynch, O. Carm., *Your Brown Scapular* [Westminster: Newman, 1950], p. 40).

Mary, dressed in a brown and yellow gown, holds a brown scapular and the Niño who is often dressed in red and often holds a scapular. Mary often wears a crown, Christ sometimes. There are often "Souls" in purgatory at the bottom of a retablo.

Against all dangers, especially hell; in the hour of death (in New Mexico a brick of adobe was often brought to a dying member of the Carmelite Third Order to ease the final agony); for the souls in purgatory.

24 = 6, 11, 5, 2.

31. *Nuestra Señora de los Dolores (Our Lady of Sorrows)
A title of Mary Friday before Palm Sunday and September 16
This is Mary enduring the sorrows predicted in Luke 2:35, especially that of the crucifixion of Jesus.

Mary standing with her hands folded, a sword or seven swords piercing her heart, wearing a red gown and a cowl; very infrequently she is crowned.

Strength in suffering; compassion for others in sorrow; help with children, help in childbirth; for sinners. There is a definite Penitente interest, as Chapter Three stated, since it is usually the Dolores who engages in the Encuentro as Christ moves toward Calvary.

53 = 10, 34, 7, 2.

32. El Corazón del Nuestra Señora de los Dolores (The Heart of the Sorrowful Mother)
A version of a title of Mary Friday before Palm Sunday and Sept. 16
This is merely a disembodying of the heart of Dolores on the model of pictures of the Sacred Heart that show only the heart.

A disembodied heart with a sword or seven swords piercing it.

For the same needs as Nuestra Señora de los Dolores was petitioned.

0 = 0, 0, 0, 0.

33. *Nuestra Señora de Guadalupe (Our Lady of Guadalupe)
A title of Mary December 12
The account of this apparition was examined at length in Chapter Five.

Mary, often with perceptibly Indian features, standing in a body halo, supported upon a dark upturned crescent and a winged angel.

For general favors in sickness; against all evil, particularly war; patroness of the Mexican and Indian peoples.

50 = 16, 24, 2, 8.

34. *Nuestra Señora de la Luz (Our Lady of Light)
 A title of Mary May 21
 This presentation of Mary as a savior from enclosure in a monster who
symbolizes Hell (or perhaps Purgatory) dates well back into the middle ages.
 Mary holding the Niño, drawing a "soul" out of the mouth of a monster;
she is crowned or an angel holds a crown over her head, and sometimes an
angel offers her a basket of roses.
 Rescue from Hell or Purgatory; illumination of the mind by her wisdom;
return of those who have left the church or of a husband who has abandoned
his wife.
 $0 = 0, 0, 0, 0.$

35. Nuestra Señora de la Manga (Our Lady of the Cloak)
 A title of Mary No Feast Day
 This is a variation of Nuestra Señora de los Dolores.
 A unique retablo, exactly like the Dolores, except titled at the bottom
"Nuestra Señora de la Manga, advocate of births, and of plagues and of those
who suffer," in the Charles D. Carroll Collection of the Museum of New Mexico
(SR/300 CDC). It is by Pedro Fresquís.
 Advocate of births; protection from plague; advocate of those who suffer.
 $1 = 1, 0, 0, 0.$

36. Nuestra Señora como una Muchacha (Our Lady as a Girl)
 A title of Mary No Feast Day
 This might be meant to represent Mary at her presentation in the Temple
as a girl of twelve or so; if so, the feast day would be November 21.
 A young girl holding a lily.
 Perhaps purity.
 $1 = 0, 1, 0, 0.$

37. Nuestra Señora como una Pastora (Our Lady as a Shepherdess)
 A title of Mary No Feast Day
 This would be a Marian echo of Christ as the Good Shepherd (#10).
 Mary in a shepherdess's hat and a scarf, with sheep in the background.
 Probably patroness of shepherdesses, possibly also for care of souls.
 $0 = 0, 0, 0, 0.$

38. Nuestra Señora del Patrocinio (Our Lady of Protection)
 A title of Mary Third Sunday of November or the day before or Nov. 11
 The devotion dates to the middle ages. There seems to be no implication
of masculinity in the title, despite the etymology.
 Mary holds the Niño; both hold scepters and are crowned. Mary's robe
is red; she stands on an angel-supported moon.
 Protection, presumably mainly from the usual preternatural dangers.
 $1 = 0, 1, 0, 0.$

39. Nuestra Señora de la Piedad (The Pietá; Our Lady of the Deposition)
 A title of Mary Good Friday
 The bereaved mother holds the dead body of Christ in her lap.
 Mary holds the dead Christ in her lap; the cross and the impliments of
the passion are in the background.
 Presumably, the associations of the crucifixion itself: salvation, pardon of
sins, bearing suffering, and so forth.
 $1 = 1, 0, 0.$

176

Appendix A

40. Nuestra Señora del Pueblito de Querétaro (Our Lady of the City of Queretaro)
A title of Mary No Feast Day
Queretaro is a city about a hundred miles northwest of Mexico City, in a state of the same name. This was a local devotion, apparently to Mary as queen of the cosmos.

Crowned and wearing a rich robe, Mary floats above Saint Francis of Assisi, who is holding three globes above himself. There are angels at the sides.

The globes symbolize perhaps the realms of heaven, earth, and hell, or perhaps heaven, church, and state, or perhaps the church on earth, in purgatory, and in heaven. The Virgin's help might be sought for any favor in any of the possible realms.

3 = 0, 3, 0, 0.

41. *Nuestra Señora de la Purísima Concepción (Our Lady of the Immaculate Conception)
A title of Mary December 8
The words "Immaculada" and "Limpia" are sometimes substituted for "Purísima." This is a devotion to the doctrine of the Roman Catholic Church that Mary was conceived without any stain of original sin; it is not identical with the virgin birth of Christ and indeed has nothing to do with it directly, and it is not a profession of the virgin birth of Mary herself, which is not held by any Christian sect I am aware of. The doctrine of the Immaculate Conception was solemnly proclaimed by Pius IX in 1854.

Mary stands on an angel-supported moon or on a serpent, often wears a crown, holds her hands folded and in them sometimes a flower.

For all favors, especially purity and repentance of sin; against all evil. Shalkop, *Wooden Saints* (Colorado Springs: Taylor Museum, 1967), p. 40, notes that a bulto of the Purísima Concepción was known in Abiquiu as Our Lady of Innocence.

21 = 4, 11, 4, 2.

42. *Nuestra Señora Refugio de Pecadores (Our Lady Refuge of Sinners)
A title of Mary July 4
An Italian devotion introduced into Mexico especially into Zacatecas by the Jesuits during the eighteenth century.

Mary is crowned, holds a sceptre or palm, and the Niño, who holds Mary's thumb. There are often roses and angels in the background, and frequently the letters or a monogram "MA." Mary is generally shown half-length.

For protection from sin, repentance of sin, both for self and others. There is probably a strong Penitente interest.

10 = 0, 9, 1, 0.

43. Nuestra Señora Reina de los Cielos (Our Lady Queen of Heaven)
A title of Mary No Feast Day
There would probably be connected with Revelations 12:1 and with the fifth glorious mystery of the rosary, the coronation of Mary as queen of heaven.

Mary holds a Niño and a sceptre, and wears a crown; she stands on a crescent moon.

Probably protection from preternatural dangers.

0 = 0, 0, 0, 0.

177

44. *Nuestra Señora del Rosario (Our Lady of the Rosary)
 A title of Mary October 7
 Because of the association of the rosary with the sea victory over the Turkish
fleet of 7 October 1571, there is probably a transfer of this title to the New
Mexican conflicts with wild or rebellious Indians; the famous La Conquistadora
of the Santa Fe Cathedral is a Spanish-made bulto very much associated with
the reconquest of the colony under De Vargas after the Pueblo Rebellion of 1680.
 The Virgin holds the Niño and a rosary; she is crowned though the Niño
is usually not; she stands on a crescent moon. Sometimes she is shown giving the
rosary to Saint Dominic, whose Order of Preachers especially spread the practice
of saying the rosary.
 Acceptance of death in the family (the saying of the rosary is a central
part of a velorio for the dead); for peace, for help in danger and protection from
accidents.
 9 = 1, 7, 1, 0.

45. Nuestra Señora de San Juan de los Lagos (Our Lady of San Juan de los
 Lagos)
 A title of Mary No Feast Day
 San Juan de los Lagos is a city about two hundred miles northwest of
Mexico City; this title originated as a statue of the Immaculate Conception
venerated there; it was introduced into New Mexico mainly by settlers at Talpa
about 1820. As has been said in connection with Nuestra Señora de las Candel-
arias, there is great confusion between the two titles, with the iconography of
this santo called "Candelarias" by the vast majority of the people.
 The Lady of the Immaculate Conception standing between two lighted
candles.
 (?)
 22 = 6, 13, 3, 0.

46. Nuestra Señora con el Santo Niño (Madonna and Child)
 A title of Mary December 25 (?)
 This title is perhaps only a misidentification of pictures of Mary meant to
be other titles, but vague and incomplete in their iconography.
 The Virgin holding the child, with no other identifying features.
 Perhaps motherhood.
 1 = 0, 1, 0, 0.

47. *Nuestra Señora del Socorro, or de los Remedios (Our Lady of Help)
 A title of Mary September 1
 This is not the same as the more famous Lady of Perpetual Help, which
was a Greek devotion not introduced into western Europe until the eighteenth
century. Our Lady of Help was patroness of the *gachupines* and the Mexicans
loyal to Spain during the Hidalgo rebellion of 1810-11.
 Mary wears a crown and holds the Niño, who may or may not be crowned.
Occasionally she holds a triple staff.
 Freedom from sickness either of soul or of body.
 2 = 0, 2, 0, 0.

48. *Nuestra Señora de la Soledád (Our Lady of Solitude)
 A title of Mary No Feast Day
 After the Ascension of Christ, Christian folklore held that Mary became
a hermitess of sorts, living a life of prayer and penance. Bereft of husband and
child, she is the archetype of the crone.

178

Mary is dressed in a very nun-like black and white, or occasionally black and red; she rarely holds anything in her hands, which may be clasped or held down at her sides, but very often the rosary hangs from her neck or arms. Sometimes implements of the passion appear.

Patroness against loneliness; consolation in bereavement; happy death; reminder of wounds of Christ; protection in general.

14 = 0, 7, 6, 1.

49. Nuestra Señora de Talpa (Our Lady of Talpa)
 A title of Mary (October 7)
This is Our Lady of the Rosary as venerated in the village of Talpa near Taos, according to some sources; but the iconography is different from the Lady of the Rosary of Talpa venerated elsewhere in the Spanish world.

Mary holds an arrow; there is a cross-topped tower in the background.

(?)

1 = 1, 0, 0, 0.

50. Nuestra Señora de Valvanera (Our Lady of Valvanera)
 A title of Mary September 10
According to the legend, an image of Our Lady was found in Spain in the tenth century in a nest of wild bees in a hollow oak. The name is sometimes spelled "Balbanera."

Mary, in a red gown and a blue cape and wearing a crown, holds the Niño who holds a pear; the Niño is not crowned. An eagle may be shown in the background.

(?)

0 = 0, 0, 0, 0.

51. Nuestra Señora de la Victoria (Our Lady of Victory)
 A title of Mary October 7
This is Our Lady of the Rosary as associated especially with the victory over the Turkish fleet at Lepanto, 7 October 1571; there are other battles as well with which Our Lady of Victory has become associated.

Mary is crowned, winged (like the Greco-Roman "Winged Victory"), holding the Niño; she stands on a plant or oversized flower.

Success in battle; here again, the opposition to the Moors would have been transferred to opposition against unruly Indians in New Mexico.

1 = 0, 1, 0, 0.

ANGELS

52. *San Gabriel Arcángel (Saint Gabriel the Archangel)
 Biblical (Daniel 8:16, 9:21; Lk. 1:11-19, 26-38) March 22
Gabriel is the messenger above all, appearing to Daniel to explain things to him and to Zachariah and Mary to announce and explain the births of the Baptist and Christ. In this last association, he is associated with the Eucharist, often holding a monstrance; I have decided to identify him as the angel on many New Mexican crucifixes who catches the blood from the side of Christ in a chalice, for he is often shown elsewhere with a chalice.

Winged, holding a monstrance or chalice or the trumpet with which he will announce the end of the world; sometimes holding a lily or a palm, sometimes crowned.

A messenger from God bringing enlightenment; announcing our good works to God, announcing our arrival in heaven; protecting small children.

9 = 0, 7, 2, 0.

Santos and Saints

53. *San Miguel Arcángel (Saint Michael the Archangel)
 Biblical (Daniel 10:13; Rev. 12:7) May 8, September 29
 Michael's main task is battle against the devil and all his symbols.
 Clad often in armor, holding balance-scales and a sword or spear, standing on a monster of some sort — often a snake; often crowned.
 Opponent of the devil and all evil, patron of soldiers, guardian of small children.
 34 = 5, 25, 4, 0.

54. *San Rafael Arcángel (Saint Raphael the Archangel)
 Biblical (Book of Tobias) October 24
 Raphael is the guide of travelers and pilgrims and the source of spiritual and physical health. He is also a protector against monsters.
 Clad in pilgrim's garb, carrying a staff and a fish. The staff often has a gourd of water at its top.
 Patron of travelers, protector against eye trouble, protector against monsters.
 30 = 8, 15, 4, 3.

55. *Angel Guardián (The Guardian Angel)
 Biblical (Ps. 91: 11-12; Mt. 18:10; Acts 12:7-11) October 2
 These are pure spirits, less powerful that the archangels and unknown by proper names, who are thought to protect each individual human. They have the same general duties as the archangels, particularly as psychopempsoi (soul-guides).
 A winged figure.
 Guides on journeys; protection against evil spirits; protection especially of small children.
 2 = 0, 1, 1, 0.

MEN SAINTS

56. Abraham (Abraham)
 Biblical (passim, but especially Genesis) October 9
 This is the progenitor of the Hebrew nation; the episode in question occurs in Genesis 18.
 Abraham wearing a conical hat or crown, bearded, with a staff (or perhaps an axe), attended by three angels who stand by a fruitbearing tree with a dove in it.
 (?)
 1 = 0, 1, 0, 0.

57. *San Acacio (Saint Acatius of Mount Ararat)
 Second century (legendary) June 22
 San Acacio was supposedly the leader of about ten thousand Roman soldiers who were converted to Christianity in Armenia, and crucified. See José E. Espinosa, *Saints in the Valleys* (Albuquerque: University of New Mexico Press, 1967), pp. 92-93.
 Bearded, on a cross, wearing an eighteenth-century military uniform, crucified, wearing a crown of thorns (or occasionally roses), flanked by two or more soldiers, one of whom has a drum, another a pennant.
 Penitente interest: a patron of those who are crucified; also military interest: protection against intruders.
 16 = 2, 9, 5, 0.

180

Appendix A

58. San Agustín (Saint Augustine of Hippo)
 Lived 354-430 August 28
 A great convert, preacher, theologian, and doctor of the Latin Church.
 A dove, a shell, a bishop's crozier, wearing bishop's robes.
 Perhaps learning.
 1 = 1, 0, 0, 0.
+ Aloysius — see San Luis Gonzaga

59. *San Antonio de Padua (Saint Anthony of Padua)
 Lived 1195-1232 June 13
 Born in Lisbon, became a Franciscan, was trained by San Francisco him-
self, became a great preacher and miracle-worker.
 Dressed in a blue Franciscan robe, holds a palm, a lily, or a flowering
branch, occasionally a heart; holds the Niño who is dressed in red; San Antonio
is clean-shaven and wears the tonsure.
 Finder of lost articles, and probably of lost animals; patron of animals,
especially burros and cattle; patron of the home; invoked by married women who
want to have children, by girls to find a worthy husband.
 73 = 19, 45, 5, 4.

60. San Antonio Abad (Saint Anthony Abbot, Hermit, of Egypt)
 Lived 251-356 (sic) January 17
 Initiated religious communities among the solitary hermits of Egypt;
opponent of the Arians.
 Miss E. Boyd identified a head of Antonio Abad on the body of a San
José bulto, Nolie Mumey Collection #448: an old white-bearded man's head
in a raised brown cowl.
 Perhaps against erysipelas, to argue from analogy with Europe.
 0 = 0, 0, 0, 0.

61. San Athenogenes (Saint Athenogenes)
 Died about 305. July 16
 A bishop and martyr, who seems to have died in Armenia; as a theologian,
he defended the divinity of the Holy Spirit.
 Variously presented: holding two palms, one black and one red, bare-
headed, with a cloak over an alb; or, in a tonsure and long robe, holding a
ladder, and protecting a deer. This last may have been meant to be San Pro-
copio.
 (?)
 3 = 1, 2, 0, 0.
+ Augustine — see San Agustín.

62. *San Bartolomeo (Saint Bartholomew, also called Nathaniel)
 Biblical August 24
 He is traditionally supposed to have evangelized India and Armenia and
to have been flayed alive.
 Kneeling, in a red robe, praying to a cross or crucifix.
 Patron against lightning and other fearful deaths; of women in childbed
(from José Espinosa, p. 92).
 1 = 0, 1, 0, 0.

181

63. San Bernardo (Saint Bernard of Clairvaux)
 Lived 1090-1153 August 20
 Abbot, founder of the Cistercians. preacher of the second crusade, writer
of devotional and polemical works. especially against Abelard.
 Crowned and bearded, holding a crucifix and a staff, with candles in the
background; his appearance on a Talpa reredos may be unique.
 Perhaps his anti-Turk bias may have made him a patron against the Indians;
but the donor of the Talpa reredos was named Bernardo Durán, so it is probably
a personal patronage rather than a practical one.
 0 = 0, 0, 0, 0.

64. San Blas (Saint Blaise)
 Died about 316. February 3
 Supposedly a bishop and martyr, he is reputed to have been a physician
and to have cured a boy with a fish-bone in his throat.
 Dressed as a priest in a long chasuble, with his hands out, bareheaded and
cleanshaven.
 Against throat troubles.
 0 = 0, 0, 0, 0.

65. San Buenaventura (Saint Bonaventure)
 Lived 1221-1274. July 14
 The great Franciscan theologian and doctor of the church, biographer of
Francis of Assisi who reputedly cured him when he was ill as a child. He later
became a cardinal.
 Holding the eucharist in a ciborium, a red staff, and a book, he wears a
cardinal's hat or a crown.
 Perhaps learning.
 0 = 0, 0, 0, 0.

66. *San Camilo de Lelis (Saint Camillus de Lellis)
 Lived 1550-1614. July 14 or 18
 An Italian soldier who joined the Capuchins but had to leave them because
of a disease of the feet, he founded an order of male nurses.
 Standing bearded in a long robe, he blesses a sick man lying in front of
him; two figures kneel at the side.
 For health, perhaps especially of the feet.
 0 = 0, 0, 0, 0.

67. *San Cayetano, or Calletano, or Gaetano (Saint Cajetan)
 Lived 1480-1547. August 7
 A co-founder of the Theatine Order who devoted himself to the care of
the poor and sick.
 Wears a black cassock with a jeweled collar or necklace, often with a cross
hanging from it; carries a palm; often kneels by a table with a biretta and cross
on it. Occasionally he appears crucified, though he may merely be meant to
be standing against a cross.
 Patron of gamblers; people used to bet him a rosary or a blessed candle
he wouldn't do some favor for them. There may be Penitente associations in
the crucifixion, though there is nothing in his biography that suggests it.
 8 = 1, 6, 1, 0.

68. *San Cristobal (Saint Christopher)
Legend dates him to the third century. July 25 or 30
A cluster of legends attached to a supposed giant or near-giant of Asia Minor, who lived by a ford and carried people across the river on his back; one night the Niño came and asked to be taken across, and when Christopher found he could scarcely carry him despite his small size, he took his new name ("Christ-bearer") and became a martyr.
A barelegged man in a kilt-like garment, standing in water, holding the Niño on his shoulder; the Niño holds a globe with a cross atop it, and Christopher usually has a staff.
For travelers.
4 = 1, 2, 0, 1.

69. San Dámaso (Saint Damasus)
Died 384 December 11
Of Spanish descent, as pope he opposed the Arians and Apollinarians.
Clad in a cape over a long robe, holding a palm and a crozier, wearing the papal triple crown.
(?)
1 = 1, 0, 0, 0.
+ Denis — see San Dionysio.

70. San Diego (Saint Didacus of Alcalá)
Lived c. 1400-1453. November 13
A Franciscan lay brother with great devotion to the eucharist, involved in the cure of Don Carlos, heir to the Spanish throne, in 1562.
Standing, holding a large cross which rests on the ground, wearing a Franciscan robe, without a tonsure. A doubtful identification of a hide-painting.
For health, probably.
0 = 0, 0, 0, 0.

71. San Dionysio (Saint Denis the Areopagite, or of Paris)
First century, reputedly. October 9
There was a Dionysius converted by Paul (Acts 17:34); to this name various legends and written works were attached. He was supposed to have become bishop of Paris and, after being beheaded, to have walked back to town carrying his head in his hands.
Wearing a red cloak over a surplice over a cassock, holding a palm and his severed head.
(?)
0 = 0, 0, 0, 0.

72. San Dimas (Saint Dismas)
Biblical (though not the name) March 25
This is the "Good Thief" of Luke 23:40-43; according to one legend, years before he had ransomed the Holy Family when they were taken prisoners during the flight into Egypt.
A man not in military garb but in a loincloth tied to a cross; a part of a full crucifixion scene in which three crosses appear.
For repentance, probably.
0 = 0, 0, 0, 0.

Santos and Saints

73. *Santo Domingo (Saint Dominic)
Lived 1170-1221. August 4
A Castilian, an Augustinian priest who founded a new order to combat the Albigensian heresy.
Bearded, tonsured, wearing black and white habit, holding rosary.
Patron of the rosary.
0 = 0, 0, 0, 0.

74. Elías (Elias or Elijah)
Biblical (Books of Kings) July 20
A great prophet, associated with Mount Carmel and therefore with the Carmelites.
An old bearded man clad in a loincloth, holding a staff, accompanied by a raven.
(?)
0 = 0, 0, 0, 0.

75. *San Estanislao Kostka (Saint Stanislaus Kostka)
Lived 1550-1568. August 15 or September 13
A Polish youth who ran away from home to join the Jesuit Order and died as a novice.
A youth wearing a surplice over a black cassock, holding a cross and a palm; he is neither tonsured nor bearded.
Patron of youth.
3 = 0, 3, 0, 0.

76. San Esteban (Saint Stephen)
Biblical (Acts 6:8-7:60) December 26
The first martyr and one of the first seven deacons, stoned to death.
Standing in the robes of a deacon, tonsured, holding sometimes a palm, sometimes a book, sometimes a monstrance, with the right hand meanwhile raised in blessing. There are stones in the background.
(?)
0 = 0, 0, 0, 0.

77. *San Felipe de Jesús (Saint Philip of Jesus)
Died 1597. February 5
A native of Mexico City, he became a Franciscan, left them, traveled to the Philippines as a merchant, rejoined the Franciscans, shipwrecked in Japan and martyred. He is the patron of Mexico City and of San Felipe Pueblo.
Two crossed lances behind him are the distinguishing characteristics; otherwise, he is either kneeling with arms outstretched or standing against a cross (or perhaps nailed to it). He may be bearded and tonsured, or either, or neither; wears blue Franciscan robes.
One respondent says he is good for mischievous children.
3 = 1, 2, 0, 0.

78. *San Felipe Neri (Saint Philip Neri)
Lived 1515-1595 May 26
A native of Florence who founded the Congregation of the Oratory and evangelized the people of Rome.
A dove hovers over him; he wears a cassock, biretta, and beard and holds a rosary and sometimes a palm or a book.
For the poor; for rain.
2 = 0, 2, 0, 0.

184

79. *San Fernando Rey (Saint Ferdinand III, King of Castile and Aragon)
 Lived 1198 or 1199-1252. May 30
 Wearing kingly robes with a sort of ermine pattern, with a crown on his head or on the arm of his throne, holding variously a pennant, a staff of office, or a flowering staff. Usually cleanshaven.
 He fought the Moors throughout his reign, during which he also gained a reputation for wisdom and sanctity.
 Perhaps the Moor-Indian configuration (Chapter Five).
 4 = 0, 4, 0, 0.

80. *San Francisco de Asís (Saint Francis of Assisi)
 Lived 1181-1226
 October 4
 The son of a merchant, founder of the Franciscans, dedicated to poverty and the passion of Christ, marked by the stigmata (the wounds of Christ). His Order of Friars Minor had sole responsibility for New Mexico until the end of the eighteenth century.
 Wearing a blue robe with a cowl and a white cord with several knots in it around the waist, bearded and tonsured, marked with the stigmata on hands, bare or sandaled feet and often forehead, holding a crucifix or a cross and a skull or occasionally a book. Very occasionally he holds a portion of the Franciscan habit down to souls in purgatory.
 Patron of birds and animals; for peace or reconciliation within the family; for all virtues and all needs.
 20 = 2, 14, 3, 1.

81. San Francisco Javier, or Xavier (Saint Francis Xavier)
 Lived 1506-1552
 December 3
 Born in Spain, student at the University of Paris, one of the first companions of Ignatius in the founding of the Jesuits; missionary in India and Japan, died off the coast of China.
 Wears a black cassock and a biretta, holds a palm and a cross or crucifix; usually has a cape over his shoulders.
 Perhaps of missionaries or for faith.
 5 = 1, 3, 1, 0.

82. San Francisco Solano (Saint Francis Solano)
 Lived 1549-1610
 July 13, 14 or 24
 A Franciscan missionary in Peru, suffering shipwreck; had the gift of tongues. He appears on the Cristo Rey stone reredos from the Castrense.
 Wears a cloak over a black (!) cassock, with a miter or loose "nightcap" on his head, is bearded, and holds what may be a scourge.
 (?)
 1 = 0, 1, 0, 0.
+ George — see San Jorge

83. *San Gerónimo (Saint Jerome)
 Lived 342-420
 September 30
 Well educated in Rome, he lived as a hermit for a time, then acted as secretary to the pope, then went to Palestine where he lived as a monk and translated the Bible from Hebrew and Greek into the Latin Vulgate version.
 Often tonsured, clad in a red mantle, striking a stone against his bare breast as he kneels in prayer, often before a small cross or crucifix; there is almost always a lion at his feet, and the trumpet of God's voice speaks in his ear.
 Patron of children and especially orphans; against lightning.
 13 = 3, 10, 0, 0.

84. San Giles (Saint Giles of Languedoc)
Died about 712. September 1
A Benedictine hermit and abbot whose tomb in Provence became a place of pilgrimage in the middle ages.
Shown as an old man in a long hermit's robe protecting a deer; compare with San Procopio, #111.
Of animals; perhaps of cripples.
0 = 0, 0, 0, 0.

85. San Gregorio (Saint Gregory the Great)
Lived c. 540-604. March 12
Mayor of Rome, he became a Benedictine monk, papal nuncio, and finally pope. He is a doctor of the church.
A cross in his right hand with three crossbars, a miniature church in his left, in a cape and decorated garment, wearing pope's triple crown.
Perhaps for the needs of the church.
0 = 0, 0, 0, 0.

86. San Hipólito (Saint Hippolytus)
Died about 235, or perhaps 258. August 13
A very confused conflation of various persons, probably including the Hippolytus of Euripides' tragedy who, like the saint, was dragged to death by horses, and various more-or-less real Christian figures; associated with San Lorenzo.
An armored Roman centurion on horseback.
Success in warfare, perhaps, though there is nothing in the saint's multiplex biography to warrant his being a soldier.
0 = 0, 0, 0, 0.

87. *San Ignacio de Loyola (Saint Ignatius Loyola)
Lived c. 1491-1556 July 31
A Basque soldier, wounded in battle, becoming very devout during his convalescence, prepared for the priesthood and hoped to be a missionary to Palestine; founded the Society of Jesus on the basis of the Spiritual Exercises, a plan of spiritual discipline.
Dressed in a chasuble or a black cassock, shown sometimes with a biretta, sometimes tonsured or bald; holding a book or plaque marked "IHS" or a monstrance; sometimes there is an apparition of Christ.
Against witchcraft and the evil eye; for repentance and return to the sacraments; against illness.
11 = 1, 9, 1, 0.

88. San Ildefonso (Saint Ildephonsus)
Lived 607-667. January 23
A Spanish monk and abbot who became archbishop of Toledo; he defended the doctrine of the virginity of Mary.
I have never seen a santo I could identify as a San Ildefonso. But since none of the other pueblo churches, much less whole pueblos, were named for saints unrepresented by the santeros, I assume there were santos of San Ildefonso made.
(?)
0 = 0, 0, 0, 0.

186

89. *San Isidro Labradór (Saint Isidore the Plowman)
 Died 1170. May 15
 A farmer, married to Santa Maria de la Cabeza, whose praying God enjoyed so much he used to send an angel to do the saint's plowing and free him for prayer.
 Shown in farmer's garb, usually with a broadbrimmed hat, often with a staff; near him an angel guides a plow pulled by two oxen.
 Patron of farmers, of crops, petitioned for rain; patron of all workers.
 14 = 2, 8, 4, 0.
+ Jerome — see San Gerónimo

90. San Joachim (Saint Joachim)
 Legendary March 20, August 16, 10, or 20
 The father of the Virgin Mary.
 He appears as an elderly man in a blue cloak over a white alb in an allegorical retablo by Pedro Fresquís, Museum of New Mexico A.60. 8-1.
 Perhaps fatherhood.
 1 = 1, 0, 0, 0.
+ James the Greater — see Santiago

91. San Jorge (Saint George)
 Legendary, supposedly third or fourth century April 23
 There may have been a Palestinian martyr named George, but the legends tell of a dragon-killing, maiden-saving warrior, model of knighthood.
 In armor, on horseback, piercing a dragon with a spear.
 For success in battle.
 0 = 0, 0, 0, 0.

92. *San José Patriarca (Saint Joseph)
 Biblical (Mt. 1 and 2; Lk. 1 and 2) March 19
 Spouse of Mary and foster-father of Jesus, traditionally a carpenter.
 Shown in New Mexico as a younger man than in most European art, he has a dark beard and dark hair, carries a flowering staff, holds the Niño, and wears a brightly colored and often intricately patterned robe. He is sometimes crowned.
 Patron of a happy death (since Christ traditionally was said to have been with him), of fathers, of families, of carpenters and all workers.
 59 = 14, 30, 14, 1.

93. *San Juan Bautista (Saint John the Baptist)
 Biblical (all gospels) June 24 and August 29
 The forerunner of Christ, a preacher hermit who baptized Christ among his converts and recognized him as the Messiah, calling him the Lamb of God.
 Dressed in a hermit's cloak, holding a shepherd's crook or a staff with a cross on top and a banner hanging from it; with a lamb in his arms or by his side.
 Patron of sheep and shepherds and of the purity of water, all of which was believed to become pure on June 24.
 1 = 1, 0, 0, 0.

94. *San Juan Evangelista (Saint John the Evangelist, or the Divine)
 (or Joaquin)
 Biblical December 27
 Apostle and evangelist, usually identified as the "beloved disciple," one of the "Sons of Thunder," who was traditionally believed to have lived into the second century and died on the Island of Patmos.

Wearing a biretta and a dark cloak over a light tunic, holding a book and pointing to it; bearded; or, wringing his hands, bareheaded and usually beardless: part of a crucifixion group.

(?)

4 = 0, 2, 2, 0.

95. *San Juan Nepomuceno (Saint John Nepomucene, or Nepomuk)
Lived 1345-1393. May 16
The confessor to the queen of Bohemia, he refused to report her sins to the jealous King Wenceslaus and was drowned. —Later research suggests that the real motivation for his killing was a power-grab between king and archbishop.

Usually bearded, wearing a surplice, black cassock, and biretta, holding a cross and palm.

Patron of silence and secrecy, especially for the Penitentes; protector against gossip and slander; patron of irrigation.

30 = 9, 15, 3, 3.

96. *San Longino (Saint Longinus)
Biblical-legendary March 15
Longinus is the name assigned to the soldier in John 19:34 who pierced Jesus' side; it derives from the Greek word for spear. He was said to have spoken clearly after his teeth and tongue were removed during his martyrdom.

Dressed as a soldier, with a bloodied spear; there is a church in the background and frequently other soldiers accompany him.

Patron of soldiers, protector against injustice.

2 = 1, 1, 0, 0.

97. *San Lorenzo (Saint Lawrence)
Died about 258. August 10
Traditionally of Spanish birth, he was a deacon in service to the pope, and was martyred by being burned on a gridiron.

Clad in a deacon's dalmatic, usually tonsured and beardless, holding a palm and a gridiron, often a cross, a book and/or a chalice.

Protector against fire, patron of crops during August, patron of the poor.

5 = 0, 5, 0, 0.

98. *San Luís Gonzaga (Saint Aloysius Gonzaga)
Lived 1568-1591. June 21
Of a noble Italian family, he joined the Jesuits; while a seminarian, he died of the plague contracted when nursing the sick.

Clad in a white alb and a dark cape with sleeves, holding a palm, neither tonsured nor bearded.

Patron of youth and especially their purity; patron or protector of dancers.

1 = 0, 1, 0, 0.

99. *San Luís Rey (Saint Louis IX, King of France)
Lived 1214-1270. August 25
A prayerful man and a good king, he went on two crusades, being captured on the first and dying of dysentery on the second.

Standing, sometimes in armor, wearing a crown, with a crown of thorns and the three nails of the passion nearby.

Probably patron of war against Moors and hence in New Mexico Indians.

0 = 0, 0, 0, 0.

Appendix A

100. San Martín de Tours (Saint Martin of Tours)
Lived c. 315-397. November 11
A soldier, he divided his cloak with a beggar who turned out to be Christ in disguise; he left the army, became a Christian and eventually bishop of Tours.
On horseback, clad in soldier's uniform, holding a sword and a cloak he cuts in two; a beggar standing by.
Presumably of soldiers and the poor.
0 = 0, 0, 0, 0.

101. San Martiniano (Saint Martinian)
see Santos Processo y Martiniano

102. Melquisedec (Melchizedek)
Biblical (Gen. 14:18; Hebr. 7:1-19). No Feast Day.
A gentile priest-king to whom Abraham did homage, taken as a prefigurement of Christ, especially in the eucharist because of Melchizedek's association with bread and wine.
Beardless, wearing a red robe with a blue sash and a beehive crown with a cross on top, holding a chalice with a cross-topped host emerging from it. He is paired with Moses (next entry) on either side of Gabriel.
Eucharistic connections, probably.
1 = 0, 1, 0, 0.

103. Moisés (Moses)
Biblical (Exodus, especially) September 4
The leader of the Hebrew people from Egypt to the Promised Land.
A black-bearded man in a long robe holding the tablets of the law; three rays come from his head (see Exodus 34:35).
(?)
1 = 0, 1, 0, 0.

104. *San Nicolás Obispo (Saint Nicholas of Myra)
Died about 350. December 6
A bishop renowned for good works (giving money to dower poor girls) and miracles (raising to life three children who had been pickled in a brine tub).
Wearing a bishop's cape over a white alb and a miter, bearded, holding a palm and a dove in a cup or shell.
For children and marriageable girls, probably.
1 = 0, 1, 0, 0.

105. San Onofre (Saint Onophrius or Humphrey)
Died about 400. June 12
An Egyptian hermit, reputed to have dressed in only a loincloth of leaves and his own abundant hair.
Kneeling in a loincloth or a hermit's cloak, either holding a crucifix or having one on a ledge before him, perhaps showing the wounds of penance.
Probably a Penitente patron.
2 = 0, 2, 0, 0.

106. *San Pascual Baylón, or Pasquale (Saint Pascal Baylon)
Lived 1540-1592 May 17
A shepherd who became a Franciscan lay brother, and who worked in the dining room or as doorkeeper; very devoted to the eucharist.

Standing in priest's chasuble, bearded, holding a monstrance, surrounded by sheep.

Patron of sheep and shepherds; his patronage of cooking may or may not derive from the last century.

0 = 0, 0, 0, 0.

107. San Patricio (Saint Patrick)
Lived c. 389-c. 461 March 17
Perhaps British, perhaps Italian in origin, he was taken to Ireland as a slave, escaped, became a priest, returned to Ireland as a missionary and became the first bishop.

I have never seen this subject, but it is listed in José E. Espinosa, *Saints in the Valleys,* p. 92.

(?)
0 = 0, 0, 0, 0.

108. *San Pedro Apostol (Saint Peter the Apostle)
Biblical June 29
The leader of the apostles, the first pope, the custodian of the "keys of the kingdom of heaven" (Matthew 16:19), hence in folklore the keeper of the gates of heaven.

In long robes, bearded, with a key or keys, sometimes also holding a book.

Patron of happy death and admission to heaven, for the freedom of prisoners (see Acts 12:6-11); patron of church unity; protector from fevers.

6 = 2, 3, 1, 0.

109. San Pedro Claver (Saint Peter Claver)
Lived 1580-1654 September 8
A Spanish Jesuit who did missionary work among the black slaves imported to Central America.

I have never seen this subject, but listed and described in Willard Houghland, *Santos, A Primitive American Art,* p. 42, is "San Francisco Xavier. . . . Crucifix, bell, vessel, negro. Portrayed as standing figure with beard, in white surplice." This is decidedly not Xavier's iconography but Claver's.

Missionary work, probably.
0 = 0, 0, 0, 0.

110. San Pedro Nolasco (Saint Peter Nolasco)
Lived c. 1182-1258 January 31
Fought as a soldier against the Albigensians, a co-founder of the Mercedarians, an order to ransom captives of the Moors.

Wears chasuble or full scapular, bearded but not tonsured; hands clasped; one angel holds a book in one hand and places the other on the saints's head, the other angel holds a crucifix.

Patron against the Moors in Spain, hence probably against Indians in New Mexico, especially as regards their captives.

0 = 0, 0, 0, 0.
+ Philip (of Jesus, Neri) — see San Felipe de Jesús, Neri.

111. *Santos Processo y Martiniano (Saints Processus and Martinian)
Perhaps second century. July 2
Roman martyrs whose tomb and basilica on the Appian Way were venerated from early times; legend identifies them as jailers converted by Peter and Paul.

190

Both clothed in Roman tunics and cloaks, holding spears and palms, being baptized by an angel with a shell of water; a prisonlike structure in the background.

Perhaps military patrons.

1 = 1, 0, 0, 0.

112. *San Procopio (Saint Procopius)
Lived c. 980-1053 July 4

A Bohemian, by some accounts a king, who became a hermit in the forest, where a deer took refuge with him when hunters pursued it; the saint later founded an abbey and became its abbot.

Wears a biretta or miter, a black cloak over a white robe; holds a book or a cross, palm or a staff; there is a deer (rarely well drawn) nearby.

Protector of animals; perhaps there is a Diana-Artemis syndrome, with chastity, hunting, and protection of young animals being found together.

2 = 0, 2, 0, 0.

113. *San Ramón Nonato (Saint Raymond Nonnatus)
Died 1240 August 31

A Mercedarian (see #110), he traded himself into captivity to free some prisoners from the Moors; while a slave, he refused to quit preaching as told, so his lips were padlocked; later released, he became a cardinal. His epithet refers to his being a caesarean birth.

Wearing orange or red chasuble or cloak over white robes; holding a monstrance and a wand with three "crowns" on it; bearded; sometimes with dots above and below his lips.

Patron of pregnant women, women in childbed, and the unborn; patron of secrecy for the Penitentes; protector from being slandered or cursed.

22 = 6, 9, 4, 3.

114. *San Roque (Saint Roch)
Died 1337. August 16

A French layman who devoted his life to the care of the plague-stricken.

Usually dressed in a tunic, cloak, and boots, with a cocked hat and sometimes a staff; occasionally in a blue Franciscan habit. There is a dog licking his sores, and sometimes an angel bringing him bread.

Against plague, especially smallpox, against wounds, against cancer; pardon from sins and punishment for them. (In New Mexico, San Roque is often confused with Lazarus of Luke 16:19-31, and sometimes with Job.)

3 = 1, 2, 0, 0.

115. *Santiago (Saint James the Greater, Apostle; of Compostella)
Biblical July 25

Brother to John the Evangelist, reputed to have been the apostle of Spain; his shrine at Compostella in northwest Spain was a famous medieval pilgrimage.

Bearded, in a soldier's uniform, with a spear or sword; on horseback, riding a field covered with the bodies of Moors.

Patron of warriors, especially those fighting the enemies of the church; patron of horsemen, of cockfights, of the sowing of fields. He appeared at various battles fought by the Spanish against both Moors and Indians; see Chapter Five.

14 = 6, 4, 2, 2.

+ Stanislaus — see San Estanislao
+ Stephen — see San Esteban

116. *Santo Tomás de Aquino (Saint Thomas Aquinas)
 Lived c. 1225-1273 March 7
 Of Italian birth, became a Dominican theologian at the University of Paris, composed eucharistic hymns.
 Wearing red mantle over white Dominican garb; holding a book and a shepherd's staff; tonsured and bearded; occasionally with a miter.
 Patron of studies and students, of priests; protector against witchcraft; patron of faith (here perhaps confused with "Doubting Thomas" the apostle).
 1 = 0, 1, 0, 0.

117. Santo Toribio (Saint Turibius of Mogrobejo)
 Lived 1538-1606 Variously April 27, March 23, June 8
 A lawyer and layman, he served as head of the Inquisition at Granada; later he took orders and became bishop of Lima.
 Wearing a bishop's robe and miter; cleanshaven.
 (?)
 0 = 0, 0, 0, 0.

118. *San Vicente Ferrer (Saint Vincent Ferrer)
 Lived 1350-1419 April 5
 Son of an English father and Spanish mother, he was a Dominican preacher especially among Spanish Jews and Moors. He advocated corporal penance, and also worked to heal a papal schism. He was reputed a wonderworker.
 Winged, holding a crucifix; wearing a tonsure, a dark cloak over a white gown, a rosary around his neck; a skull in the background.
 Patron of charity; also probably a Penitente patron.
 2 = 1, 1, 0, 0.

WOMEN SAINTS

+ Agnes — see Santa Inés
119. *Santa Ana (Saint Ann)
 Legendary mother of Mary July 26
 Joachim and Ann were the legendary names given the parents of Mary, the grandparents of Jesus; in the extended families of New Mexico, these were important relationships.
 A woman holding or standing near a small girl.
 Mother-child relationships, family needs; patroness of women riding horses, since her feast follows that of Santiago, patron of horsemen, by one day.
 5 = 0, 3, 1, 1.

120. *Santa Apolonia (Saint Apollonia of Alexandria)
 Died 249. February 9
 An aged deaconess, she had her teeth broken off, then was led to a bonfire and asked to renounce Christ, whereupon she jumped into the flames.
 In a long dress, with long hair and no veil; hands tied; having teeth broken by a Roman soldier with large pliers.
 Against toothache.
 1 = 1, 0, 0, 0.

121. *Santa Bárbara (Saint Barbara)
 Legendary, third or fourth century. December 4
 A legend originating in the tenth century or so avers that her father shut her up in a tower and killed her himself for her faith, whereupon lightning killed him.

Wearing a crown, often with red plumbs; holding a palm and a monstrance; a long dress with three flounces (probably symbolizing the Trinity); a tower in the background, and a thundercloud with lightning; sometimes a font or altar with a cross.

Protectress against lightning and tempests; a rhyming prayer ran, "Santa Bárbara doncella, Libra nos del riyo y a la centella."

16 = 4, 10, 2, 0.

122. *Santa Caterina, or Catalina, de Siena (Saint Catherine of Siena)
Lived c. 1347-1380 April 30
A Dominican nun who lived at home, worked with the poor, and persuaded the pope to return to Rome from Avignon.

A white or white and black nun's habit, holding a sceptre with three diamonds (?) on it and a cross with a pennant; a crown of thorns, the three nails of the passion, and two candles are nearby.

Protectress against talking uncharitably of others; protectress against infection; protectress against hunger.

0 = 0, 0, 0, 0.

123. *Santa Clara (Saint Clare)
Lived c. 1193-1253. August 12
A native of Assisi, foundress with Francis's help of the Franciscan nuns, a very devoted penitent.

Wearing Franciscan nun's habit, holding a monstrance.
Probably penitence with a Penitente interest.

0 = 0, 0, 0, 0.

124. Santa Coleta (Saint Colette)
Lived 1381-1448 March 6
A carpenter's daughter who dropped out of two orders of nuns, became a recluse, then revived the local Franciscan convent, and eventually the superioress of the entire order of Poor Clares.

Wearing a white nun's habit with a black veil, holding a crucifix.
Possibly penitence.

1 = 1, 0, 0, 0.

125. Santa Dulubina (Saint Lydwina or Ledwina of Schiedam)
Lived 1380-1433 April 14
A peasant's daughter who met with an accident at the age of sixteen, was permanently bedridden, became a mystic.

Wearing a red and white dress without hood or veil, long hair, not holding anything in her clasped hands, praying to a crucifix.

Patroness of those who suffer for the sins of others.

1 = 0, 1, 0, 0.
+ Elizabeth of Portugal — see Santa Isabel

126. *Santa Flora de Córdova (Saint Flora of Cordova)
Died 856. November 24
One of two Christian maidens who were beheaded by the Moors; there is a legend that Flora's brother, a Moor, had them threatened with prostitution.

Wearing a dress with a crossed sash in front, holding a cross, with a wound in the back of the neck.

Patroness of sexual purity; protectress against rape, perhaps.

1 = 0, 1, 0, 0.

127. *Santa Gerturdis (Saint Gertrude the Great)
 Lived 1256-1302. November 16
 A German Benedictine nun and mystic with a great devotion to the heart
of Christ; Teresa of Avila was devoted to her; she is patroness of the West
Indies, which was probably understood to include New Mexico.
 Wearing a black nun's habit, holding a crosier or simple staff with a pen-
nant, holding a heart which is occasionally circled with thorns.
 Patroness of devotion to the Sacred Heart; patroness of young, especially
students; perhaps for faith and for souls in purgatory.
 15 = 6, 8, 0, 1.

128. *Santa Inés del Campo (Saint Ines, Agnes, or Josepha — her name in
 religion — of Benigamin)
 1625-1696 January 21 or 22
 A discalced Augustinian nun of a convent near Valencia, especially devoted
to the eucharist.
 A long garment, sometimes a nun's veil or wimple, sometimes long hair;
holding a palm and candle or a staff which is in flower; in a landscape of sorts,
sometimes with lambs.
 Patron of persons and animals lost in the wilderness, for transients and
runaways; for purity; for trees, flowers, crops, flocks.
 2 = 1, 1, 0, 0.

129. *Santa Isabel de Portugal (Saint Elizabeth of Portugal)
 Lived 1271-1336. July 8
 Grand-niece of the king of Hungary, daughter of the king of Aragon, wife
of the king of Portugal (who made her a very bad husband), she served as a
peace-maker and retired in her widowhood to live with the Franciscan nuns as
a tertiary.
 Dressed in a queen's crown and royal robe, holding a cross.
 Possibly patroness of peace, possibly has Penitente associations.
 2 = 0, 2, 0, 0.
+ Kümmernis — se Santa Liberata
+ Ledwina or Lydwina — see Santa Dulubina

130. *Santa Librada (Saint Liberata, Kümmernis, Uncumber, or Wilgefortis)
 Wholly legendary July 20
 Reputedly the daughter of a Portugese king, one of nine sisters born of a
single birth, she wished to devote herself to Christ; her father, who wanted to
to marry her off to his advantage, was thwarted when she grew a beard; so he
had her crucified. The whole tale grew up, it seems, from a misinterpretation of
a clothed crucifix; see Hippolyte Delahaye, *The Legends of the Saints* 1961
(original, 1907); Roland Dickey, *New Mexico Village Arts* 1949, p. 157; José
Espinosa, *Saints in the Valley* 1967 (original, 1960), pp. 93-94.
 A crucified woman in long robes, with a hood or long hair.
 A Penitente saint for women.
 9 = 0, 8, 1, 0.

131. *Santa Lucía (Saint Lucy)
 Died 304. December 13
 A Sicilian maiden, reputed to have been denounced by her rejected suitor
as a Christian; her virginity was saved despite her being sent to a house of
prostitution, her life saved despite being thrown in the fire, but finally her throat
was successfully cut. In some accounts, she was blinded.

A young girl in long robes carrying a palm and a pair of eyes on a dish ("lucia" means light).

Protectress against disease of the eyes.

0 = 0, 0, 0, 0.

132. *Santa Margarita de Cortona (Saint Margaret of Cortona)
Lived 1247-1297. February 22

The mistress of a young nobleman, bearing him a child; seeing in his death a warning, she publicly repented her sins, became a Franciscan tertiary, and served the sick, living otherwise the life of a recluse.

A woman in nun's garb carrying a cross and a handkerchief.

Patroness of charity to the poor; protectress against eye trouble.

3 = 3, 0, 0, 0.

133. *Santa María Magdalena (Saint Mary Magdalen)
Biblical (the real Magdalen is treated in Lk. 8:2, Mk. 15:47
and 16:1-9; she is generally identified with the woman in
Lk. 7: 36-50, and often with the woman in John 8:3-11;
and sometimes with Mary the sister of Martha and Lazarus
in John 11). July 22

Mary, not the sister of Martha and Lazarus, was a harlot converted by Christ, a witness of his crucifixion and resurrection.

In a long green dress, red cloak, no veil, praying.

Patroness of conversion of bad persons, women especially; prayed to especially on Good Friday.

1 = 0, 1, 0, 0.

134. *Santa Rita de Casia (Saint Rita of Cascia)
Lived 1381-1457 May 22

By her parents' wish, married to a bad husband; became a nun when he and her two sons all died, having mystical experiences during one of which a thorn from Christ's crown pierced her forehead.

Wearing a nun's habit, holding a cross and a skull, occasionally with a wound on her forehead or the full stigmata.

Patron of girls in need of husbands, of marriage, of mothers, of those in bad marriages, of all who must bear suffering; advocate of the impossible; for sickness. There was a fear that too great a devotion to Santa Rita might bring both the virtue of patience and a bad husband to exercise it. She probably also had Penitente connections.

18 = 3, 12, 2, 1.

135. *Santa Rosa de Lima (Saint Rose of Lima)
Lived 1586-1617. August 30

Like Catherine of Siena, she lived in her parents' home as a Dominican tertiary; a friend of Santo Toribio.

In a nun's garb of white dress and blue cloak, holding a crucifix and sometimes a scourge and a crown of thorns, with roses in background.

(?)

2 = 0, 2, 0, 0.

136. *Santa Rosa de Viterbo (Saint Rose of Viterbo)
Lived 1234-1252. September 4
A poor girl, she preached in the streets of Viterbo against the Ghibellines and for the Guelphs, the papal faction; reputed to have been made to undergo an ordeal by fire; refused entrance to Franciscans, but eventually buried in their convent.
Wearing a white dress with a green cloak and a crown of thorns; carrying a basket and a staff or cross.
Possible Penitente associations.
0 = 0, 0, 0, 0.

137. *Santa Rosalía de Palermo (Saint Rosalia of Palermo)
Died about 1160. September 4
According to a Sicilian legend, she was a girl of good family who became a hermitess; many years after her death, she saved Palermo from a plague, and became its patroness.
Wearing a black, brown, or grey dress, a crown of roses, long hair, holding a cross, usually a skull, sometimes a book or a scourge.
Protectress against plague; prayed to at velorios for the dead; patroness of engaged couples; probably patroness of penance with a Penitente interest.
12 = 2, 6, 0, 4.

138. *Santa Teresa de Ávila (Saint Theresa of Avila)
Lived 1515-1582 October 15
A Discalced Carmelite, leader of the reform of the order, mystic.
Wearing a nun's garb usually of white and black, often a cloak; holding a crucifix, a crozier with a banner reading "IHS" and having the same emblem on her breast, and/or a palm.
Patroness of faith; protectress from "the ditch of perdition."
5 = 1, 4, 0, 0.
+ Uncumber — see Santa Librada

139. *Santa Verónica con el Divino Rostro (Saint Veronica with the Veil)
Legendary (the Sixth Station of the Way of the Cross) Good Friday
This matter has been dealt with above, #15. When the saint holds the veil, she usually is clad in a nun's habit.
Imprint of Jesus in our hearts, miracles, converts, sexual purity. Also, through association of Santa Verónica with the woman in Mt. 9:20-22 and Mk. 5:25-34, for healing hemorrhages.
8 = 4, 3, 1, 0.
+Wilgefortis — see Santa Librada.

OTHER SUBJECTS

140. La Alma Sola a Bautismo (The Soul at Baptism)
Allegorical No Feast Day
The soul newly made a member of the church, cleansed from sin, and united with Christ.
A kneeling, floating figure of indeterminate sex in a white robe with arms crossed on breast; something like a star in the background.
Probably, a sort of patron of retaining baptismal innocence.
1 = 0, 1, 0, 0.

196

Appendix A

141. Las Cálveras (Skulls)
Allegorical No Feast Day
An allegorical reminder of death, usually as an attribute of some saint, here used by itself.
Various skulls, probably part of an altar at one time.
A reminder of death.
$1 = 0, 1, 0, 0.$

142. El Escudo de San Francisco (The Franciscan Shield)
Allegorical No Feast Day
The emblem of the Franciscan Order.
A cross, with two men's arms crossed in front of it, the one (Christ's) bare, the other (Saint Francis's) in the sleeve of the blue Franciscan habit, both marked with the wounds of the passion.
A reminder of the passion of Christ.
$1 = 0, 1, 0, 0.$

143. *Doña Sebastiana, La Carreta or El Angel de Muerte (The Death Cart)
Allegorical No Feast Day
A reminder of death, not to be prayed to; used as a penitental instrument in Penitente processions. They all date from after the middle of the last century.
An allegorical figure of death as a skeletal woman with a bow and arrow or a club.
Most often accepted only as a reminder, perhaps in some places superstitiously prayed to for longer life.
$5 = 0, 0, 4, 1.$

197

ADDENDUM TO APPENDIX A

This is a list of the thirty most commonly represented subjects of the New Mexico santeros, according to my count of the thousand santos. The list includes all saints represented ten times out of a thousand or oftener; hence all who make up one percent or more of the sample. The top five saints total 31.6% of the sample, the next five only 11.4%; the thirty among them make up 74.3% of the thousand. Our Lady is the subject, altogether, of 22.7% of the thousand.

81 Cristo Crucificado (Crucifijo)
73 San Antonio de Padua
59 San José Patriarca
53 Nuestra Señora de los Dolores
50 Nuestra Señora de Guadalupe
34 San Miguel Arcangel
30 San Rafael Archangel
 San Juan Nepomuceno
26 El Santo Niño de Atocha
24 Nuestra Señora del Carmen
22 Nuestra Señora de las Candelarias
 (de San Juan de Los Lagos)
 San Ramón Notato
21 Jesús Nazareno (Ecce Homo)
 Nuestra Señora de la Purísima
 Concepción

20 San Francisco de Asís
18 Santa Rita de Casia
16 San Acacio
 Santa Bárbara
15 Cruz
 Santa Gertrudis
14 Nuestra Señora de la Soledád
 San Isidro Labradór
 Santiago
13 La Santísima Trinidád
 La Sagrada Familia
 El Santo Niño de Praga
 San Gerónimo
12 Santa Rosalia
11 San Ignacio de Loyola
10 Nuestra Señora Refugio de Pecadores

APPENDIX B

SANTO-IDENTIFICATION CHART

This chart is an aid for identifying any New Mexico santo, whether retablo or bulto. It is divided into several main sections: Multiple Main Figures; Single Main Male Child; Single Main Male Adult; Single Main Female Figure; Not Complete Person. Within some of these sections, and especially the third-last and second-last, there are appropriate subdivisions. The reader must first choose the proper section, then identify the main features of iconography — how is the figure dressed, what is he or she holding, and so forth; then work through the section in question and any appropriate subdivisions, noting the numerals as they occur; then refer to the subjects as numbered in Appendix A.

The reader is warned that not all santos can be identified, especially bultos which have lost items once attached to them, but also retablos, and those even if they are in good condition. This chart came into existence because I have been trying for four years and more to identify a retablo I have; that I am still unsuccessful is an indication of the limitations this chart still has.

Multiple Main Figures

(Not including an adult holding a child, an altarscreen, or a retablo with different subjects separated from each other by interior borders)

More than three persons:
Crucified man in soldier's garb plus soldiers — 57 (Acacio)
Christ, virgin, angels, priest, deacons — 20 (Poder)
Christ Child above cross, each flanked by two figures — 21 (Alegoría)
Christ on donkey, crowd holding palms — 11 (Entrada)

Three: Angels — 52-54 (Archangels, sometimes presented together)
crucified man in soldier's garb plus soldiers — 57 (Acacio)
men — 1 (Trinidád)
man, angel, woman on donkey holding Niño — 4 (Huida)
man, woman, child in middle — 5 (Sagrada Familia)
man on cross with loincloth, two standing figures — 16 (Cristo Crucificado)

Two: men, one older, dead body of one younger, dove — 1 (Trinidád)
man and angel, with oxen and plow — 89 (Isidro)
man leading donkey ridden by woman holding child — 4 (Huida)
soldier pulling woman's teeth — 120 (Apolonia)

Single Main Male Child

Reclining or sitting figure of infant — 6 (Niño — but probably if very small meant to be an attribute of a larger bulto)
Sitting on a chair, or occasionally standing, with baskets of roses, holding basket of roses and a pilgrim's staff with a gourd of water; in legirons, hat, sandles or shoes — 7 (Niño Atocha)
Standing figure in loincloth — 8 (Niño Perdido)
Holding globe with cross on top, in red robe — 9 (Niño Praga)
Floating in air, wearing white garment, star in background — 140 (Alma)

Single Main Male Adult

Single Main Male Adult, ON or IN:

air — 22.
casket — 18.
cross — 16, 57, 67, 72, 77.
donkey — 11.
horeback — 86, 91, 100, 115.
knees — 77, 83.

representation of cloth (head only) — 15 (cf. 139).
seat/throne — 12, 79.
serpent/snake — 53.
stream of water — 68.

Single Main Male Adult, WEARING:
on head

biretta — 78, 81, 87, 94, 95, 112.
crown (papal beehive) — 69, 85, 102.
crown (royal) — 2, 56, 63, 65, 79, 92, 99.
crown (of thorns) — 12, 13, 14, 15, 16.
halo, triangular — 2.
hat, broadbrimmed — 10, 89.

hat, cardinal's — 65.
hat, cocked — 114.
helmet of armor — 53, 91.
hood of brown — 60.
miter — 82, 104, 112, 116, 117.
tonsure — 59, 61, 73, 76, 77, 80, 83, 87, 97, 116, 118.

Single Main Male Adult, WEARING:
as garment

alb — 90, 94, 98, 104, 112, 113, 116, 118.
armor — 53, 86, 91, 99.
bishop's robes — 58, 104, 117.
breeches — 89.
cassock — see robes.
chasuble — 64, 87, 106, 110, 113.
cloak/cape — 69, 71, 81, 82, 85, 90, 94, 98, 111, 112, 114, 116, 118.
coat — 89.
cope — 104.
dalmatic of deacon — 76, 97
hermit's cloak — 83, 84, 93, 105.
king's robes — 79.
jeweled collar/necklace — 67.
loincloth/"kilt" — 16, 18, 68, 72, 74, 105.

pilgrim's garb — 54.
robes of black — 61, 66, 67, 71, 75, 78, 81, 82, 87, 95.
of black and white — 73.
of blue — 59, 70, 77, 80, 114.
of brown — 60.
of purple — 12, 13, 14.
of red — 62, 83, 102, 108.
of white — 11, 22, 69, 116.
patterned — 92.
rosary — 118.
sash — 102.
soldier's uniform — 57, 86, 96, 100, 115.
surplice — 71, 75, 95.
tunic — 111, 119.
wings — 2, 52, 53, 54, 55, 118.

200

Appendix B

Single Main Male Adult, WEARING:
on feet

boots — 89, 114.
laced sandals — 54.
nothing — 12, 13, 14, 16, 18, 68, 72,

74, 80, 83, 84, 93, 105.
sandals — 80.
stockings — 89.

as "mark"

dots above and below lips — 113.
no beard — 59, 64, 75, 79, 94, 97, 98,
 102, 117.
stigmata — 10, 16, 18, 22, 80.

three rays coming from head — 103.
white beard — 60.
wounds of penance — 83, 105.

Single Main Male Adult, WITH (in foreground or background):

angel (or angels) — 22, 56, 89, 110,
 111, 114.
apparition of Christ — 87.
apparition of Mary — 67.
beggar — 100.
biretta — 67.
black man — 109.
bodies (of Moors) — 115.
bread — 114.
church — 96.
deer — 61, 84, 112.
cross or crucifix — 62, 67, 77, 83,
 105, 110.
crown — 79.
demon/dragon — 91.
dog — 114.
dove — 56, 58, 78, 104.
drum — 57.
globe with cross on it — 68.
gridiron — 97.
halo (triangular) — 2.
lamb — 10, 93, 106.

lances/spears — 77.
lion — 83.
men lying and/or kneeling — 66.
oxen — 89.
palms — 11.
passion implements — 99.
pennant — 57.
persons bearing palms — 11.
pillar — 12, 13.
prison — 111.
raven — 74.
sheep — 10, 93, 106.
ship — 109.
shell — 58, 111.
skull — 118.
snake (sometimes winged) — 91.
soldiers — 57, 96.
souls in purgatory — 80.
stones — 76.
tree — 56.
trumpet — 83.

Single Main Male Adult, HOLDING:

balance-scales — 53.
bell — 109.
book — 76, 78, 80, 87, 97, 108, 112, 116.
candles — 63.
chalice — 52, 97, 102.
child — see Niño.
church (miniature) — 85.
ciborium — 65.
cloak — 100.
crook, shepherd's — 93.
cross or crucifix — 14, 63, 70, 75, 80, 81,
 85, 95, 97, 105, 109, 112, 118.
crozier — 58, 69.

dead Christ — 1.
fish — 54.
flowering branch or staff — 59, 79, 92.
gridiron — 97.
head (his own, severed) — 71.
heart — 19, 59.
key — 108.
ladder — 61.
lamb — 10, 93.
lily — 52.
monstrance — 52, 76, 106, 113.
Niño — 59, 68, 92.
nothing, with hand blessing — 2, 11.

hands tied — 12, 13.
hands clasped — 110.
hands raised — 22.
palm — 61, 67, 69, 71, 75, 76, 78, 81, 95, 97, 98, 111, 112.
palm with three "crowns" — 113.
pennant — 79, 93.
plaque — 87.
rock (see stone).
rosary — 73, 78.
sceptre — 79.

scourge — 82.
shell — 58, 104.
skull — 80.
spear — 53, 91, 96, 111, 115.
staff — 56, 63, 65, 68, 74, 89, 93, 112, 116.
staff with gourd of water — 54.
stone — 83.
sword — 53, 100, 115.
tablets of law — 103.
trumpet — 52.

Single Main Female Figure

Single Main Female Figure, ON:

an angel — 33.
a cart — 143.
a chair — 26, 27.
a cross — 130.

the moon — 33, 38, 41, 43, 44, 45.
a plant or flower — 51.
a snake/serpent — 23, 41.

Single Main Female Figure, WEARING:
on head

crown — 26, 28, 30, 31, 34, 35, 38, 40, 41, 42, 43, 44, 45, 47, 50, 51, 121, 129.
crown of roses — 135, 137.
crown of thorns — 135, 136.

shepherdess's hat and scarf — 37, 128.
veil/mantle — any color — 130.
 black — 48, 124, 128, 132, 143.
 blue — 23, 31, 35, 41, 45, 50.
wimple — 128, 132, 134.

as garment

body-halo — 33.
cape/cloak — 50, 133, 135, 136, 138.
gown of black — 127, 137, 143.
 black and red — 48.
 black and white — 48, 122, 138.
 blue — 123.
 brown — 30, 137.
 green — 133.
 red — 31, 35, 38, 50, 125.

 white — 122, 124, 125, 135, 136.
hoop skirt — 26.
nun's habit — 48, 132, 134, 135, 138, 139, 143.
rosary — 48.
royal robes — 129.
sash — 126.
skirt with three flounces — 121.
wings — 51.

as "mark"

is a skeleton — 143.
stigmata — 134.
sword or swords in beast — 31, 35.

wound in back of neck — 126.
wound in forehead — 134.

Appendix B

Single Main Female Figure, WITH (in foreground or background):

altar — 121.
angel or angels — 23, 28, 34, 40, 42.
basket of roses — 26, 34.
body halo — 33.
candles — 45, 122.
child — see Niña.
cross/crucifix — 39, 121, 125.
crown of thorns — 39, 48, 122.
eagle — 50.
font — 121.
globes — 40.
implements of the passion — 39, 48, 122.
lamb or lambs — 128.
lightning, thundercloud — 121.

monogram of "MA" — 42.
monstrance — 24.
Niña — 119.
piece of fruit — 50.
pliers (pulling teeth) — 120.
roses — 42, 135.
Saint Dominic — 44.
Saint Francis of Assisi — 40.
sheep — 128.
soldier pulling teeth — 120.
souls in purgatory — 30.
teeth — 120.
tree with buds — 24.
tower — 49, 121.

Single Main Female Figure, HOLDING:

arrow — 49, 143.
basket — 136.
body of Christ — 39.
book — 137.
bow and arrow — 143.
candle — 128.
child — see Niña, Niño.
cloth with face of Christ imprinted on it — 139.
club — 143.
crosier — 127, 138.
cross/crucifix — 23, 122, 124, 126, 129, 132, 134, 135, 136, 137, 138.
crown of thorns — 135.
dove — 23.
flower or flowers — 29, 41, 128.
globe — 27.
handkerchief — 132.
heart — 127.

lily — 36.
monstrance — 121, 123.
Niña — 119.
Niño — 23, 26, 27, 28, 29, 30, 34, 38, 42, 43, 44, 46, 47, 50, 51.
nothing — 31, 33, 35, 41, 45, 48, 120, 125, 133.
palm — 28, 42, 121, 128, 131, 138.
pennant — 122, 127, 138.
plate with eyes — 131.
rosary — 44.
scepter — 38, 42, 43, 122.
scourge — 135, 137.
skull — 134, 137.
soul (being drawn from monster's mouth) — 34.
staff — 28, 47, 127, 128, 136, 138.
sword — 23.

Not Complete Person

a dove — 3 (Espíritu Santo).
a cross — 17 (La Santa Cruz).
a heart without a sword sticking in it — 19 (Sagrado Corazón).
a heart with a sword or swords sticking in it — 31 (Corazón del N.S. Dolores).

skulls — 141 (Calveras).
two arms, one bare and the other clothed in blue, pierced through the palms, crossed in front of a cross — 142 (El Escudo de San Francisco).
skeleton of a woman on a cart — 143 (Doña Sebastiana).

APPENDIX C

CALENDAR OF THE NEW MEXICAN SAINTS

Included are all that appear twice or more in the sample of 1000, and who have a designated feast day; the final number indicates the frequency of occurrence in the sample.

JANUARY:
 Sunday after Epiphany — Sagrada Familia — 13.
 21 or 22 — Inés del Campo — 2.

FEBRUARY:
 5 — Felipe de Jesús — 3.
 17 — Huida en Egipto — 2.
 22 — Margarita de Cortona — 3.

MARCH:
 15 — Longino — 2.
 19 — José Patriarca — 59.
 22 — Gabriel — 9.
 Friday before Palm Sunday (and Sept. 16) — N.S. Dolores — 53.

APRIL:
 5 — Vicente Ferrer — 2.
 Good Friday — Nuestro Padre Jesús Nazareno — 21.
 Jesús es Cargado con la Cruz — 5.
 El Divino Rostro and Verónica — 8.
 Cristo Crucificado — 81.
 La Santa Cruz — 15.
 Holy Saturday — El Santo Entierro — 2.
 Easter Sunday — Resurrección — 2.

MAY:
 8 (and Sept. 29) — Miguel — 29.
 15 — Isidro Labradór — 14.
 16 — Juan Nepomuceno — 30.
 22 — Rita Casia — 18.
 26 — Felipe Neri — 2.
 Pentecost — Espíritu Santo — 2.
 30 — Fernando Rey — 4.

Santos and Saints

JUNE:
Trinity Sunday — Santísima Trinidád — 13.
12 — Onofre — 2.
13 — Antonio de Padua — 73.
22 — Acacio — 16.
29 — Pedro Apóstol — 6.

JULY:
4 — N.S. Refugio de Pecadores — 10; Procopio — 2.
8 — Isabel de Portugal — 2.
16 — Athenogenes — 3.
18 — N.S. Carmen — 24.
20 — Librada — 9.
25 (or 30) — Cristobal — 4; Santiago — 14.
26 — Ana — 5.
30 (or 25) — Cristobal — 4.
31 — Ignacio — 11.

AUGUST:
2 — N.S. Ángeles — 3.
7 — Cayetano — 8.
10 — Lorenzo — 5.
15 (or Sept. 13) — Estanislao Kostka — 3.
16 — Roque — 3.
30 — Rosa de Lima — 2.
31 — Ramón Nonato — 22.

SEPTEMBER:
1 — N.S. Soccoro — 2.
4 — Rosalía — 12.
13 (or Aug. 15) — Estanislao Kostka — 3.
16 (and Friday before Palm Sunday) — N.S. Dolores — 53.
29 (and May 8) — Miguel — 34.
30 — Gerónimo — 13.

OCTOBER:
2 — Angel Guardián — 2.
4 — Francisco de Asís — 20.
7 — N.S. Rosario — 9.
15 — Teresa de Ávila — 5.
24 — Rafael — 30.

NOVEMBER:
16 — Gerturdis — 15.

DECEMBER:
3 — Francisco Javier — 5.
4 — Bárbara — 16.
8 — N.S. Purísima Concepción — 21.
12 — N.S. Guadalupe — 50.
27 — Juan Evangelista — 4.

APPENDIX D

MOTIVATIONAL CHART

This chart is basically derived from David Birch and Joseph Veroff, *Motivation: A Study of Action* (Belmont: Brooks-Cole, 1966); I added to it from Abraham Maslow, *Motivation and Personality* (New York: Harper and Row, 1970). Secondly, I added other particulars to suit the chart to a peasant culture, and finally some subdivisions specifically to contain New Mexican Spanish concerns that arose. The number that follows a saint's name designates the number of times the saint appeared in the sample of a thousand.

1. *INDIVIDUAL*
1.1 *SENSATION*
1.11 *NEGATIVE*
1.111 vs. hunger Isidro 14
1.112 vs. earthquake, storms, etc. Trinidád 13, NSCandelarias 22, Bárbara 16
1.113 vs. sickness
 general: Niño Atocha 26, Corazón 9, N S Socorro 2, Rita Casia 18 (perhaps for impossible cases)
 special: of throat Blas 0
 of teeth Apolonia 1
 of eyes Rafael 30, Lucía 0
 of skin Roque 3
 by plague N S Manga 1, Roque 3, Rosalia 12
 by burns Lorenzo 5
 by hemorrhages Veronica 8
 of mind
1.114 vs. intemperance N S Purísima Concepción 21, Luís Gonzaga 1, Inés 2, María Magdalena 1
1.115 vs. death José 59, Pedro 6, Doña Sebastiana 5
1.1151 vs. lightning Bárbara 16
1.12 *POSITIVE*
1.121 sex and fertility Antonio 73
1.1211 help in childbirth N S Dolores 53, N S Manga 1, Ramón 22
1.122 rain Juan Bautista 1, Isidro 14, Lorenzo 5
1.1221 irrigation Juan Nepomuceno 30
1.123 crops, food Isidro 14, Lorenzo 5, Santiago 14
1.124 animals used for food Antonio de Padua 73, Francisco de Asís 20, Juan Bautista 1, Procopio 2, Inés 2

1.125 exercise and relaxation
1.1251 work Isidro 14, José 59
1.1252 play Cayetano (for gambling) 8, Luís Gonzaga (perhaps for dancing) 1
1.126 sleep
1.127 aesthetic, sense of symmetry
1.2 *CURIOSITY*
1.21 *NEGATIVE*
1.211 vs. ignorance (see studies, below)
1.212 vs. boredom (see play, above, and all affiliative, below)
1.213 vs. weakness in the face of the unknown N S Carmen 24, N S Guadalupe
 50, N S Luz 0, N S Purísima Concepción 21, Miguel 34, Rafael 30,
 Gerónimo 13
1.22 *POSITIVE*
1.221 studies Tomás 1, Gertrudis 15
1.222 more unitary understanding of cosmos, being comfortable in nature; en-
 lightenment Trinidád 13, Padre Diós 3; mystical experience
1.223 faith Trinidád 13, Corazón 9, Rosa Lima 2, Teresa Ávila 5
1.3 *ACHIEVEMENT*
1.31 *NEGATIVE*
1.311 vs. guilt feelings (see shame and sinfulness, below)
1.312 vs. sinfulness (see shame and sinfulness, below)
1.313 vs. failure in enterprises (see being comfortable in nature, above)
1.314 vs. violation of ownership by loss or straying
1.3141 of animals Juan Bautista 1, Pasquale 0
1.3142 of things Antonio 73 (and animals, probably)
1.32 *POSITIVE*
1.321 ownership, amassing wealth
1.322 self-satisfaction, self-esteem
1.323 value commitment
1.324 hopes and plans for distant future
2. *SOCIAL*
2.1 *AFFILIATION*
2.11 *NEGATIVE*
2.111 vs. shame Jesús Nazareno 21, Jesús Cargado 5, Crucifijo 81
2.112 vs. sinfulness in self and others Jesús Nazareno 21, Jesús Cargado 5,
 Crucifijo 81, N S Refugio 10, Acacio 16, Gerónimo 13, Librada 9
2.113 vs. loneliness N S Soledád 14
2.114 vs. effects of death in family N S Dolores 53, N S Rosario 9, N S
 Soledád 14
2.12 *POSITIVE*
2.121 mutuality (including ownership of common lands)
2.122 belonging to tradition; at-home feeling; loving and being loved and
 esteemed; caring for and being cared for Gabriel 9
2.123 fulfilment of duties
2.1231 to church
2.1232 to nation or race N S Guadalupe 53
2.1233 to morada Juan Nepomuceno 30, Ramón 22
2.1234 to village
2.1235 to family Sagrada Familia 13, Francisco Asís 20, José 59
2.12351 as child Estanislao 3, Felipe de Jesús 3, Luís Gonzaga 1, Gertrudis 15
2.12352 as father Padre Diós 3, José 59
2.12353 as mother Ana 5, Rita 18
2.12354 in choice of husband Antonio 73, Nicholas 1, Rita 18, Rosalia 12

Appendix D

2.2 *POWER*

2.21 *NEGATIVE*

2.211 vs. dependence on others who are not kind; for poor Felipe Neri 2, Lorenzo 5, Margarita 3

2.212 vs. influence by others

2.2121 by witches Ignacio 11

2.2122 by devils N S Angeles 3, N S Luz 0, Miguel 34, Rafael 30

2.22 *POSITIVE*

2.221 fulfilment of interpersonal relationships of responsibility

2.2211 by self (see fulfilment of duties, above)

2.2212 by others toward self or kin Rita 18 (husband to wife)

2.3 *AGGRESSION*

2.31 *NEGATIVE*

2.311 vs. opponents Acacio 16, Longino 2, Santiago 14

2.3111 of welfare of community Santiago 14

2.3112 of welfare of church Gregorio 0, Pedro 6

2.3113 of welfare of family (children) N S Ángeles 3, Angel Guardián 2

2.3114 of welfare of travelers Huida a Egipto 2, Niño Atocha 26, Niño Perdido 4, N S Atocha 0, Rafael 30, Ángel Guardián 2, Cristobal 4

2.3115 of welfare of captives Niño Atocha 26, Niño Perdido 4, N S Atocha 0, Pedro 6

2.312 vs. anxiety

2.313 vs. frustration

2.32 *POSITIVE*

2.321 for tolerance of frustration, acceptance, Jesús Nazareno 21, Jesús Cargado 5, Crucifijo 81

2.322 for safety, security, protection, peace Trinidád 13, N S Rosario 9, Domingo 1

APPENDIX E

A LIST OF SANTEROS

From prior to the earliest times to the present.

In each instance, the dates given are the dates the santero may be guessed to have worked; supplementary information is added, as well as a bibliographical reference of the shortest possible sort.

1587 (apocryphal) José Manuel Montolla and Montolla de Pacheco — mythical painters of the Trampas altarscreens; see 1756 Miera, 1785 Fresquís, and 1860s, José Gonzales. *N. M. Magazine* 11 (1933), p. 52.

1700-1720 "Franciscan 'F'" was a painter of hide paintings, more renaissance than baroque in spirit, who did not make use of "architectural" borders. *El Palacio* 76 (1969), 3-5; this article will hereafter be referred to as Boyd.

1725-1740 "Franciscan 'B' " was a more baroque stylist of hide painting. Boyd, 5.

1743-1772 Fray Juan José Toledo made some statues. E. Boyd, *Popular Arts of Colonial New Mexico,* p. 24.

1745-1749 (Anonymous) Painter of an oil painting of San Miguel in the Church of San Miguel, Santa Fe, given by the commander Don Miguel Saenz de Garvisu. E. Boyd, *Popular Arts,* p. 24.

1748-1778 Fray Andrés Garcia decorated many pueblo churches and those at Albuquerque, Santa Fe, and Santa Cruz: he tended to paint faces very red. Boyd, pp. 6-7; Espinosa, *Saints in the Valleys* 1967, pp. 23-24.

1753-1755 Fray Toledo, a bulto-carver at Nambé. Espinosa, *Saints,* pp. 23-24.

1756-1789 Don Bernardo Miera y Pacheco was a Spanish-born military cartographer who made images for the pueblo churches at Nambé, San Felipe, Ácoma, and Zuni and for San Miguel's in Santa Fe and the church in Trampas. Mentioned by Pino in Carroll, ed., *Three New Mexican Chronicles,* p. 99; Boyd p. 7.

1775-1800 (Anonymous) Gesso-relief Maker. Possibly a priest from Mexico. Boyd, p. 7.

1780-1800? (Anonymous) "Eighteenth-Century Novice" was a copyist of oil paintings who tended to use solid red backgrounds. Boyd, pp. 7-8.

1785-1831 Pedro Antonio Fresquís of Las Truchas, probably the first native-born santero, did work in the Truchas, Nambé, and Chamita churches and in the Rosario Chapel in Santa Fe. He tended toward space-filling designs, dark backgrounds, and sgraffito. Boyd, pp. 8-10; Chapter One above.

Santos and Saints

1790-1809 (Anonymous) "Laguna Santero" decorated the church at Laguna and Ácoma; he had more contact with European and Mexican art than Frequís, it would seem. Boyd, p. 10.

1790-1810? Antonio Silva of Adelino, identified as the carver of the crucifix and Nuestra Señora of Tomé church. Espinosa, *Saints,* pp. 38, 50; *N. M. Magazine* 51 # 7-8 (July-August 1973), 21.

1804-1845? Antonio Molleno, formerly known as the "Chili Painter," painter of progressively more stylized retablos, carver of bultos, very occasional painter of hides. Boyd, pp. 10-12.

1820-1835 José Aragón, Spanish-born but perfectly acclimated to New Mexico's santero tradition, painter and carver of works that are, along with Rafael Aragon's, the easiest to like of the New Mexican school. Boyd, pp. 13-14.

c. 1822 (Anonymous) "A. J. Santero" is named from initials appearing on one of his retablos; Boyd notes his "thick, gritty gesso ground and acid coloring," p. 13.

1826-1855 José Rafael Aragón of Córdova, painter of reredoses at Picurís, Talpa, Chimayó, Córdova, Llano Quemado, and Chama; firm outlines and colors. Boyd, pp. 14-15; Ahlborn, *Américas* 22 # 9 (September 1970), 9.

1830s-1840s (Anonymous) "Santo Niño Santero" was aptly named from his most charming work, a Santo Niño de Atocha, a fit subject for his simple composition and bright colors. Boyd, pp. 15-16.

1830s-1840s (Anonymous) "Quill-Pen Santero" was named for his apparent use of a pen instead of a brush to make fine lines. Boyd, p. 16.

c. 1860? ? Lopez — a father or grandfather of José Dolores Lopez, probably a resident of Córdova, reputedly the maker of the first death-cart (Doña Sebastiana). Miller, *Bulletin of the Museum of Modern Art* 10 # 5-6 (May-June 1943), 5; Boyd. p. 22.

c. 1860? Eusebio Córdova of Córdova, identified as possibly the sculptor of the San Isidro shown in plate 45 of Espinosa, *Saints,* pp. 38, 50, 79; E. Boyd, *Saints and Saint Makers of New Mexico,* p. 64.

1860s José Gonzales of Guaymas, Sonora, Mexico, painter of Trampas altar-screens and # 343 in the 1969 exhibit at the Museum of International Folk Art; E. Boyd, Supplement to Boyd, p. 5, # 343.

1860s? Tomas Salazar of Taos, noted as a name without works attached, Espinosa, *Saints,* p. 80.

1870s-1880s Miguel Herrera of Arroyo Hondo, maker of bultos with shell-shaped ears. Boyd, pp. 16-17; Jaramillo, *Romance of a Little Village Girl,* p. 188.

1870s-1890s Juan Ramón Velasquez of Canjilón, maker of very large bultos of a very striking sort, employed housepaint when it was available. Boyd, pp. 17-18.

1870s-1890s Antonio Herrera of Capulín, Colorado, a San Luís Valley santero. Wallrich, *Western Folklore* 10 (1951), 154-58; hereafter Wallrich.

1880s? Sanchez, apprenticed to a santero in Ojo Caliente, quit to become a farmer; father of Joe Sanchez, an informant of Wallrich, pp. 158-59.

1880s-1907 José Benito Ortega of La Cueva near Mora, maker of many death-carts, he endowed his figures with imitations of stylish Yankee-made pegged boots and with dotted eyelashes. Boyd, pp. 18-20.

1880s-1900s? (Anonymous) "Abiquiú Morada Santero," whose works appear as plates 24-25 of Wilder-Breitenbach, *Santos: The Religious Folk Art*

212

Index E

of New Mexico and figures 42, 52, and 53 of Ahlborn, *The Penitente Moradas.*

1890s-1910s José Inez Herrera, active in the area of El Rito, the sculptor of the Death Cart of the Denver Art Museum collection; Robert Stroessner, *Santos of the Southwest,* pp. 52-53.

1910s-1943 Celso Gallegos, carver of pine, leaving it without the standard santero finishing of gesso and paint; he introduced many non-religious subjects, but had a reputation for holiness. Boyd, p. 22.

1918-1938 José Dolores Lopez of Córdova (or perhaps at times Quemado), also working in unfinished wood, specializing in such subjects as Adam and Eve, the Flight into Egypt, and the Tree of Life.

1920s?-1964 Patrocinio Barela, a near-surrealist in comparison to his predecessors on this list. *N. M. Magazine* 14 # 11 (November 1936), 25, 33; Crews, Anderson, and Crews, *Patrocinio Barela;* Crews, *Américas* 21 # 4 (April 1969), 35-37.

1930s Santiago Mata, who worked under the W.P.A. Federal Artists' Project. E. Boyd, Supplement to Boyd, p. 6.

1930s Juan Ascedro Maes of the San Luís Valley, who quit when he left the Catholic Church. Wallrich, p. 160.

1930s? Francisco Vigil of the San Luís Valley. Wallrich, p. 160.

1950? Richard Chavez. E. Boyd, Catalogue of Auction of Nolie Mumey Collection, April 19, 1968, # 218.

1960-1970s Luís Aragón of Shoemaker, Mora County, and Albuquerque; the last of the authentic santeros, a carver of bultos of unfinished wood, using occasional stains and gessoed cloth.

The remainder of the list is of primitivists rather than folk santeros; these are persons who I believe have a choice of styles, and choose to imitate the works of the New Mexico folk tradition.

1920s-1930s Frank Applegate, author and collector and dealer.

1930s-1960s Elmer Shupe, "on the highway" north of Taos, a dealer.

1950s-1960s In Tesuque: Benjamin (Benito) Ortega.

In Córdova: George Lopez, Benito Lopez, José Mondragón (later moved to Chimayó), Samuel Córdova. See *Desert Magazine* 21 # 1 (January 1958), 10-12; *American Artist* 27 #4 (April 1963), 25-29, 78-79; Córdova, *Echoes of the Flute,* p. 61.

In Chimayó: Apolonio A. Martinez.

In Santa Fe: J. Ben Sándoval, Henry Quintana, and Luís Sándoval. See Santa Fe *New Mexican* (13 August 1967), for all in this section.

1960s-1970s. Robert Lentz, Pecos; Bill Tate, Truchas; Jorge Sanchez, Albuquerque; Luz Martinez, Taos; Tomás Burch, Ratón; Cándido Garcia, Albuquerque; Edmund L. Navrot, Santa Fe; Jolaroque, Utah; Victor Emert, Albuquerque; Ruth Campbell, Albuquerque; Jo Martinez, Chimayó; Eleanora, Albuquerque; Rosina, Albuquerque; Abenicio Montoya, Santa Fe; Jackie Nelson, Santa Fe, Frank Brito, Santa Fe.

INDEX

This Index does not attempt to include anything that is in alphabetical order in Appendix A, in logical order in Appendices B and D, or in chronological order in Appendices C and E. The reader is advised to begin with the appendices, especially Appendix A, for most of the subjects likely to be looked for.

Abiquiu Corporation—160.
Acacio, San—22, 61, 128; illustration of—31.
Ácoma—114.
Adonis—30, 35.
agrarianism—80.
Ahlborn, Richard E.—129, 130, 212, 213.
A. J. Santero—15; illustration by—92.
alabado—59, 63-66, 70, 123-24.
Albert, Ethel M.—96, 135.
Albuquerque—19, 160, 163.
Alegoría de la Redención—51; illustration of—23.
Alianza Federal de Mercedes—160, 162-65.
Ana, Santa—131, 133.
Anderson, Wendell—213.
Ángeles, N.S. de los—122, 126, 134.
Angel Guardián—126.
Antonio de Padua, San—20, 91, 94, 131, 134, 143; illustration of—132.
Apache Indians—97.
Aphrodite—103.
Apocalypse (Revelations), Book of —126.
Apolonia, Santa—22, 134.
Aragón, José—15, 24; illustration by 17, 102.
Aragón, José Rafael—15-16, 24, 41, 173; illustration by—31, 88, 112, 120.
Aragón, Luís—illustration by—151, 164.
Aristotelianism—46-47, 52, 69.
Arizona—2.

Assembly of God Church—161.
Athene—103.
Atocha, N.S. de—109, 115.
Atocha, Santo Niño de—87, 98, 109-10, 115, 119, 138; illustration of —108, 112.
Austin, Mary—93, 107.
Aztlán—107-09, 165.

Barabbas—58.
Bárbara, Santa—134.
Barreiro, Antonio—152, 153.
Bellah, Robert—135.
Benedict XIV, Pope—118.
Benrimo, Dorothy—96.
Berefelt, Gunnar—101.
Bernini, Giovanni—10.
Beshoar, Barron B.—71.
Birch, David—207.
Blas, San—134.
Blawis, Patricia Bell—163.
Bonney, William (Billy the Kid) —154.
Bouyer, Louis—69.
Boyd, E.—3, 14, 25, 27, 39, 40, 109, 118, 121, 129, 130, 170, 181, 211-13.
Brayer, Herbert O.—145.
Breese, Frances—121.
Breitenbach, Edgar—212.
bulto (defined)—12.
Bumppo, Natty—81.
Bustamante, Friar—100.
Byzantine painting—13, 26, 30-32.

California—2, 161.
calzones—63.
Campbell, Joseph—100.

Index

Candelarias, N.S. de las—121.
Cargo, Governor David—165.
Carmen, N.S. del—22, 122, 125, 126, 134; illustration of—17.
Carroll, H. Bailey—106, 152, 153, 211.
Castrense (chapel)—8.
Cather, Willa—116.
Catron, Thomas Benton—155, 159.
Cayetano, San—90.
Chavez, Fray Angelico—54, 55.
Chihuahua—2, 80.
Chili Painter—see Molleno.
Chimayó—40, 110.
China—133.
Clavijo, Battle of—113.
Cobos, Rubén—153.
Cofradia de Nuestro Padre Jesus Nazareno—see Penitentes.
Colorado—149.
Comanche Indians—97.
Cooper, James Fenimore—149.
Corazón, El Sagrado—89, 118, 119, 133.
Córdova, Lorenzo de—54, 63, 93, 213.
Corpus Christi (feast)—63, 69.
Cortez, Hernando—97.
Costilla, N.M.—6.
Cottrell, Fred—133.
Crews, Judson—213.
Crews, Mildred Talbot—213.
Cristo Crucificado—20, 22, 24, 63; illustration of—38, 49, 60, 68.
Cristo Rey, Church of—8.
Crucifijo—see Cristo Crucificado.
Crusoe, Robinson—33.
Cuba (nation)—107.
Cubism, Cubists—1, 13, 26.
Cupid—30.
Curandera, curandero—78.
Currier and Ives—16.

Delahaye, Hippolyte—129, 194.
Demarest, Donald—100.
Denver, Colorado—160.
Denver Art Museum—25.
De Vargas, Diego—101, 178.
Diana—131, 191.
Dickey, Ronald F.—27, 37, 127, 148, 194.
Diderot, Denis—83.
Dolores, N.S. de los—24, 59, 67, 104, 122, 128; illustration of—82.
Doniphan, General Alexander—6.
Dorsey, Stephen W.—158.

Dozier, Edward P.—70, 96.
Durán, Bernardo—182.
Durand, Gilbert—100, 103.
Durango, Mexico—80.

Ecce Homo—50.
Echo Amphitheater—163.
Eighteenth-Century Novice—12.
ejidos—143, 154-55.
Eliade, Mircea—51, 103.
Ellis, Florence Hawley—58-59.
El Paso—2.
Emerson, Ralph Waldo—80.
Escudero, José Agustín de—152.
Espinosa, Aurelio—66.
Espinosa, Gilberto—37, 101, 114, 155.
Espinosa, J. Manuel—101.
Espinosa, José E.—37, 39, 128, 180, 181, 190, 194, 211, 212.
Espíritu Santo—50, 117, 134, 138.
Esquípulas, Nuestro Señor de—40.
Estanislao Kostka, San—134, 139.
Euripides—186.
Exodus, Book of—118.
Extramadura—100.

Fall, Albert Bacon—155.
Familia, Sagrada—22, 118, 119, 133, 138; illustration of—120.
Felipe de Jesús, San—128, 134.
Fergusson, Erna—107, 155.
Fernando Rey (III), San—113.
Finn, Huck—81.
Flora de Córdova, Santa—139.
Fontenrose, Joseph—53.
Fra Angelico—35.
Fra Filippo Lippi—35.
Franciscans—2, 9, 54, 55, 100, 185, 197, 211.
Francisco de Asís, San—19, 55, 94, 129.
Francisco Solano, San—8.
Frank, Lawrence P.—14, 27.
Frankenstein's monster—81.
Franklin, Benjamin—83.
Fresquís, Pedro—12-13, 20, 21, 22, 24, 40, 41, 126-27, 176, 187; illustration by—11, 38.
Freud, Sigmund—122.
Fromm, Erich—85-86.
Fulton, Robert—79.

Gabriel Archangel, San—22, 126; illustration of—34.

216

Gallegos, Celso—40.
Garcia, Fray Andres—9.
Gardner, Richard—63, 155, 157, 158, 160, 162, 163.
Gauguin, Paul—1.
Genesis, Book of—118.
Gerónimo, San—36, 127, 128, 129, 135.
Gertrudis, Santa—91, 94, 118, 134; illustration of—92.
Gettens, Rutherford J.—39.
Giedion, S.—146-47.
Gonzalez, Nancie—90, 107.
Gorras Blancas—160.
Gregg, Josiah—57.
Grove, Richard—54, 89-90, 99, 136.
Guadalupe-Hidalgo, Treaty of—106, 150-53.
Guadalupe, N.S. de (Mexican)—13, 25, 98-107, 115, 122, 123, 125, 126, 134; illustration of—5, 42, 102.
Guadalupe, N.S. de (Spanish)—100, 136.

Haggard, J. Villasana—106, 152, 153.
Hamill, Hugh M.—106.
Hammond, George P.—114.
Haydn, Hiram—43.
Hera—103.
Hermes—103, 115.
Hernandez, Juan—59.
Herod, King—22.
Herrera, Miguel—16, 18.
Hidalgo y Costilla, Miguel—106.
hide paintings—9.
Hodge, F.W.—114.
Horgan, Paul—172.
Houghland, Willard—190.
Huida en Egipto—20-21, 22, 115, 119, 138; illustration of—88.
Hummingbird-on-the-left—98, 105.
Huxley, Francis—100.

Ignacio Loyola, San—8, 89, 127, 128, 135.
Ilfeld, Charles—158.
Indians—1, 2, 6, 89, 93, 135, 139.
 See also Navaho Indians, Pueblo Indians, etc.
Inés del Campo, Santa—131, 134, 139.
International Folk Art Museum—20, 22.
Irving, Washington—114.

Isidro Labradór, San—90, 131; illustration of—144, 151.

Jaramillo, Cleofas M.—212.
Jemez Pueblo—101.
Jenkins, Myra Ellen—155.
Jenkinson, Michael—162.
Jesuits—8, 19, 67, 94, 118, 134, 177.
Jesús Cargado con la Cruz—119, 128.
Jesús Nazareno—18, 50-51, 54, 61, 63, 67, 69, 119, 128, 138; illustration of—56.
John Birch Society—163.
Jonah—122.
Jorge, San—illustration of—164.
José Patriarca, San—8, 21, 94, 118, 133; illustration of—11.
Joseph Marie, Sister—55, 59, 81.
Juan Bautista, San—91, 131, 143.
Juan Diego—98-99.
Juan Nepomuceno, San—8, 93-94, 127, 128, 129, 131.
Judas Iscariot—58, 59.
Julian, George W.—158.
Jung, Carl—123.

Kant, Immanuel—146.
Kearny, General Philip—6.
Keleher, William A.—143, 150, 155, 157.
Kenner, Charles L.—6.
Kiev, Ari—89, 103, 135.
Kluckhohn, Florence—96.
Knowlton, Clark—153, 157, 158.
Korea—149.
Kubler, George—27.
Ku Klux Klan—106.

Laguna Santero—8, 12, 14.
Lamy, Archbishop Jean Baptist—67.
Las Trampas, N.M.—76.
Las Truchas, N.M.—40.
Lee, Laurence F.—125.
Leonard, Irving A.—111.
Leonard, Olen E.—167.
Lepanto, Battle of—179.
Leyba, Ely—89, 90.
Librada, Santa—24, 61, 128.
Lincoln County War—154.
Linton, Ralph—3.
Longino, San—115, 129.
Lopez, José Dolores—130.
Lorenzo, San—86-87, 131, 134.

Index

Los Angeles, California—160.
Lucas, San—100.
Lucia, Santa—134.
Luís Gonzaga, San—134, 139.
Luz, N.S. de la—8, 122, 126, 134.
Lynch, E.K.—175.

Maccoby, Michael—86.
Madrid, Spain—80.
Magdalena, Santa Maria—30, 35, 57, 134.
Magna Mater—103.
Malinowski, Bronislaw—53.
Mango, Cyril—33.
Mano Negra—160.
Mansi, Giovanni Dominico—118.
Margarita de Cortona, Santa—20.
Maria de la Cabeza, Santa—187.
Maria Magdalena, Santa—see Magdalena.
Marín del Valle, Francisco Antonio —8.
Mars—30.
Martindale, Andrew—43.
Martinez, Padre Antonio José—4.
Martinez de Ugarte, Maria Ignacia—8.
Marx, Karl—**78-79**.
Maslow, Abraham—207.
McCarty, Frankie—155.
McCormick, Cyrus—79.
McKenzie, John L.—70.
McLuhan, Marshall—4.
McWilliams, Carey—2, 153, 154-55, 158.
Mead, Margaret—59, 87, 90, 159.
Meier, Matt S.—107.
Mexico City—2, 98.
Miera y Pacheco, Bernardo—9.
Miguel Arcangel, San—20, 22, 24, 126, 135; illustration of—34.
Miller, Margaret—130, 212.
Mills, George—27, 37, 54, 89, 95, 96, 99, 136, 153.
Molleno, Antonio—8, 13-14; illustration by 82, 137.
Moors—22, 97, 100-01, 111.
Mora, N.M.—110.
Morse, Samuel—79.
Mumey, Nolie—181.

Nabokov, Peter—162, 163, 165.
Navaho Indians—53, 97.
Nestor—84.

Neumann, Erich—103, 123, 127.
Newton, Isaac—81, 83.
Niño de Atocha, de Praga, Perdido— see Atocha, Praga, Perdido.
Niño, Santo—8, 30, 37, 119.
Nuestra Señora—see different titles— Ángeles, Atocha, Carmen, etc.; in general—121-25, 138-39.
Nuestra Senora de la Luz, Chapel of —8.
Nuestro Padre Jesús Nazareno—55.

Odysseus—84.
Old Pecos Bull Dance—101.
Ong, Walter J.—81, 83-84, 127.
Ortega, José Benito—16-18; illustration by—5, 49, 124, 144.
Ortiz, Alfonso—52, 110-11.
Ortiz, Ramón—150-52.

Pablo, San—114, 136.
Padre Diós—8, 50, 117, 118, 133, 134, 138.
panocha—66.
Parish, William J.—158.
Pascual Baylon, San—91, 131, 143.
Pastora, N.S. como una—131.
Pawnee Indians—97, 110.
Pearce, T.M.—104.
Pearson, Jim Berry—167.
peasants—73-80.
Pecos Pueblo—101.
Pedro, San—115, 129.
Pelagianism—50, 62.
Pelham, William H.—155.
Penitentes—18, 45, 54-57, 59-70, 89, 91, 93, 94, 104, 119, 122, 123, 125, 128-30, 136, 142, 162, 166, 171, 175, 182, 195, 196, 197.
Perdido, Niño—115, 138.
Phoenix, Arizona—160.
Physiocrats—80.
Picasso, Pablo—1.
Pile, Governor William A.—159.
Pino, Pedro Bautista—106, 113, 152, 211.
Pizarro, Francisco—97.
Platonism—46-47, 69.
Plumb, J.H.—130.
Portiúncula (N.S. de los Ángeles) 101.
Post-Impressionists—1.
Praga, Niño de—119.

Procopio, San—127, 128.
Pueblo, Colorado—160.
Pueblo Indians—26, 40, 53, 77, 78, 79, 97, 101, 105, 110-14, 131, 145-47.
Puerto Rico—107.
Purísima Concepción, N.S. del—24, 121, 122, 125, 126, 134.

Quetzlcoatl—100, 103.
Quill Pen Santero—16; illustration by —23, 34, 42.

Rael, Juan—64-66.
Rafael Arcangel, San—110, 126, 135; illustration of—34.
Rahner, Karl—47, 52.
Rallière, Father J.B.—58.
Ramón Nonato, San—90, 94, 129, 134.
Rascón, Juan Rafael—40.
Read, Benjamin W.—114.
Redfield, Robert—75.
Refugio de Pecadores, N.S.—122, 128.
Reichard, Gladys A.—52.
Remedios, N.S. de los—106.
reredos (defined)—12.
retablo (defined)—10-12.
Revista Católica—67.
Rey, Agapito—114.
Rio Abajo—77.
Rio Arriba County—163.
Rita de Casia, Santa—89, 94, 129, 133.
Rivera, Feliciano—107.
Rome—80.
Roque, San—134.
Rosalía de Palermo, Santa—129, 134; illustration of—137.
Rosario, N.S. del—127.

Saint Louis, Missouri—18, 136.
Salazar, Eulogio—163.
Samora, Julian—96.
San—see different names—Acacio, Antonio de Padua, etc.
Sanchez, Alfonso—163.
Sanchez, Alonzo—114.
Sanchez, George—96.
Sandoval-Duran Chapel (Talpa)—24.
San Felipe Church (Albuquerque) —19.

Sangre de Cristo Land Grant—63.
Sanhedrin—58.
San Joachín del Rio Chama Land Grant—163.
San Juan de los Lagos, N.S. de—121.
San Miguel (del Vado) County— 150, 160.
San Pedro, N.M.—63.
Santa—see different names—Ana, Apolonia, etc.
Santa Fe, N.M.—2, 19, 41, 163.
Santa Fe Railroad—18, 136.
Santa Fe Ring—155, 158.
Santa Fe Trail—6, 16, 18, 77, 136.
San Luís Valley—40.
Santiago—8, 22, 90, 98, 105, 110-15, 131, 142; illustration of—116, 156.
Santo—see Tomás.
Santo Entierro—58.
Santo Niño Santero—16; illustration by—108.
Santurario (at Chimayó)—40.
Sauer, Carl O.—96.
Sebastiana, Doña—89, 129-30; illustration of—76.
Sedgwick, Mrs. William T.—114.
Segale, Sister Blandina—157.
Seville, Spain—55.
sgraffito—12.
Shalkop, Robert L.—27, 118, 129, 177.
Shelley, Mary Wollstonecraft—81.
Simon of Cyrene—57.
Socorro, N.S. del—89, 106, 122.
Soledád, N.S. de la—24, 59, 67, 122, 123, 128; illustration of—124.
Stang, Alan—163.
Stanley, F.—57.
Steele, Thomas J.—110.
Steiner, Stan—155, 163.
Strodtbeck, Fred L.—96.
Stroessner, Robert—27, 51, 213.
Swadesh, Francis—75, 77, 84, 94-95, 167.
Symeon of Thessalonika—32-33.
Sypher, Wylie—43.

Talpa, N.M.—24.
Tate, Bill—54.
Taylor Museum (Colorado Springs) —19.
Teapot Dome Scandal—155.
Tenebrae—55.
Territorial architectural style—148.

Index

Tewa Pueblos—110-11.
Texas—2, 89, 106, 107, 154, 161, 162.
Third Order of Saint Francis—55.
Thoreau, Henry David—80.
Tierra Amarilla, N.M.—163.
Tierra Amarilla Land Grant—155, 160.
Tijerina, Reies Lopez—155, 160, 161-65.
Tinieblas—55, 67.
Tlatelolco—98.
Tobias, Henry J.—167.
Tobit, Book of—126.
Tolpetlac—98.
Tomás, Santo—91.
Tomé, N.M.—57-58.
Tonantzin—98, 100.
Trinidád, Santísima—117-18, 134, 138.
Turner, Evan H.—39.
Turquoise Trail—2.
Twitchell, Ralph Emerson—143.

Udell, Isaac L.—59.
uroboros—123.
Ute Indians—97.

Valdez, Armando—158.
Valdez, Bernard—158.
Valle de la Paz—161.
Valvandera, N.S. de—8.
Van der Leeuw, Gerardus—33.
Vedder, Alan C.—27.
Velasquez, Juan Ramón—18.
velorio—37, 69.

Venus—30, 35.
Veroff, Joseph—207.
Verónica, Santa—129.
Versailles—83.
Vicente de Paul, San—136.
Victoria, Texas—161.
Vietnam—149.
Vigil, Donaciano—152.
Villagrá, Gaspar Perez de—114.
Virgil—84.
Vogt, Evon Z.—96, 135.

Wagley, Charles—141.
Wallrich, William J.—40, 212, 213.
Warren, Robert Penn—75.
Watt, James—79, 81, 83.
Way of the Cross—55.
Weigle, Marta—54, 69, 93.
Westphall, Victor—155.
Whitney, Eli—79.
Wilde, Oscar—30, 41.
Wilder, Mitchell A.—27, 212.
Wolf, Eric R.—83-84, 98, 100.
Woodhouse, Charles E.—167.
Wordsworth, William—80.
Wyoming—149.

Xerez, Battle of—113.
xoanon—18.

Ysleta, Texas—161.

Zaldivar, Vicente de—114.
Zuburía, Bishop José Antonio—67, 94.